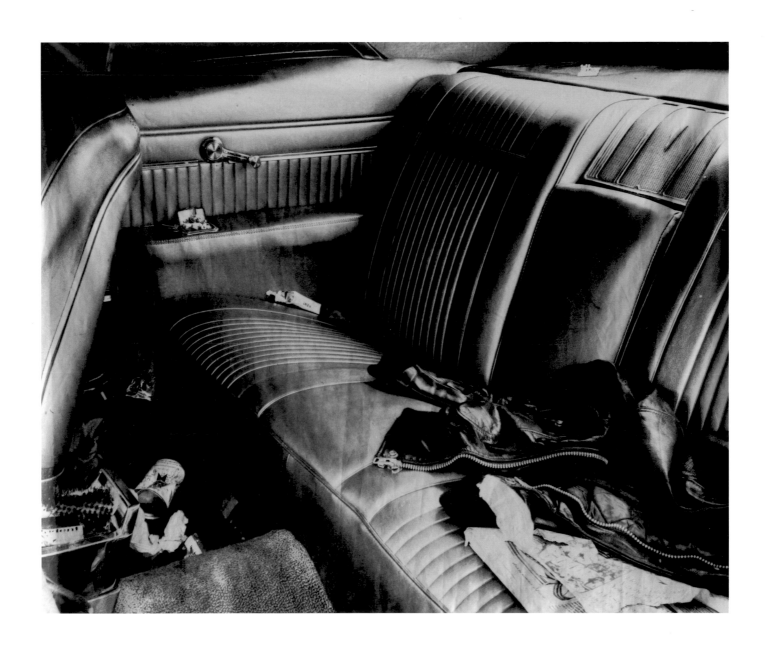

Backseat, 1977, Photograph on canvas

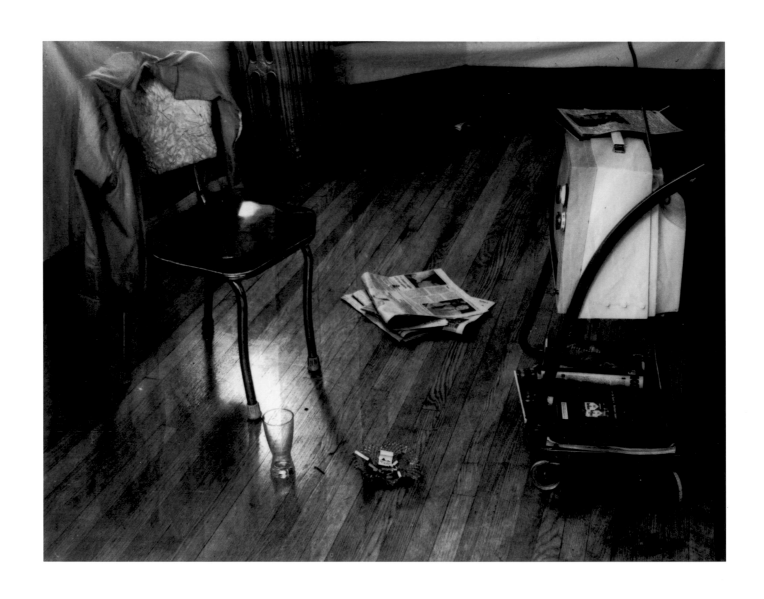

TV Chicago, 1977, Photograph on canvas

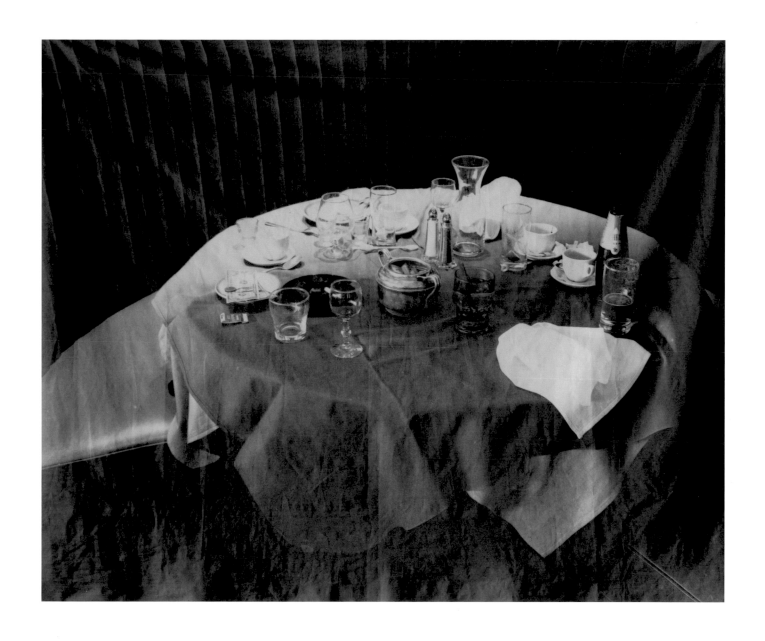

Table, 1977, Photograph on canvas

Balthasar Burkhard

OMNIA

Essay Matthias Frehner

Kunstmuseum Bern / Scalo Zurich–Berlin–NewYork

Foreword

Balthasar Burkhard takes a position in the development of international photographic art similar to Ferdinand Hodler's in the classical modern. Both Bernese, as journeymen, draw positions abroad independent of the currents of their time. Both have extremely strong artistic personalities speaking only their own language. Art as self-manifestation: each of their works is a new personal answer to the fundamental questions of existence. True for both: the picture is not the surface of the visible alone. Art is rather an instrument of perception; in the analytical process strategies for revealing the essence are searched for. Hodler's parallelism and Burkhard's conceptual approach make images possible that are free of the arbitrary and where hidden regularity becomes visible. What one normally overlooks becomes incident; fleeting emergence becomes unalterable existence. Each painting a Hodler – each photograph a Burkhard. Most evident is the correlation of alpine motifs. As portraitists the two artists are just as close: they maintain distance in order to achieve complete visualization of the scheme.

That it has become possible – thanks to Balthasar Burkhard's significant engagement – to realize the largest, most comprehensive and, in our collective opinion, most beautiful exhibition in the Kunstmuseum Bern of his work, I consider a stroke of luck for both sides. The range of Burkhard's work, the complexity and breadth of form and content, the size of the formats (Burkhard is a pioneer in the definitive emancipation of photography from painting) made it clear from the outset that the spatial needs of a "complete Burkhard" would surmount the usual for an exhibition. His magical gray-black intermediary worlds spread over the ground floor of the new building that was recently vacated after the transfer of the Klee Foundation to the Paul Klee Center. The large formats fill the hall with their powerful presence and necessitate inclusion of the galleries on the second floor. We are indebted to Burkhard's friend the artist Franz Gertsch who suggested temporarily rehanging the permanent collection of his photorealistic large-formats to the benefit of real photography.

The project was starred from the start: encouragement to do the exhibition, even before I began work here, came from my former colleague the critic Konrad Tobler. That I immediately contacted an artist and let my enthusiasm about his work take flight is due to Burkhard who, full of elan, dedicated himself to the realization of this exhibition. Without this *feu sacré* it would have hardly been possible to obtain all of the desired loans, and it is certain that the artist will not take upon himself the task of sorting through ten thousand contact sheets again for the next twenty years at least. We thank the architect Franca Comalini for her creative support of this project. She produced an exhibition architecture which in the "reading" of the photographs displaced the vertical, to the horizontal, and in the diagonal in a diverse parcours. Her "reading blocks" are minimalist sculptures inciting another way of reading the photographs. For the uncompromised realization of the complex ideas in the exhibition and catalogue we owe thanks to a further stroke of luck: the artist's friendship with Alexander Schärer, CEO of USM in Münsingen. Burkhard took photographs for this company that set new standards in the so-called field of applied photography. Sincere thanks as well to Alexander Schärer as patron. We give thanks to official Berne for providing Balthasar Burkhard with its generous support, and the Berne community in particular for its significant contribution by supporting the project in the context of the Kunstmuseum Bern's 125th birthday celebration. We owe thanks to the artist's friendship to District Councilor Alexander Tschäppät who was

present to honor Burkhard at the exhibition opening. Thanks also go to Burkhard's assistant Anette Schafer, who curated the exhibition with me, as well as Rafael Buess, the indefatigable assistant to the artist. In the museum Nathalie Baeschlin, Daniel Küng, Hans-Ruedi Pauli, Kurt Scheidegger, Alfred Spycher, Brigitta Vogler, Yasmin Welti, and Jürg Winzenried energetically mobilized in order to realize the exhibition and catalogue. Special thanks to them all. Our warmest thanks goes naturally to the lenders who were all very well-disposed to us. The following museums and foundations made their objects available: Federal Office for Culture, Berne; Collection Groupe Lhoist, Limelette; Collection le Consortium, Dijon; Emanuel Hoffmann Foundation, Basle; Fonds régional d'art contemporain (FRAC), Marseille; Cabinet des estampes und Musée d'art et d'histoire, Geneva; Musée de La Roche-sur-Yon; and the Stiftung Kunstsammlung Teo Jakob, Berne. We would also like to thank the private collectors Jean-Paul Jungo, Alexander Schärer, and Maryana Bilski.

Matthias Frehner

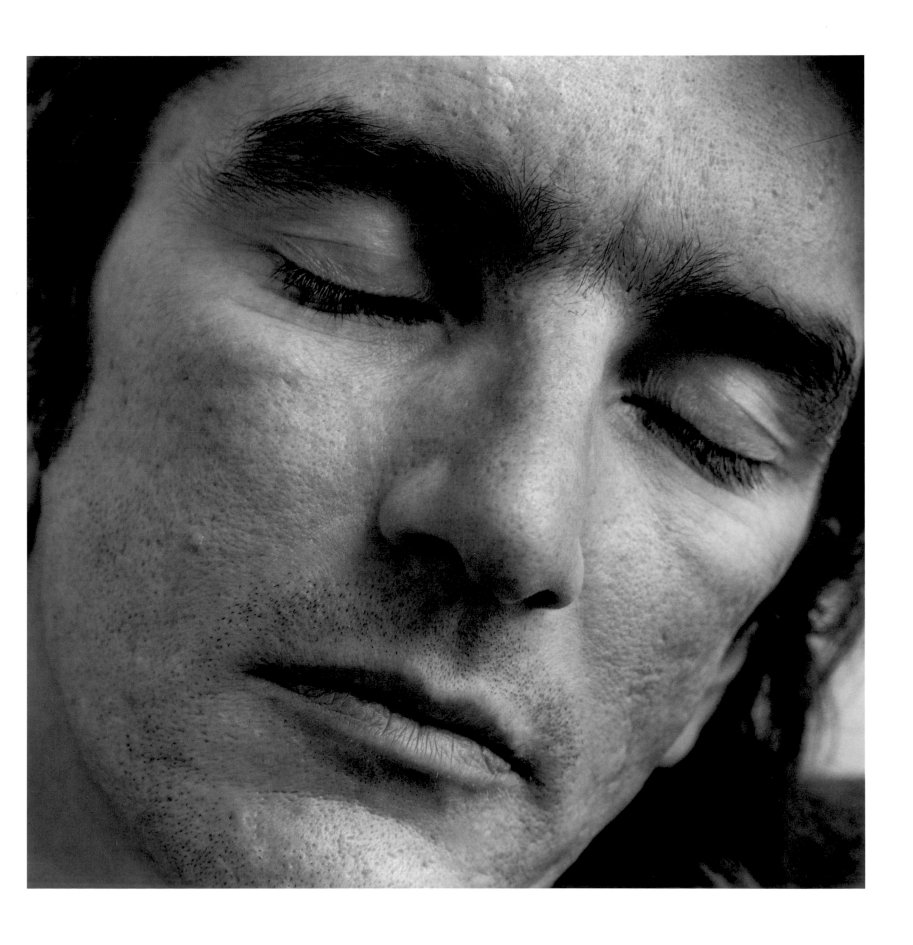

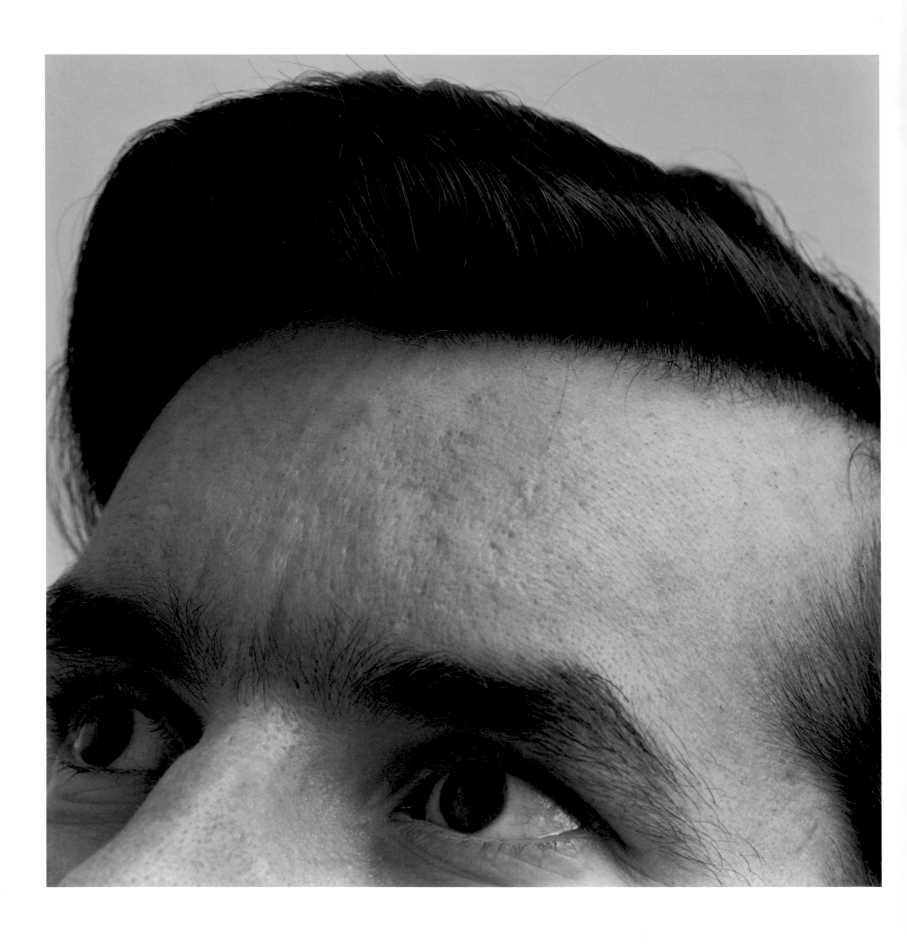

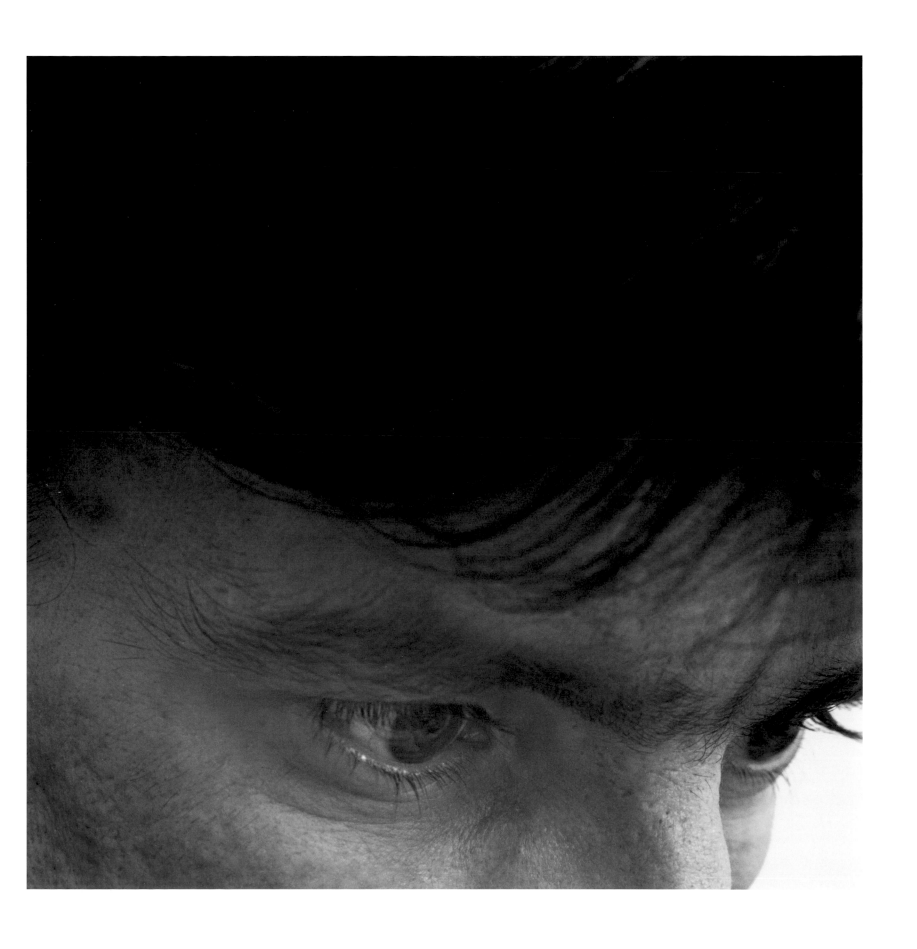

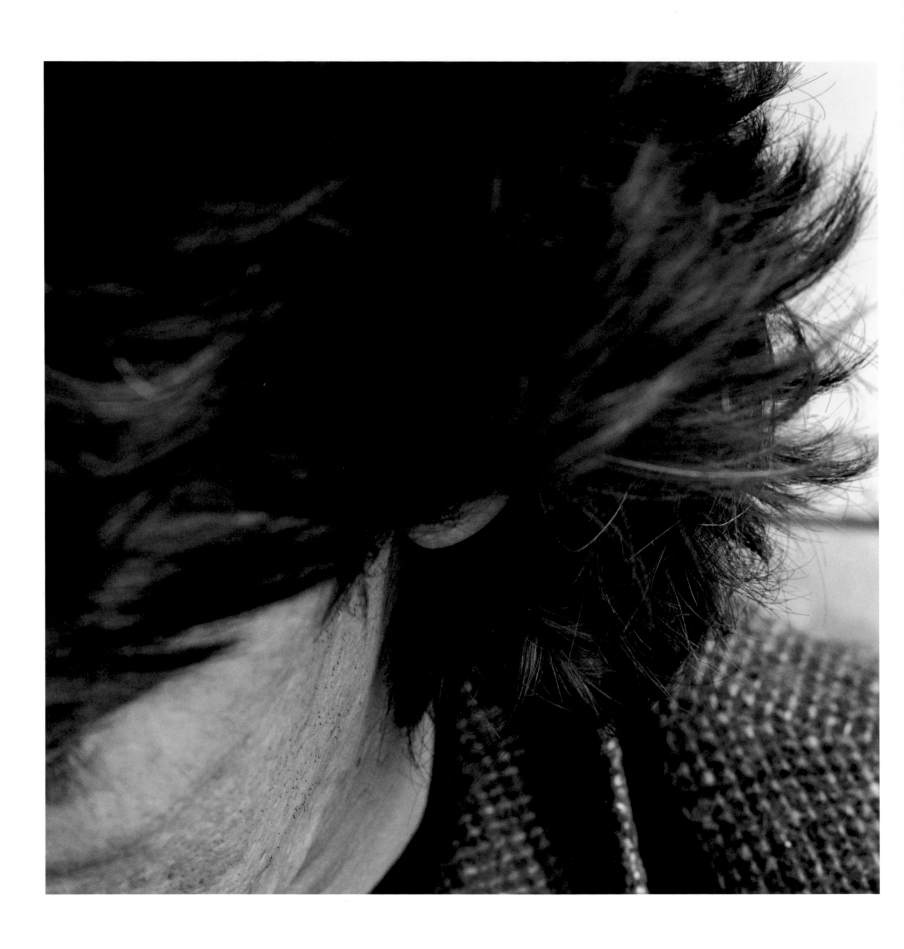

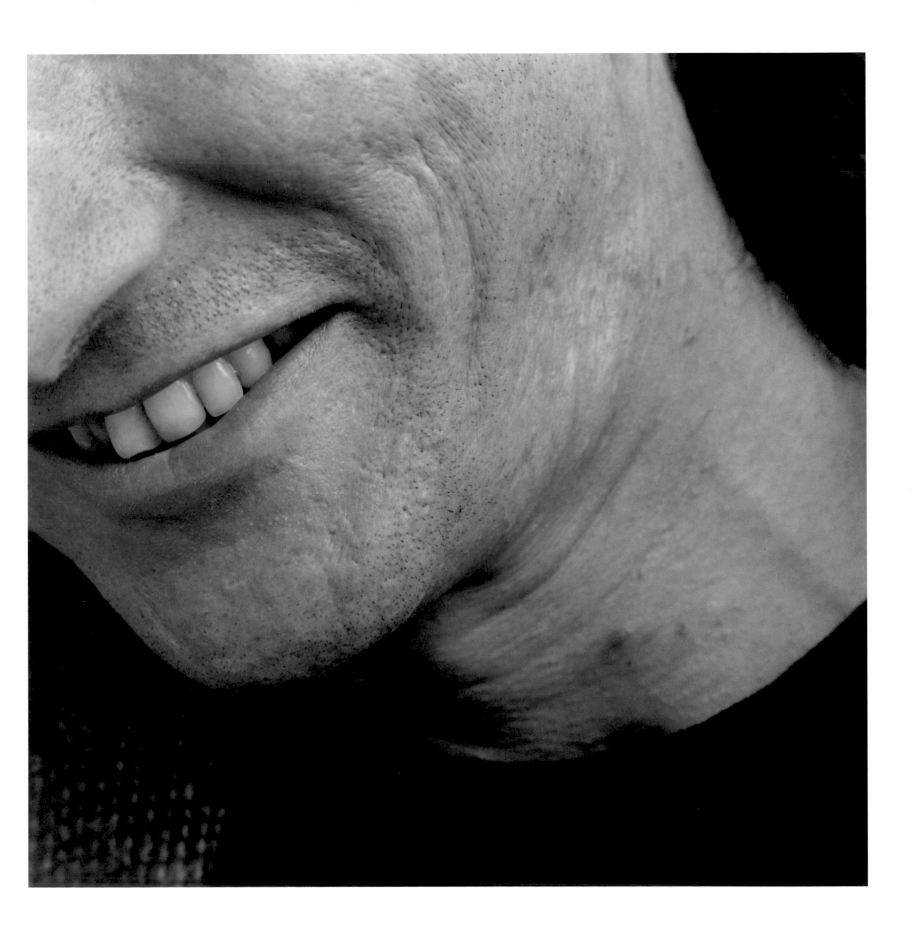

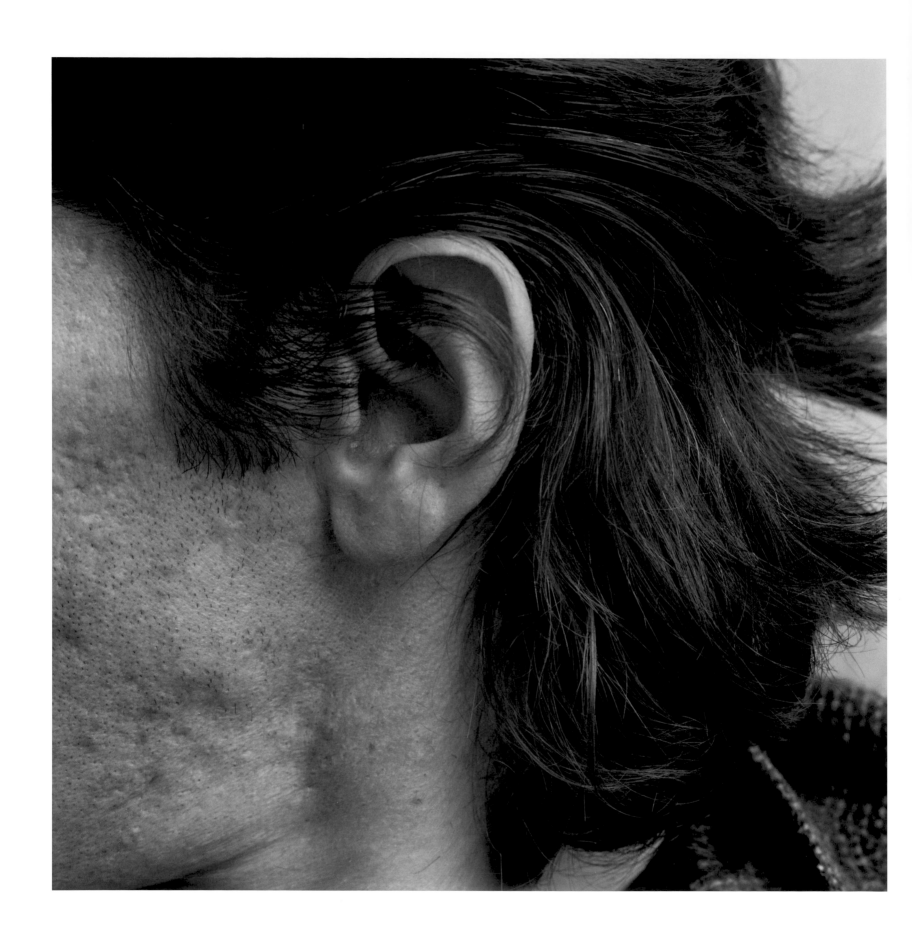

14 Portfolio Chicago, 1977, Balthasar Burkhard and Tom Kovachevich

Balthasar Burkhard – OMNIA

"What otherwise no one sees." Balthasar Burkhard, Chicago 2004

"A photograph is a secret about a secret." Diane Arbus, 1971[1]

Chicago 1977: Balthasar Burkhard's first solo exhibition is called "Photocanvases." It takes place between June 3 and July 12, 1977 in Chicago at the Zolla Liebermann Gallery, 368 W. Huron. The show is composed of only nine works. Critical response is undividedly positive. Burkhard's innovative accomplishment is recognized: enlarging formats to the monumental dimensions of American postwar painting and incorporating an independent new theme is perceived as consciously modern. Alan G. Artner writes, "Burkhard easily enters into the company of the most impressive photographers on today's scene" in his June 1978 review "5 artists who made last 5 years memorable."[2] Burkhard's technique – projecting the negative on large, light-sensitive canvases in the end hung with a pair of photo clips like linens on the wall – also enables a new relationship between artwork and viewer. "Burkhard's technique brings the content right up to you and you are put on close terms with it."[3] The sagging of the "soft linens" on the one hand, the enigmatic content of the photographs on the other, established a virtually sacred forcefulness, "Gigantic pieces of cloth – modern day handkerchiefs of St. Veronica – pinned to the wall as pieces of evidence."[4] Folds in the cloth question the documentary credibility of the photographic image making it possible for him (Schwartz quotes Burkhard) "to create a new reality."[5]

The tightrope walker: Since this first solo exhibition, Balthasar Burkhard's work has contributed significantly to the international development of art in his time. Subsequent to this show he has behaved like a tightrope walker without a safety net. His work is based on tremendous discipline, intuition, and somnambulant certainty in the realization of new forms of expression. A constant, even through today, is his relationship to a portrayed object. He maintains distance in order to achieve clarity and eliminate spontaneous subjectivity, because for him it is ultimately about perception and truth which "disclose themselves as a new reality." Robert Frank, arguably the most important figure of orientation for Burkhard's discovery of his own style while in the United States, defined the unity of truth and art in his publication *The Americans*, "There is no such thing as truth alone. It exists only in connection with art."[6] Burkhard's photographs, like Robert Frank's, single out unique magical moments from the flood of possible images that lend validity to the arbitrary. Frank summarized this special something in words that also apply to Burkhard, "When people look at my photos, I would like them to feel the way they do when they want to read a line of poetry twice."[7]

Looking back to 1968 – Rebellion against reportage photography: The three photographic still lifes *Backseat, TV Chicago*, and *Table* from 1977 are as large as Edouard Manet's history paintings. What distinguishes them from the photocanvases made together with Markus Raetz in Switzerland is the new compelling graphic quality that immediately catches hold of you. For Burkhard it is now no longer about conceptual problems of perception like before in the Berne

coproduction with Raetz. Back then the two clever young stars of the Swiss scene around Harald Szeemann and Jean-Christophe Ammann demonstrated what they learned from the groundbreaking as well as legendary avant-garde exhibition "When Attitudes become Form" (Kunsthalle Bern 1969). In "Visualisierte Denkprozess" (Kunstmuseum Luzern 1970) they took part themselves. The technique of applying a negative to soft canvases was an independent invention of the photo-professional Burkhard. An ingenious emancipatory step of tremendous consequence was however the enlarged format. The photos were as large as Andy Warhol's series of painted blow-ups of black and white reportage photographs of terrible accidents and crimes.

Admittedly the places that Burkhard and Raetz shot together – Monika and Markus Raetz's cheap bed in Amsterdam and Raetz's comfortlessly empty atelier there – are not unique in Swiss photo history. They are more an expression symptomatic for their time of a late (in international comparison) upheaval in Swiss photo history triggered by the unrest of 1968. At that time artists like Urs Lüthi, David Weiss, Heinz Hebeisen, Christian Vogt, and Heinz Brand turned away from the previous generations of reportage photography. Hans Finsler, Gotthard Schuh, Werner Bischof, Jakob Tuggener, Paul Senn, like Burkhard's teacher Kurt Blum, in spite of fundamental differences between them, rarely ever questioned specifically Swiss values in their classically composed images. As a result in 1968 their critical students attempted frontier crossings in every direction. Burkhard was not a rebel joining other students in the political struggle for freedom. By challenging all values, it became possible for him to experimentally adopt as his own a cross-over of genre, style, and content to reveal new forms of expression. As Harald Szeemann's "court photographer" entrusted to document his epochal exhibitions including the two most significant of that year "When Attitudes Become Form" (1969) and Documenta 5 (1972) among others, Burkhard was at the forefront of the avant-garde. It is hardly an exaggeration to refer to the contract-photographer in general as the most well-informed Swiss artist. Through the friendship with Szeemann, Burkhard became and remains personally acquainted with key artists like sculptors Richard Serra and Claes Oldenburg, conceptualists James Lee Byars and Marcel Broodthaers, Fluxus activists Joseph Beuys and Charlotte Moormann, as well as Mario Merz from the Arte Povera and Allan Kaprow, or the Vienna Actionist Otto Mühl.

In the "photographs on canvas" realized together with Markus Raetz, Burkhard grew from documentary photographer into independent artist. 1968 meant for him that there were no more borders. He ranks among those photographers who experiment with the new possibilities first and with their medium actively engage in avant-garde discourse. At first the new strategy – implementing a manner of synthesis of conceptual art, Arte Povera aesthetic, and the individual search for clues – rested less with the picture itself and more in the format approaching the dimensions of pop art painting. The motifs were, appropriate to the '68 generation of nonchalance, intentionally banal and unspectacular.

Backseat, TV Chicago, Table – Hyperrealism: The Chicago *Photocanvases* show a new Burkhard who has completely and definitively returned to photography as photography. These photographs are utterly free of what were considered paragons of genre, both then as now. They do not have the pretension of greater credibility over painting. They do not intend to visualize thought processes. They explicitly stand for absolutely nothing other than what they are. Therefore they are not documents, but rather autonomous art works. *Backseat* depicts Burkhard's Pontiac in Chicago. The gaze falls

from the top left to the interior. On the shiny black seat a leather jacket lies on a crumpled newspaper; further an open pack of cigarettes. On the armrest – as is always the case in Burkhard's proximity – is an overflowing ashtray. On the floor garbage, a crushed beer can, scraps of paper. *TV Chicago* shows a narrow view of a living room that is anything other than comfortable, containing only the most essential furnishings of American living: a chair in front of a television set on a trolley in a room with shiny waxed wood plank floors. The jacket over the back of the chair, an empty beer glass, and a burning cigarette in the ashtray on the floor hint at the absent inhabitant of the room. We cannot discern whether or not the television is turned on, since we only see it from the side. *Table* shows an uncleared table just left by customers in a restaurant. Coffee cups, water glasses, a beer bottle, empty wine carafe, ashtray, book of matches, table napkin, and a saucer holding change for the waiter are on the table. The chairs are pulled out. An arrangement like Daniel Spoerri, but completely different than a *tableau piège* glamorizing excessive Epicurean pleasures in flashy pop art style. No, a cautious, melancholy, almost sacred mood marks not only *Table* but the other pictures in this series as well.

The three "spaces" are not empty in the sense of being neutral. Objects have referential character providing conclusions about people who have just left the stage. The objects are in a way still warm from contact with the people who were just holding them in their hands. As representatives they seem to have absorbed something about the character of their users. This impression is accomplished formally through the severe direction of artificial light. Light is used in these pictures for more than simple illumination. It actively makes an appearance. It generates unnaturally bright spots, pulls away by means of unfathomable shadow, produces sharp contrast in the same way that it conjures infinitely differentiable transitions. Burkhard's light is reminiscent of the hyper-realistic, toppling-into-the-magical drama of light that Caravaggio introduced to art.

The box of snake skin: Burkhard's magical realism of the Chicago *Photocanvases* is explained, by almost all authors who write about them, by his onetime ambition of becoming a film actor. Contemporary critics who support their texts with conversations with the artist name directors of American *cinéma noir* like Roman Polanski as direct role models.[8] In a conversation I had with Burkhard he mentioned that Alfred Hitchcock also fascinated him, which made me bear in mind that he never alluded to any particular film in his work; the Chicago *Photocanvases* were fully autonomous creations. Fact is that he wanted to become an actor ever since he moved to the United States. Not director or camera man which as a photographer would have been self-evident. His goal was to be in a "picture" himself. In contrast to the majority of the avant-garde who at the time were abandoning pictures and hurling themselves into real life – Fluxus, Happening, Land Art, Performance – it was Burkhard's desire to physically catapult himself into the picture. Thus a meaning other than just photography is attached to the image: it is not just the documentary representation of life, but rather like in cinema is its own reality of life.

So he traveled first to Hollywood. Intending to introduce himself to the admired Roman Polanski Burkhard constructed a portfolio out of a wood box completely covered in snake-skin. The legendary *box of snake skin* (which Martin Schaub realized "could find a home in Harry Szeemann's imaginary museum of 'private mythologies'")[9] contained "14 polaroids, 12 diapositives, 1 slide viewer" in various compartments, and on the inside of the lid was a photograph showing Burkhard looking out at the viewer. The chance never arose to hand over the box to Polanski.

Burkhard did however make the acquaintance of the Swiss director Urs Egger who in 1978 cast him in the role of the crook in his film *Eiskalte Vögel*.

Burkhard and Cindy Sherman – Cinema as dead end: The images in which Burkhard plays various character roles as an actor in front of the camera have their parallels in Cindy Sherman's black and white *Untitled Film Stills* started a short time later. Like Burkhard, Sherman slips in front of the camera not only in different clothes, but acquires other identities at the same time. For both, it is more than just a role play. The existential force of Sherman's photos are expressions characteristic of the time of an 'I' that realizes that one's own identity almost automatically adapts to the idols of mass media. Susan J. Douglas spoke in this context of the erosion of personality typical of Sherman's generation, "Along with our parents, the mass media raised us, socialized us, entertained us, comforted us, deceived us, disciplined us, told us what we could do and told us what we couldn't. And they played a key role in turning each of us into not one woman but many women – a pastiche of all the good women and bad women that came to us through the printing presses, projectors and airwaves of America. This has been one of mass media's most important legacies for female consciousness: the erosion of anything resembling a unified self."[10] Burkhard is ten years older than Cindy Sherman. In the fifties before the wide-spread advent of television, the dictate of mass media had less influence on teenage personality development than in the sixties. Comparing scenes from the film *Eiskalte Vögel* (that show Burkhard the actor in action) with Sherman's *Untitled Film Stills*, one thing becomes clear: Sherman is consistently a different person, Burkhard on the other hand, remains Burkhard. In front of the camera he does not become a "split" personality perpetually changing identity. For him cinema became a dead end: and that is why he remained a photographer. And as such he always asked himself why he (like Rembrandt) was always, in all of his probing self-portraits in spite of all the role playing, inescapably confronted with the same absolutely steadfast existence.

Delegated presence: Burkhard's vacant spaces of the *Photocanvases* show cinematic settings – François Grundbacher even speaks of "crime scenes"[11] – without actors. Burkhard did not arrange the pictures. The photos are not staged, rather they are found. From his preoccupation with movies he developed a feeling for settings and locations with suggestive meaning evoking absence almost reminiscent of Luis Buñuel. That Robert Frank was a guide is undisputed. For both, the handling of atmosphere-creating light and the resulting build-up of concentrated mood is equally intense. Burkhard avoids narrative moments by switching off the screen from the observer and intensifies the mood through tight framing. Frank like Burkhard continues a major contribution of American painting through the medium of photography: the invocation of the living presence of absent inhabitants in interchangeable American middle-class living rooms, staircases, and theater lobbies. By foregoing the use of color, Frank abstracts and concentrates the mood of Edward Hopper also found in Charles Sheeler's interior photographs; Burkhard intensifies it even further through almost microscopic tightening of the frame.

Facial torsi: In *Fragments of Self-portraits* (1979) Burkhard experimented with the strategy of extreme framing to reveal only partial views of an obvious whole. Acting in front of the camera was limited to facial expressions and posture of the head, in contrast to the production of staged stills that were abandoned definitively after seeing Cindy Sherman's *Untitled Film Stills*. The photos were shot together with Tom Kovakovich. They met at the Documenta 5 in Kassel, where Kovakovich's work was on exhibit. Burkhard maintained an intense friendship with the physician and meditative object builder throughout his first Chicago visit, including hour-long chess games by telephone. What was new in the

Fragmenten von Selbstporträts was the notion of a series. However if you hold the photographs next to each other, no meaningful sequence of movement ensues. Rather the snapshots seem to have been generated by chance.

We are accustomed to perceiving traits hierarchically in order to identify a face, or anything in general that we want to recognize again. A visual profile focuses on eyes, mouth, nose, and hair. Faces are memorized through these features. That is why it is possible to hide the identity of a person who does not want to be photographed or filmed by simply covering these parts of the face with a bar. In the photos of his face Burkhard circumvents this subconscious mechanism of recognition. Through the repeated turning of his head, as well as the restricted view of a section of the face, the forehead, part of the cheek, the ear, or the large pores of the skin become themselves alone the fixed points of perception. Burkhard directed the camera so close to his head that we see completely differently than when presented a passport photo. The face as a fragment becomes structural field, a landscape. These photographs make us aware that the camera can "see" fundamentally differently than the human eye. This fragmentation would be impossible without a tool to extract such a close detail in this fashion, unless one were to get very close. But even then the edges of the field of vision would not be so razor sharp. The cut-outs of Burkhard's face are specimens produced through the means of photography that oblige a new reading. Strangely enough these radical facial torsi have few if any predecessors in photo history – unless one considers Alfred Stieglitz's sensual, step-by-step investigation of Georgia O'Keeffe's body. But Stieglitz's much larger sections are by comparison consciously composed, something which Burkhard particularly avoids. A parallel in content can be made with Rembrandt's experimental self-portraits. Through unnatural hard shadows his face develops a fragmentation which reminds one of Burkhard's literally cut out details. What is fascinating is the balance that the two create between the autonomization of the individual parts and the suggestivity for which these are suitable. We are first puzzled 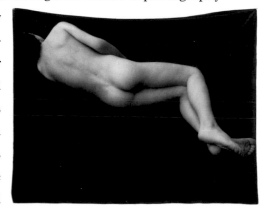 by these facial fragments, then notice what we would otherwise see second. One must discover the face anew; it is not simply there. And yet through the unfamiliar access that sets fantasy in motion, there is a complete picture of the personality in both. Indeed the shadows in a Rembrandt, the fragment of a Burkhard make us aware of characteristic traits that otherwise do not appear so explicitly. Introversion, self-questioning, irony, doubt.

As Burkhard's camera only renders fragments, it programmatically refuses the expectation that the primary function of photography is to give an "objective" account of a situation, ie. a complete one. By freeing photography from this traditional position of bondage, Burkhard makes the step from photographer to photo-artist.

Burkhard style: With his photos of isolated body parts including the self-portrait series, Burkhard found his own style, an expression of his own view of the world. His *stilwollen* is so plain and clear that all of the photographs produced since then can be recognized as "Burkhard's." Characteristic of his style is the irritatingly distance-creating, classicist clarity that unites Ingres's emphasis of comprehensive outlines of the body with Edward Weston's "abstract" concept of form. Burkhard's singularity rests further in his ability to wait until "everything" is right, even if these magical moments are as rare as a total solar eclipse. And with his sensorium for designing form and content through light, he joins the rank of artists from Caravaggio and Rembrandt through New Objectivity and Edward Hopper, and reaches the photography of Edward Steichen through Weston. His phenomenal intuition for the expressiveness of light is responsible for his preference for black and white photography. Colors would distract. Burkhard loves the abstract middle ground. In

addition, his radical principle of cutting always detaches just what is absolutely necessary from the panorama of reality to allow the essential to emerge from the incidental. Burkhard belongs to the first generation of photo-artists actively networking their medium with the strategies of the expanded concept of art since the late sixties. The majority of photographers – with the exception of individual experiments in Surrealism – were at this point in time still running along as compliant reporters and submissive interpreters next to the "grand arts" and were not about to even dream of raising claims to large formats. In contrast Burkhard regards himself primarily as an artist who, since the seventies, approaches ideas as sculptor, concept artist, painter, architect, Land Artist, or performer as the case may be. And as a second step delegates execution to Burkhard the photographer.

The Nudes – a fundamentally individual view: It would be a crude simplification to place Burkhard's photographic investigation of the male and female body in linear dependency with the theme of nudes in photography. It would be equally shortsighted to see it merely as a contribution to the theme of the torso motif. In his depictions of the body Burkhard implemented fundamentally new formal and technical means and with them realized his own view of the body. His examination of the body as theme stems from his cooperation with Markus Raetz before his stay in the United States. A picture of a body in space, which could have been the inspiration for Gerhard Richter's conceptual homage to Duchamp's *Nude Descending a Staircase*, also belonged in their investigation of questions of perception. At first the idea remained unrealized.

Kovachevich's son: The large-format photocanvas *Entwurf* (1977) depicts a horizontal nude that is in certain ways a riddle. Man or woman? Age? Surroundings? Is this an intentional exhibit of allure? Are we clandestine observers? The image shows a life-size figure. All the more irritating is the absence of any kind of clue clarifying the situation. Interpretation remains completely open. Not until only very recently were we told who the model is. For this book the artist unveiled the secret for the first time. It never would have occurred to anyone that the person depicted is a six-year old boy, Tom Kovachevich's son, amusing himself with his father and his father's friend. Burkhard had already produced the large *Self-portrait*, also belonging to the *Photocanvases* series, with his friend Kovachovich. The attempt to realize the theme of the nude in self-portrait form à la Urs Lüthi failed. Burkhard is not an ironist, nor can he imitate this stance. His strategy of distance to the portrayed is, in the photograph of the young boy, substantiated by the effect of the soft light. The body on the impenetrable black background is thus not put on show like the naked adolescents by Jock Sturges who shamelessly lets the viewer encroach on the milieu of the actors. Kovachevich's son is in contrast so close that one all but sees him breathing, though he is still absent protected by the impermeable black, recovered from another sphere. This interweaving of physical nearness and psychological distance protected Burkhard ten years later from voyeurism in his photographs of the most intimate parts of female models, *L'Origine du Monde*. Photography as reflection is usually too close to reality to keep the male view of the naked body clear of sexual connotation. In photographic history there are thus, with the exception of Brassaï, few forerunners to Burkhard's specific portrayal of the naked body.

The particular atmosphere that Burkhard creates with his models, in addition to posture and light direction, lies further in the quality of his baryt prints as he himself points out. The complex working processes of the darkroom make it hardly possible to print two identical photographs; each differs from the next in middle tones and clarity. Thus each photo is unique. The temperamental individuality of each print lends an aura to his photos. This is however not only technically determined – that would contradict Walter Benjamin's statement that with technical reproducibility art loses

its aura – but primarily an intellectually directed perspective of the world. Henri Cartier-Bresson described most precisely this cognizant vision that brings photographers to a new reality, "Photography means recognizing a circumstance and rigorously organizing the visually perceptible forms that render and communicate this circumstance without hesitation and in fractions of a second. Reason, eye, and heart must be aligned."[12]

Photographic sculpture – living objects: In the first half of the eighties Burkhard concentrated on the theme of the naked body. For him it is neither about portraits and individuality, nor intimate, pictorial sentiment. He understands the bodies as plastic material like a sculptor usually cutting it into details with the camera to detach photographic sculpture. Important points of reference at the time were sculptors and conceptual installation artists, foremost Richard Serra and Niele Toroni. Serra impressed him with the monumentality and cryptic organicism of concrete form as well as the transcendence of the genre of sculpture into architecture. With Toroni it was the creation of complex impact through simple repetition. At this time, Hannah Villiger was also occupied with "sculpture" by means of photography. She takes imprints, so to speak, of her body with a Polaroid camera, enlarges and joins them in monumental wall installations. With Villiger the body parts are kaleidoscopically reordered. The fragments conform to a new sculptural whole beyond human anatomy. Burkhard alienates on the opposing path; he emphasizes anatomy, closes down his bodies, reduces them to living objects that are in the Platonic sense the elementary idea behind that which others deal with time and again.

The arm: The first *Arm* was produced between 1980 and 1982. It is clearly a man's arm. Burkhard used Markus Raetz as his model. The second *Arm* is more than just a remake as Burkhard supposes, on the contrary it concerns a female counterpart generated more than a decade later. *Der Arm* from 1980 to 1982 is composed of four separately framed photographic fragments tapering in the direction of the hand forming as a unit a trapezoid. The man's arm is completely outstretched like that of the famous spear-throwing Zeus. Technically Burkhard photographed Raetz's arm frontally from four different positions and assembled the four individual images into a whole arm.

Construction of an ideal representation: Burkhard categorically eliminates the perspectival distortion that inevitably accompanies the "one-eyed" camera lens, even when it for the most part can be compensated for. He reconstructs the *Arm* from partial images that reflect reality one-to-one, while the photographic image from one viewpoint – according to our visual habits – posits a distorted image as objectively correct. Theoretically an infinite number of "stops" is imaginable by guiding the camera along the arm; the finer the deconstruction the more precise would convergence with the actual expanse be. This new way of seeing becomes clear only when the body is enlarged several times larger than in real life – something that Burkhard would fulfill later in *Akt I* and *Akt II*.

Burkhard's *Arm* reflects the model like a cast. Original and representation are each completely equally proportionate. This procedure corresponds with the pointing method in sculpture, when the original is proportionally enlarged or reduced in size. With this investigation Burkhard joins the circle of avant-garde pioneers that revolutionized photography in the eighties. The belief in photography as a conclusive account of (past) reality becomes obsolete for good. Susan Sontag spoke in general about the "surrealism of photography" as each photograph transforms the object and allows it to appear differently than how our eyes see it in reality.[13] This insight was fundamentally necessary to free photography definitively from the bonds of reproductive function, and to allow it to evolve from an interpretive art to an instrument of discovery. Urs Stahel alluded to the eighties as "by far the most innovative and imaginative decade of photographic

history."[14] Also tied in to that effect is that the discussion about the Postmodern – the linear model of the avant-garde bidding farewell in favor of a revival of historical positions – should be corrected. The predominant line of innovation did not simply break off at that point, but rather shifted into other genres. Significant innovative achievements in the art of

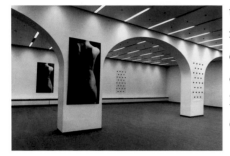

the eighties occurred in the photographic medium, and Balthasar Burkhard played a fundamental role therein. The modified form of presentation is paradigmatic of new expectations. Instead of a *single* framed photograph the work is, analogous to the shaped canvases of Frank Stella and Ellsworth Kelly, composed of conceptually joined parts. Burkhard's *Arm* is also composed of single images which generate a new whole, emancipating it from Markus Raetz's arm.

Transformation process: *Le Bras* from 1993 consists of three individual images delineating the joints – shoulder, elbow, wrist. The outstretched arm is (like Alberto Giacometti's famed sculpture *Le bras*) bent slightly towards the floor; fingers are spread further apart than in the first version. In this *Arm* the musculature needed to stretch the arm becomes part of the statement, one thinks one can discern subtle movements of the finger tips like leaves on a branch. The male arm seems sculptural; the female dancer-like, emotional, alive. As the preparatory collages show, Burkhard regards the arm through close framing in both cases as a conclusive whole in itself. *The Arm* developed through photography into sculpture is not a fragment, but rather an autonomous artistic construct. The exceptionally sensitive command of light, which reveals at the same time as it enshrouds also makes clear, "Profusely illuminated areas as well as heavily shadowed sections are additional effects of the photographer's staging of the body serving as a defense against visual access. The body that the photographs exhibit refuses appropriation."[15] With this specific direction of light and shadow, Burkhard simultaneously accented and withdrew, in spite of direct illumination, creating a dialectical form of expression. The radically framed image becomes an autonomous whole, the torso an "abstract" sculpture.

Prior to Burkhard this transformation of the body can be found to all intents and purposes only in Brassaï, who photographed nudes with analogous light sources and cropping in the early thirties. Brassaï however emphasizes the pictorial in his *Nu* from 1931/32; the photograph remains within the possibilities of painting. In Burkhard's work anatomical details (like the abruptly dramatic ribs) come to the fore like in Michelangelo's sculpture. The acute light-dark contrast in his work produces more than just an intimate atmosphere like Brassaï, propped on her elbows devotedly waiting like Danae for Zeus' shower of gold. Burkhard avoids mythological poses as a matter of principle. He generates drama solely through contrast of form. He objectifies the physical to a classical ritual of form, without ever lapsing into detached eroticism – similar to Ingres's transfer of plump anatomy into classical rigor. Burkhard focuses irritatingly on body parts. Closely cropped and in an incomprehensible drama of light an armpit or navel, a hand or foot becomes an area of the body that one has never seen in this way before. Burkhard's photographs are elemental, singular. He does not render details, rather he investigates structures in order to find them again in completely different contexts. He treats bodies like unknown landscapes whose topography it is imperative to explore.

The photographed dreams of a visual being: Reference to the classicism of an Ingres is, however, only one pole. It also comes to downright contrary picturesque transfigurations that remind one of Alfred Stieglitz's pictorialism. The cropped face of a woman over a mysterious, shadowed neck and upper body proves Burkhard to be one of the major sensualists in the perception of the most subtle transitions from light to dark. In such photographs he revokes the

sculptural just as emphatically as he in other places consciously accentuates it. A virtually unrestricted closeness prevails over these images, though it is anything other than revealing. Through the art of the most subtle gradation of light, the closeness becomes unreal; the portrayed slips into the phantasmagoric. Burkhard is the 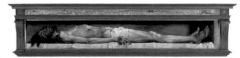 great shadow puppeteer not only in contemporary art, not merely in photography. Harsh shadows and selective illumination objectify the body to classical sculpture. Shadows that veil and blur enable him to visualize erotic areas of the body without displaying them pornographically. His close-up depictions of a vagina were just as much transgressions of the pornographic taboo as was Gustave Courbet's *L'Origine du Monde* to which it refers, and is thus to be justified primarily by strategies beyond artistic ones. In Courbet's realism, the folded-back cloth reminds one at best of a medical demonstration in front of students of gynecology. The purchaser of the painting was however a Turkish libertine. To whom is Burkhard's photograph directed? Surely not to clandestine pornography consumers. In his investigation he treats all parts of the body equally. Hairy armpits become surreal portals of delight in the same way that feet, hands, or thighs appear as *objets du désir*. Burkhard's pictures all share a direction of light and shadow that obscures, withdraws the subject in a visionary manner. Burkhard achieves distance, permits ambiguity. It is not about sexual practices, like Mapplethorpe's crystal-clear, highly aesthetic, staged images. His photographs are, like Thomas Ruff's digitally-edited internet pornography, not representation but interpretation. The difference between Burkhard and Ruff lies primarily in that the latter confuses without disguising. Like Jeff Koons in his photorealistic copulation scenes with Cicciolina, Ruff also refers to Duchamp's Readymade. The inherently outrageous picture staged or reworked – is declared art. Burkhard is light-years away from this strategy. For him it is about investigation. He wants to see as if for the first time. He wants to pinpoint and identify structures. He is a visual being who does not allow his sight to be channeled by social conventions and taboos. His curiosity and investigation of the world know no bounds. He flouts taboos like Rembrandt or Picasso with their drawings of "urinating women."

Space installation: Burkhard bares structures in his investigations of the body that the simple image conceals. These illustrated structures have inspired him to new criteria of order and forms of presentation. Burkhard's installations of his own works of photography in the Kunsthalle Basel (1983), in the Musée Rath in Geneva together with Niele Toroni (1984), and in the Chapelle de la Salpêtrière in Paris (1986) are legendary. In the two-storied stairwell of the Basler Kunsthalle he installed his work *Das Knie* – nine enlarged sections of a man's leg in serial rotation. A similar production, this time of five "knees" was realized in the Salpêtrière. Like a column shaft, cut off at the top and bottom, photographed again and again from different angles, the section of leg becomes an architectural element and still retains – in itself – its human individuality. The most interesting of these installations was the one in Musée Rath, where he placed his oversized nudes in juxtaposition to the equally large surfaces of Toroni's celebrated spots of paint.

Pictures from both artists were applied to pillars in the basement of the Musée Rath. Matthias Haldemann referred to the extreme positions of a pair of taxonomists in this antithetical installation, mutually contrasting and expounding each other, "Burkhard's images of the body and Toroni's non-representational paintings are dialectically opposed. Kandinsky already theoretically analyzed and impressively presented (in his almanac "Der Blaue Reiter" in 1912) the dialectic of Realism and Abstraction: the greatest Realism is tantamount to an abstraction, and the greatest Abstraction conversely becomes a new reality, what ultimately connects both poles in spite of all disparity."[16] In his art Toroni dismisses the referential character of what he paints. As for the brushmarks, "What you see is what you see." Individual gesture is also eliminated through delegable painting instructions. Burkhard approached his work in a similarly distanced way. He too

wants to free the image from overtones in terms of content. It is not about one particular person's back on which one projects memories, rather it is about the auto-referential archetype of a back – of *the* back before any other backs. Thus, the ambiguity of gender assignation. Man or woman, either would be possible. When it is about the profound, archetypal, then Burkhard always uses a woman or child – in the case at hand the model is a female dancer from Chicago. Burkhard and Toroni set benchmarks with this collaboration: photography as the equal partner of painting addresses architectural structures in an installation. The uncompromisingly clear Geneva installation is, in spite of inadequate response, a milestone in the history of photography as well as of installation art.

Expanding the field of vision: The Nude. The confrontation in the installation of two gigantic, reclining female nudes in the Kunsthalle Basel in 1983 – *Der Körper I* and *Der Körper II* (both created in 1983) – is unparalleled in photo history. One even looks unavailingly for equivalents in painting (even in Mannerism). What we see is not one photograph, but rather the collage of three or four. Developing a black and white photograph over 2 x 13 meters in size on a single sheet is not possible. The idea of assembling the picture from pieces is primarily determined by technical limitations. Burkhard did not, however, cut one image into pieces to enlarge separately. The nude is composed namely of four individual images presented together. Burkhard transferred the photographic strategy already evident in the work *Arm* (1980–1982) to the larger than life full-body depiction of a woman lying with outstretched arms. Thus there is on both horizontal compositions not only one but several vanishing points. Robert Frank with whom Burkhard dealt intensively again and again, had already in 1971 photographed landscapes taping together individual exposures to create panoramas. This method has, however, many forerunners in photographic history. That Burkhard handles a nude like a landscape panorama is a momentous innovation formally as well as in terms of content, above all because he developed thereupon the possibility for photography to catch up with painting in terms of dimension.

Martin Schaub compared Burkhard's "scanning" of the body from different positions with film. The images assembled next to each other correspond to the "traveling" of the cinemascope camera, "The recumbent body is shot in four stops, in body parts – each with a name, 'leg', 'hip', 'buttock', 'head and arm' – fragmented and reassembled as 'The Body.'"[17] One becomes conscious of the procedure only in the enlarged format. A smaller reproduction places the central perspective back with the observer; what becomes sensually clear in the original must be replayed in one's memory like a test. By adapting the method of "traveling" and in addition replacing the chronology of cinematic images with a spatial one, he as a photographer shows the viewer what in reality could not be seen in one glance. The advantage of painting – to present in one image moments that are chronologically and spatially apart – was not possible in photography as its short exposure time could freeze "only" a single moment. In the eighties concurrent with (though independent of) Jeff Wall, Burkhard not only freed photography from its conventional formats but also made the montage of larger images from separate pieces possible. Wall's montage of a giant, naked, older woman in the open stairwell of a library – *The Giant* (1992) – is far more complicated than Burkhard's merging of single images into a horizontal nude. The comparison, however, also makes the different goals distinct: Wall is, like a historical painter, a storyteller, and like a painter the colors with their ability to characterize details are also important. On almost every square centimeter of his ingeniously composed and mounted pictures information can be found which, like a mystery by Agatha Christie, makes us realize that the whole picture resembles an entangled labyrinth. And another thing: Wall wants to deceive. The photomontage is so refined that the seams are completely erased. Burkhard on the other hand shows how his picture is "made."

For Burkhard, like for Jeff Wall, painting is the central reference in his large nudes. (Wall's nude is not life-size in the image-format itself; she becomes a giant solely in the unreal relationship to her context.) Burkhard, however, does not orient himself on painting in terms of content, nor do his photographs demonstrate any technical superiority over painting like Wall's illuminated "lightboxes." The reference is primarily in motif. The two outstretched "nudes" are indeed related to Hans Holbein the Younger's celebrated *Body of the Christ in the Tomb* in the Kunstmuseum Basel. Adoption of the predella format jumps to the eye as a shared feature. Similar to the Holbein, one associates the rectangular form with a tomb. Holbein's dead Christ has a formidable physical presence that is only partially explained by the quasi photographic hyperrealism. Through the extreme landscape format one is forced to pace the body like with Burkhard's nude. Regard the painting as a whole, and it becomes a narrow band. In comparison to the entire visual field the strips render only what one can descry through a horizontal slit in the wall. If one concentrates only on the female nude, an anamorphic effect unfolds: it stretches out so that one is forced to gradually shift position in order to see the entirety. The picture, the body, exerts a dominating force over its observer. Burkhard intensified this effect. His figure with outstretched arms is comparatively longer than the dead Christ. And as the woman is twisting her body like a corkscrew the viewer is pulled into the picture even more. An irrational tilting effect results as the body lifts off of the black background as if it were floating in space. The color of the background fabric was made (compared to the individual images) significantly darker in the developing process for the large collage. The black becomes dense like impenetrable material "swallowing" the shadowy areas of the body and the model's hair. The silhouette lifts razor-sharp off the black ground, like lunar craters over the atmospheric void of the universe. The faceless body becomes a magical floating apparition. In its mode of appearance the two gigantic bodies are reminiscent of the symbolic fusion of man and landscape, of Edvard Munch in particular, whose islands and hilltops open up like gigantic lips, and cliffs and mountains anthropomorphically come to life.

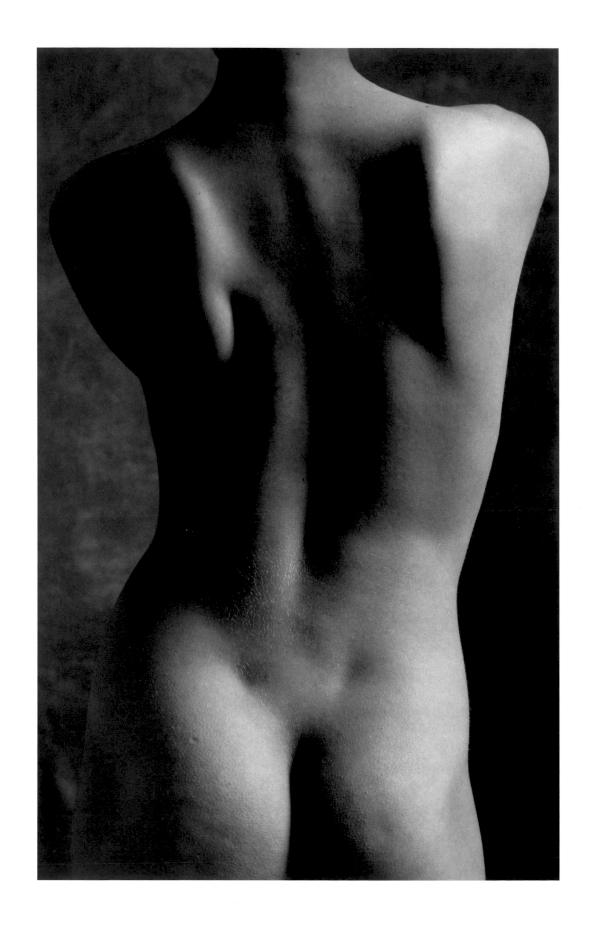

Torso, 1984

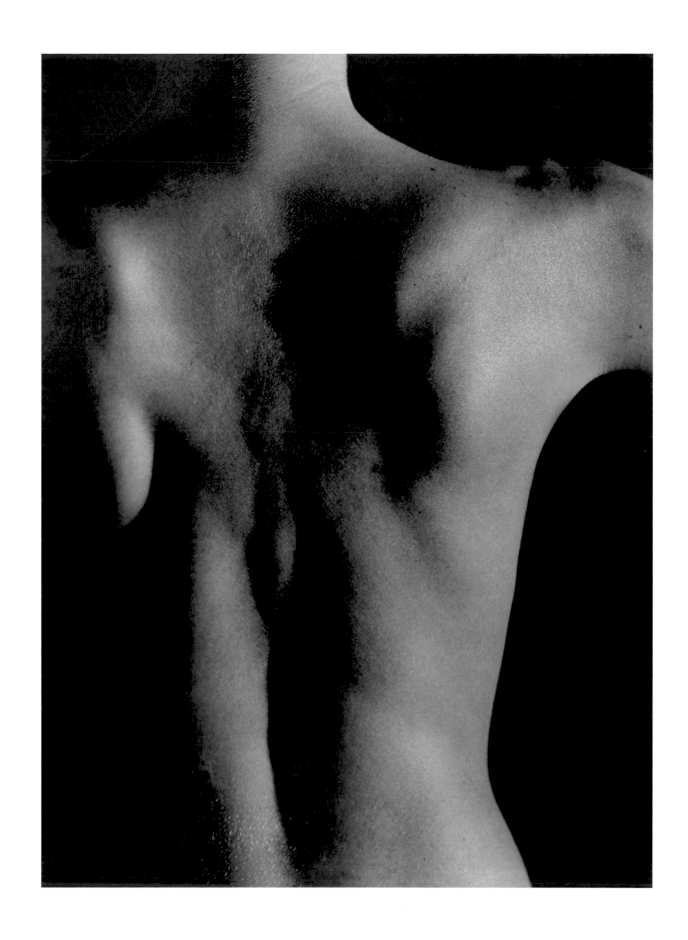

Torso, 1988

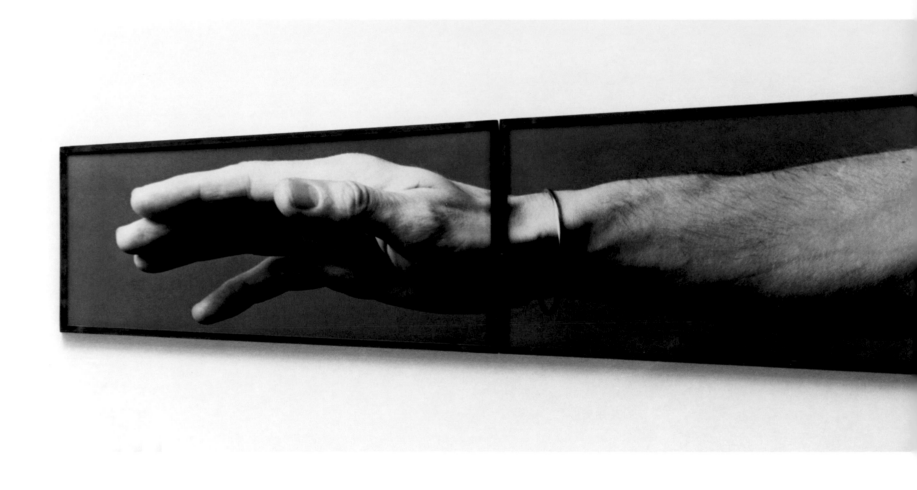

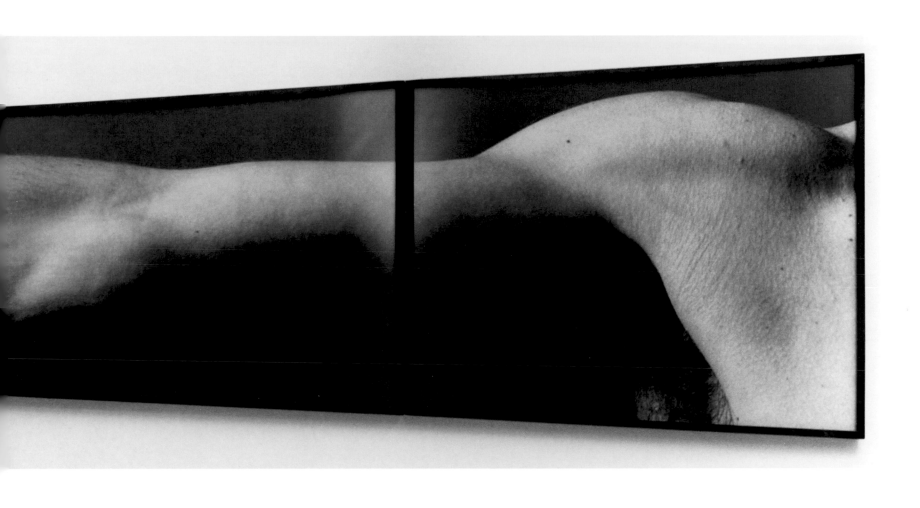

Der Arm, 1980–1982

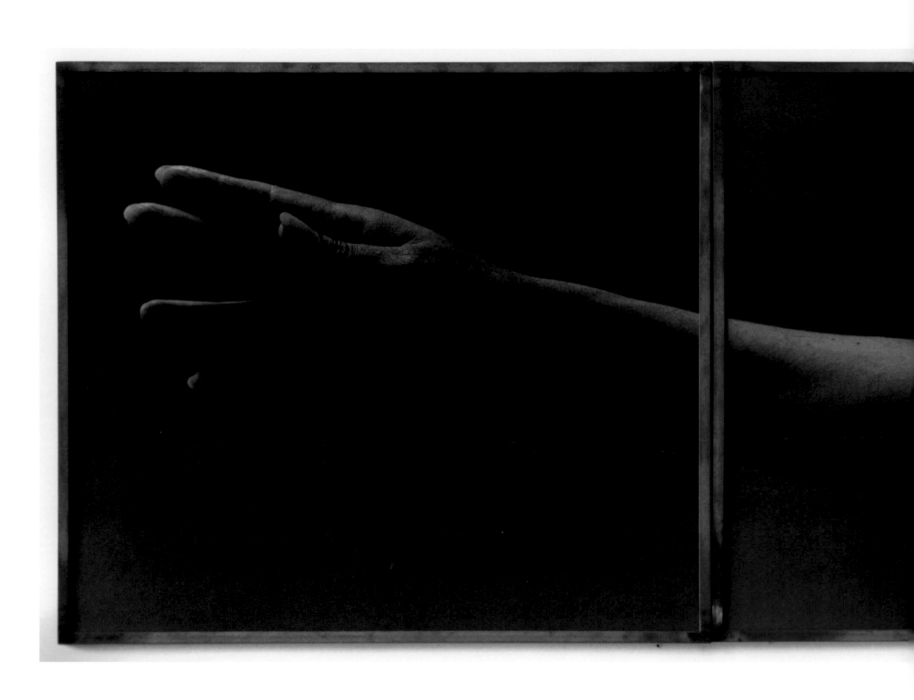

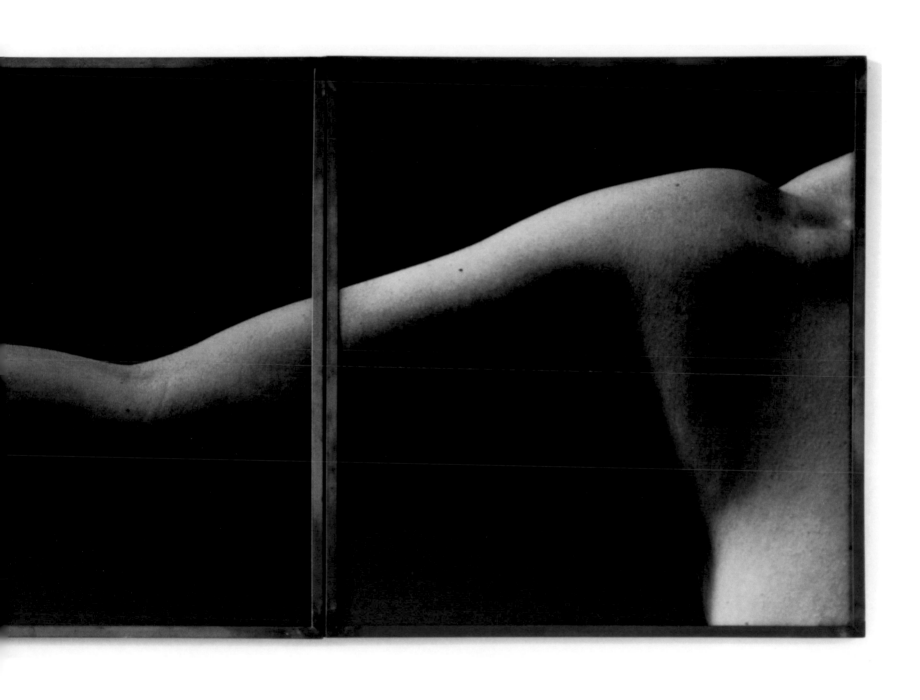

Der Arm, 1993

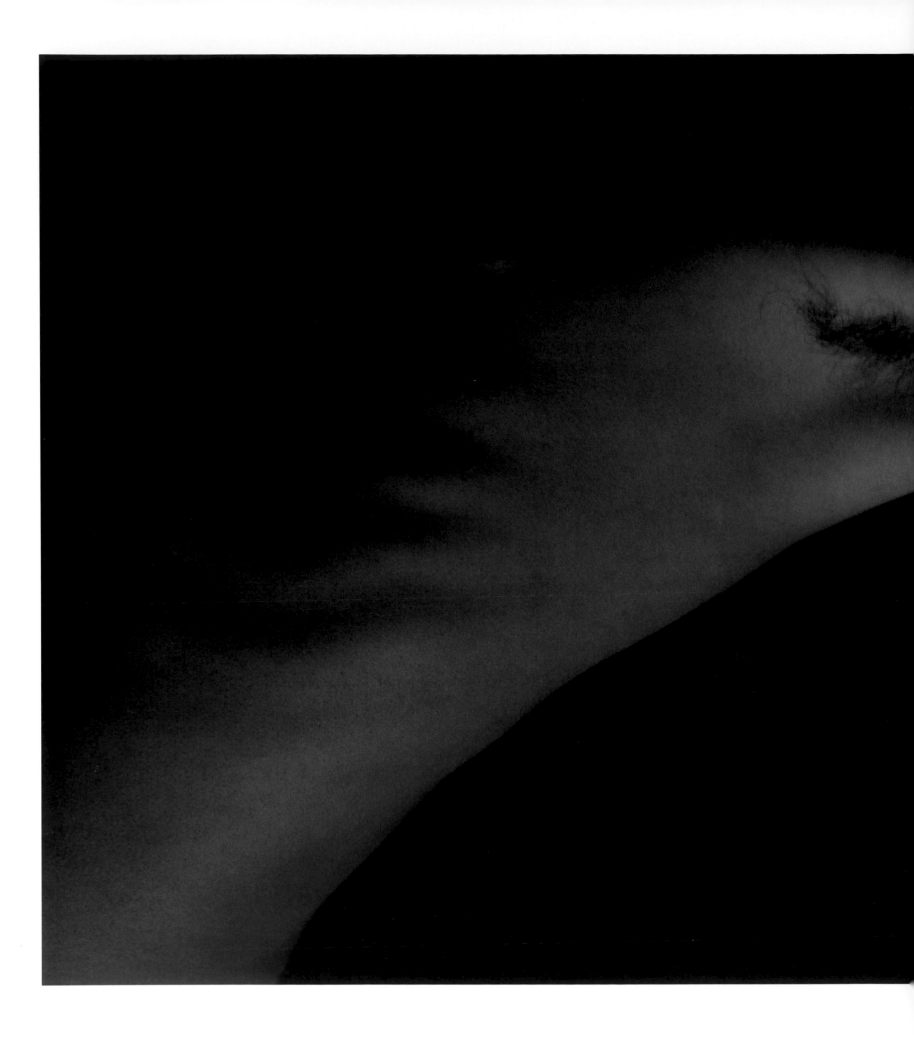

1988

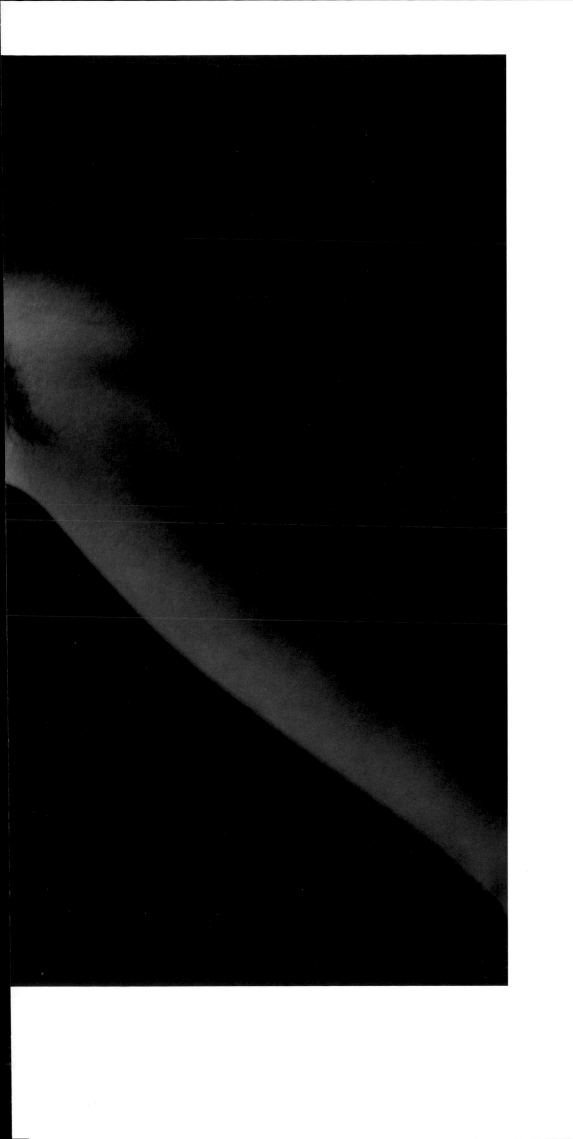

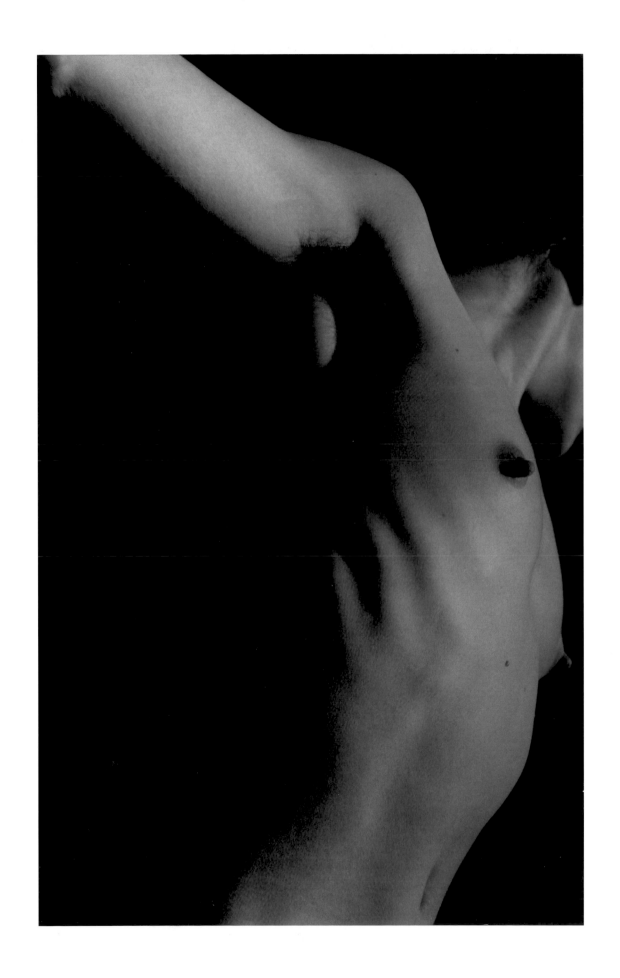

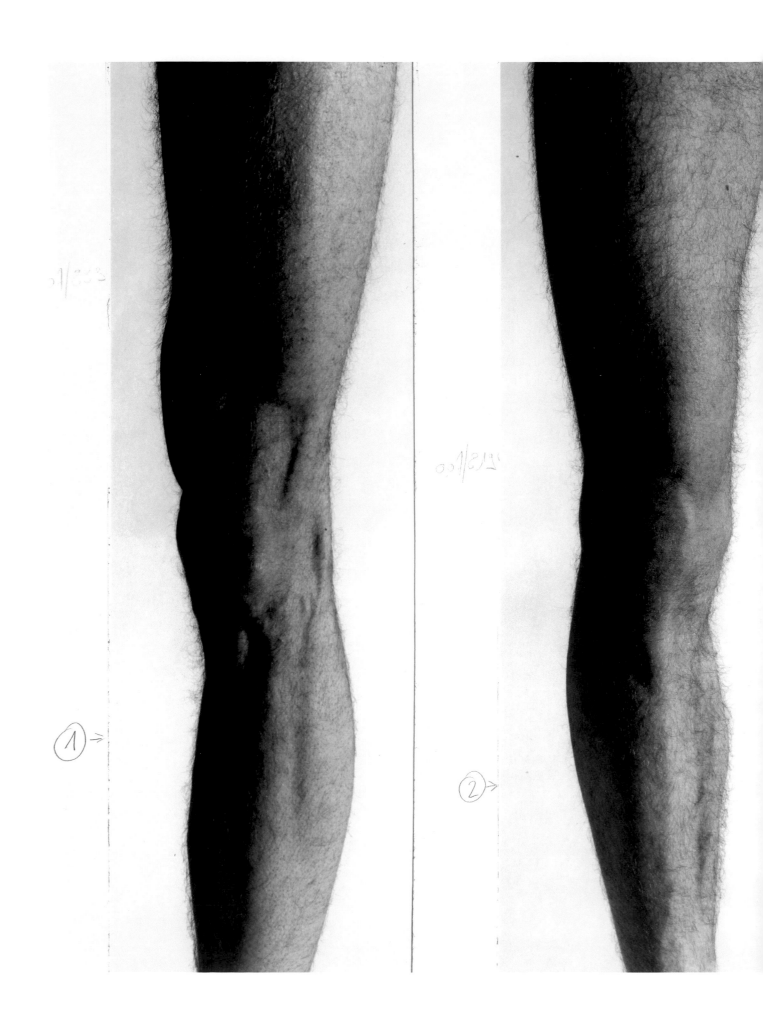

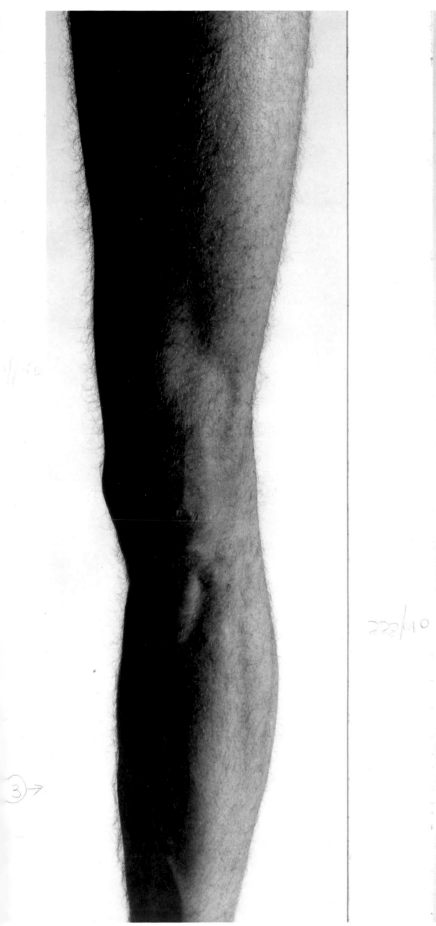
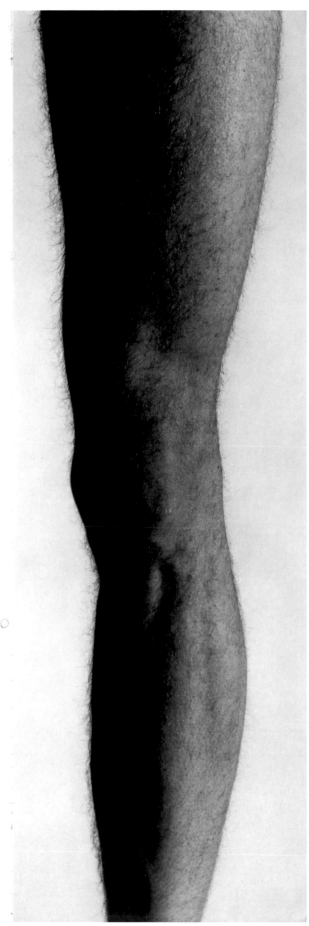

Das Knie, 1983

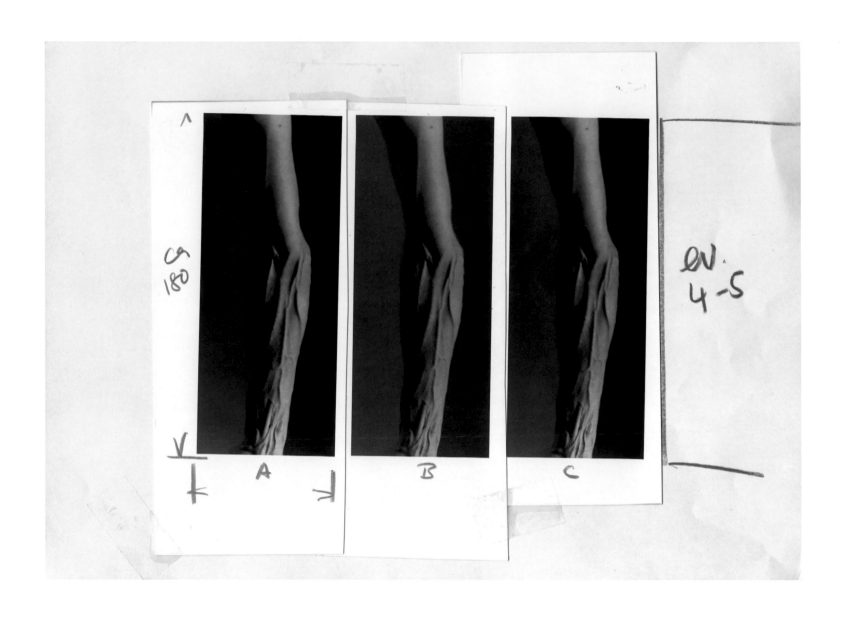

Die Vene, 1988/89

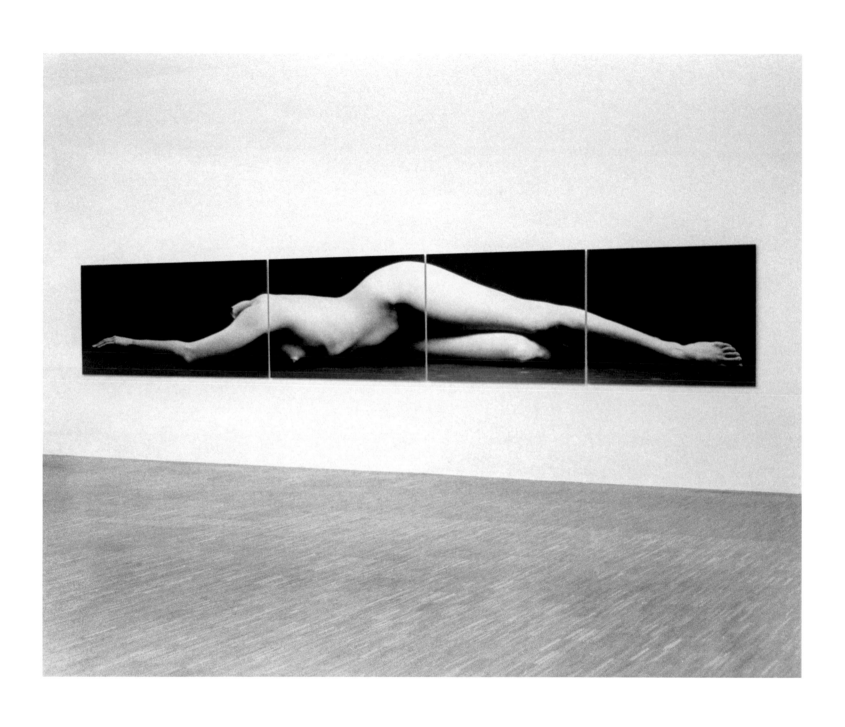

Der Akt, 1983

Study, 1983

$$\frac{6}{19,2} = \frac{x}{800} \rightarrow$$

$48000 : 192 = 2\overset{5}{\cancel{K}}$

$$\begin{array}{r} 384 \\ \hline 960 \\ 768 \\ \hline 192 \end{array}$$

$\overset{250}{\underline{192}}$

1375 cm

33

5,8

$264000 : 192 = 13\underline{7.4}$

$$\begin{array}{r} 192 \\ \hline 720 \\ 576 \\ \hline 1440 \\ 1344 \\ \hline 600 \end{array}$$

$\frac{33}{5,5} = \frac{1200}{x}$

$x = \frac{1200 \cdot \overset{5}{\cancel{55}}}{\underset{3}{\cancel{35}}} =$

$\frac{600}{3} = \overset{200}{\cancel{\text{9600}}}$

$\frac{19,2}{x} = \frac{33}{1200}$

$\frac{19,2}{800} = \frac{33}{x}$

$x = \frac{33 \cdot 800}{19,2}$

$\frac{1200}{200} = \frac{1375}{55 \; x}$

$x = \frac{1375 \cdot 800}{1200} = 229$

Study, 1983

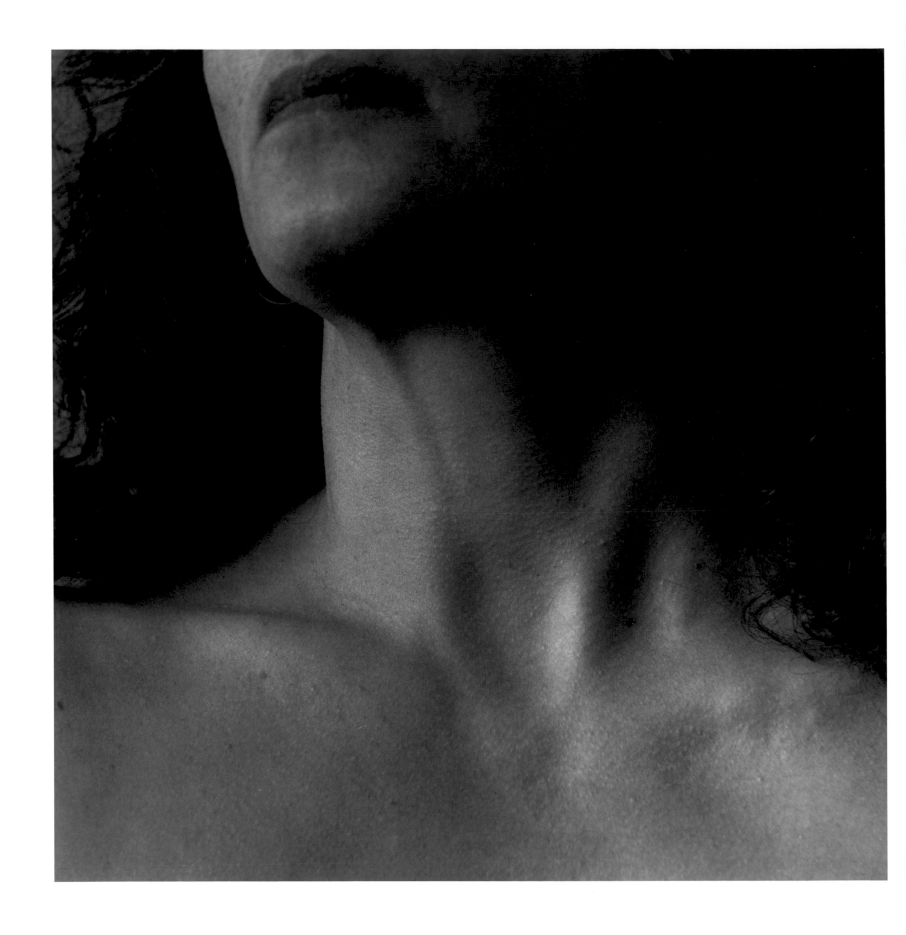

1989

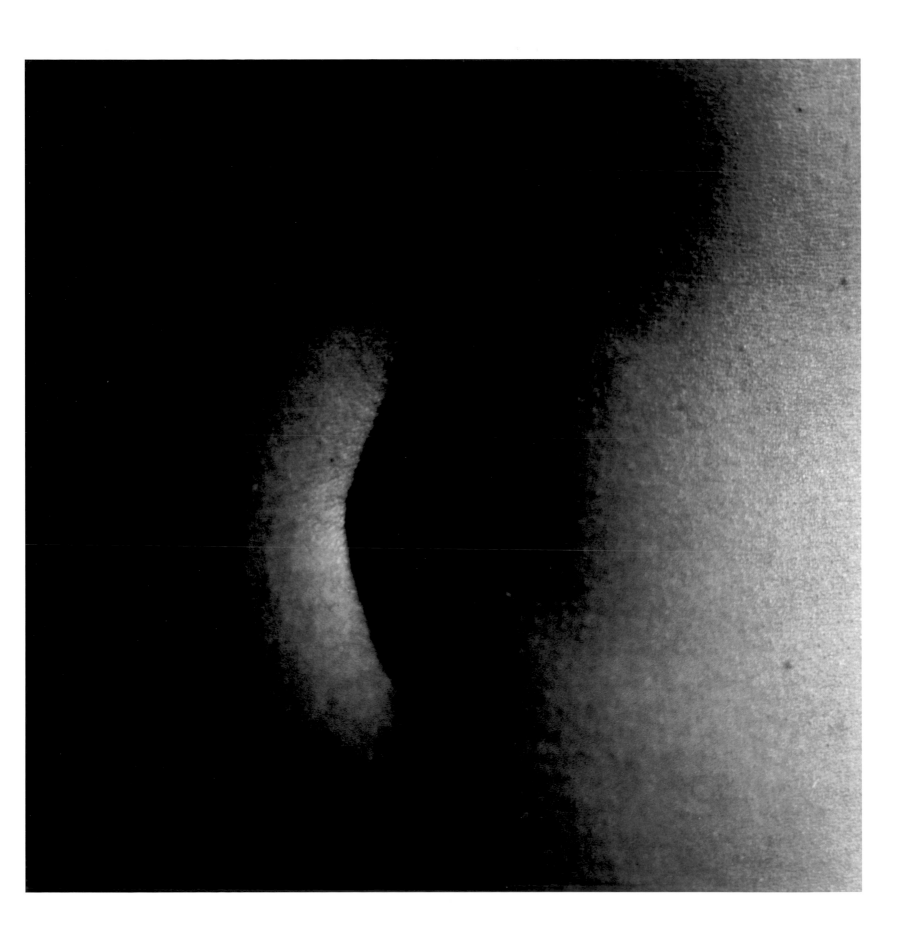

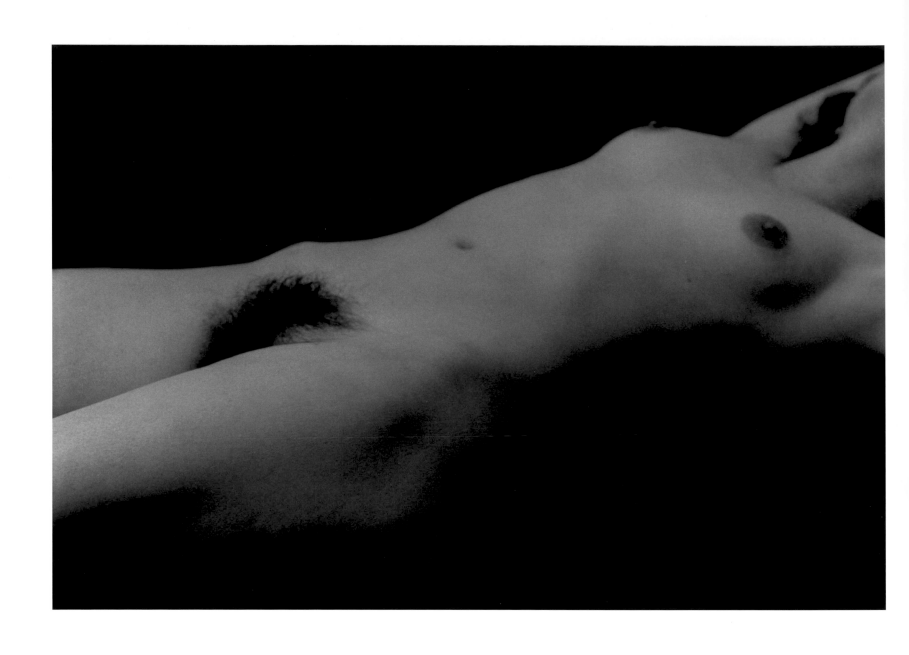

c. 1981

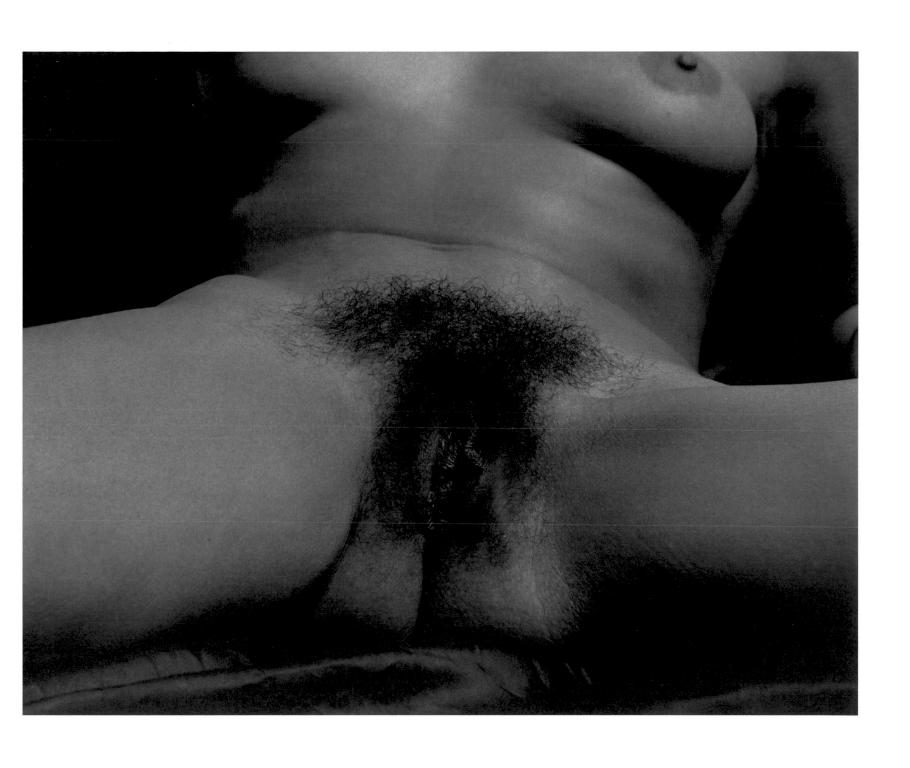

L'Origine du Monde, 1988

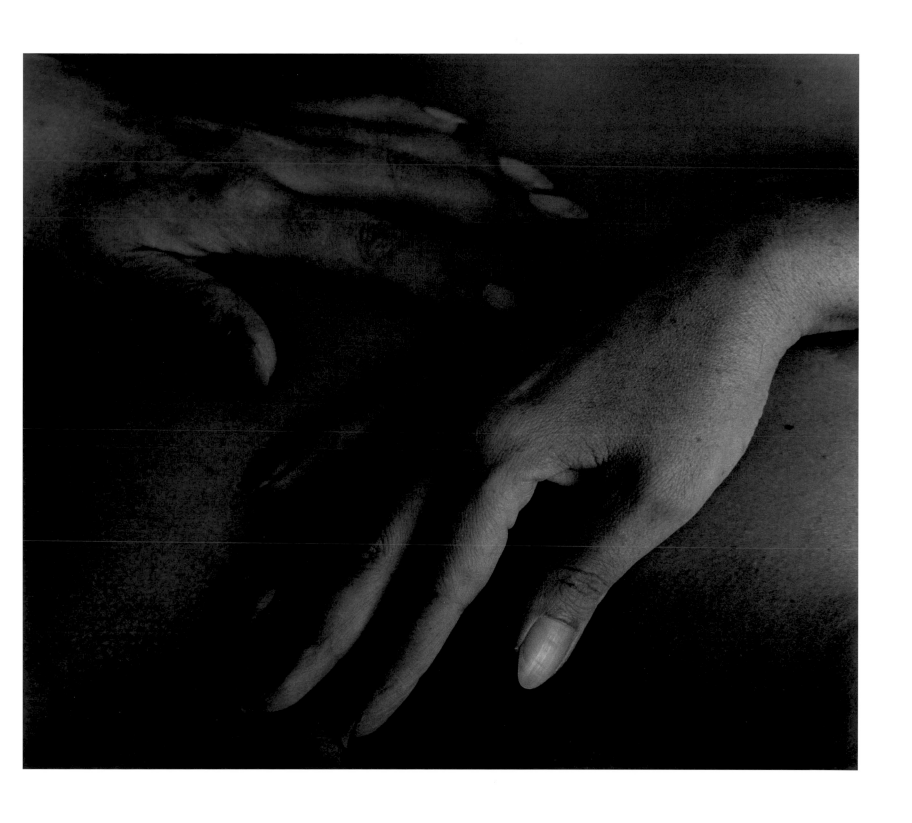

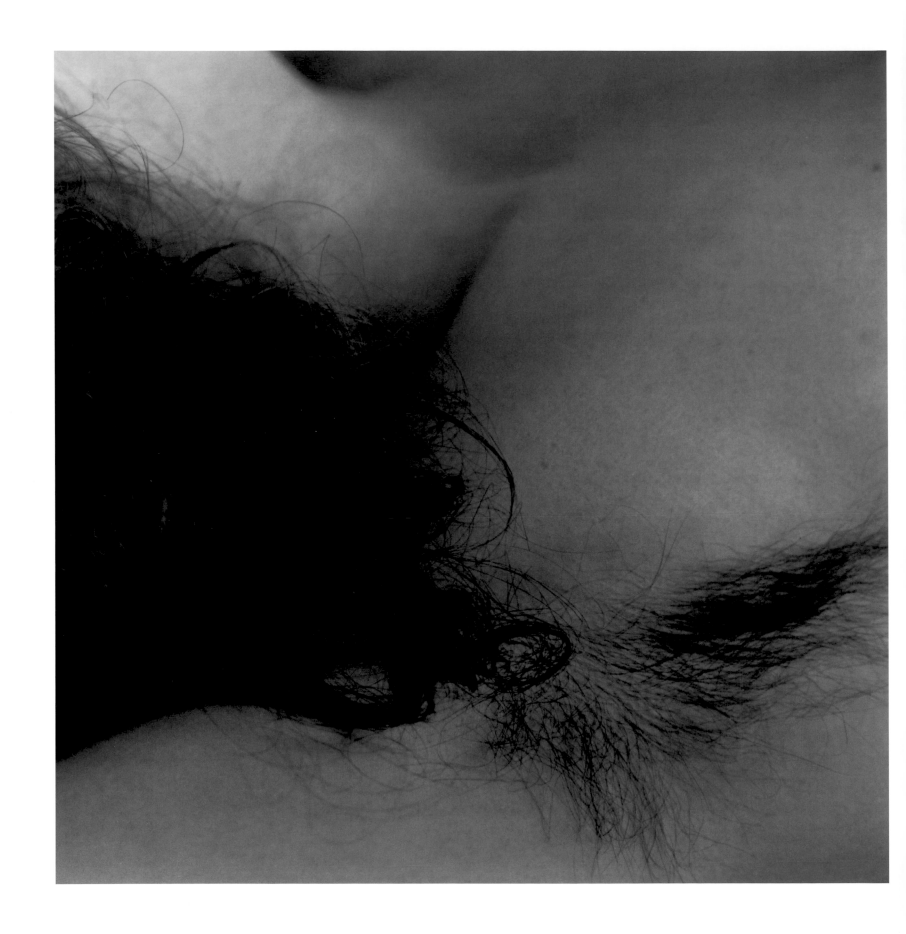

1989

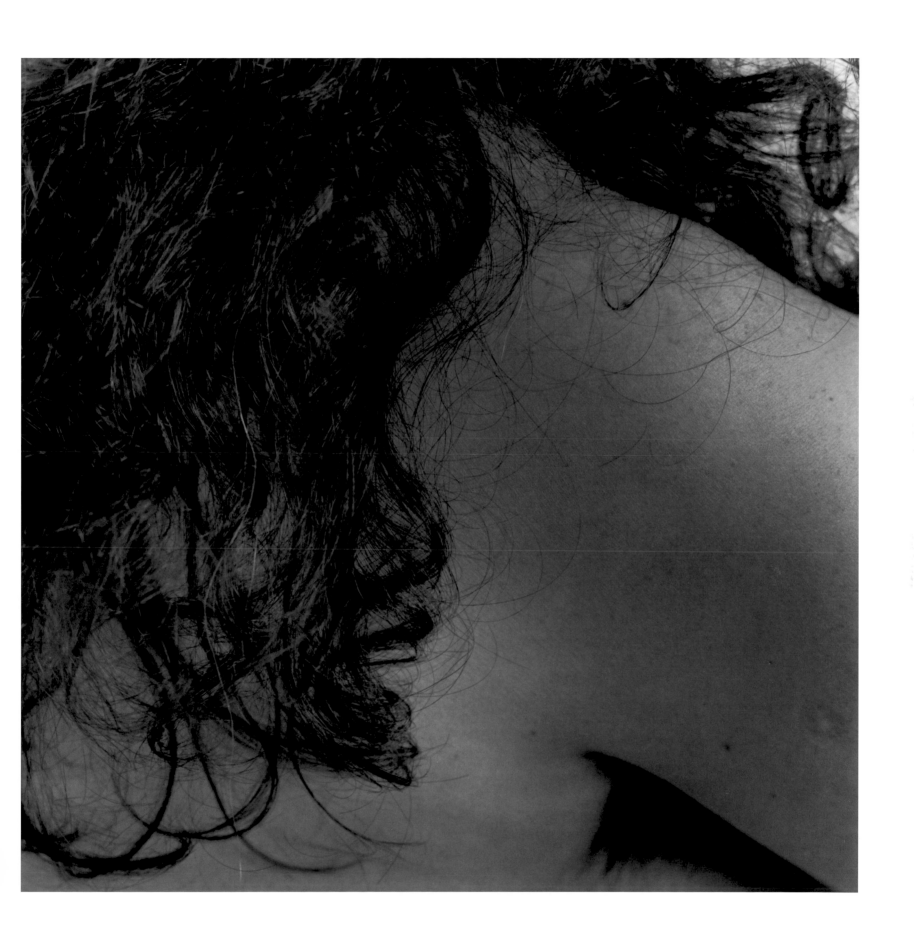

1988

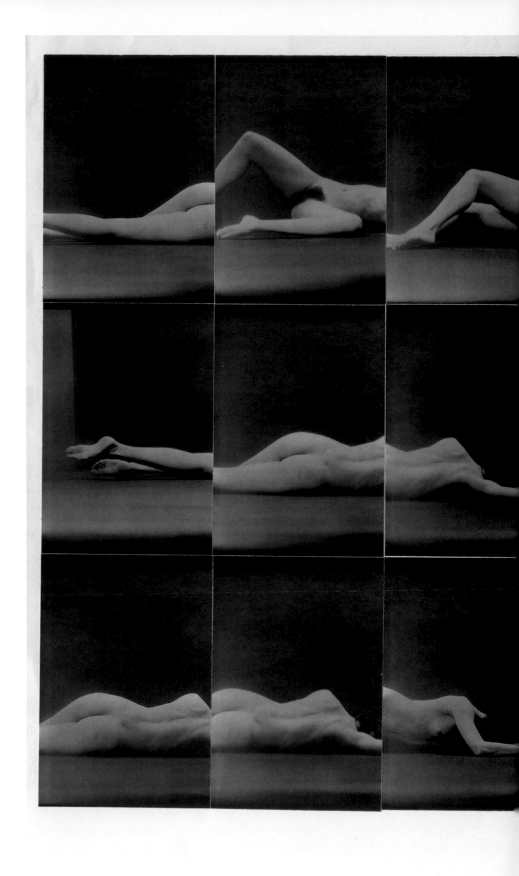

Study, 1983

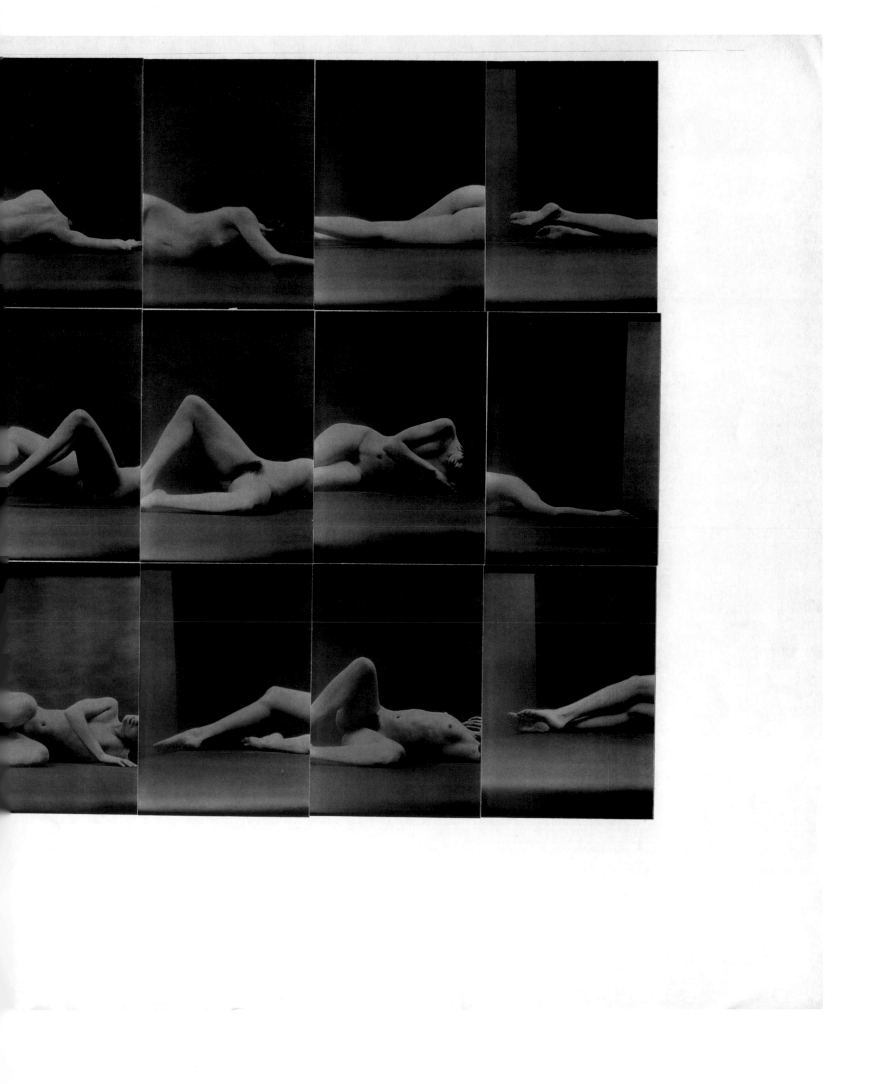

1996

1996

1996

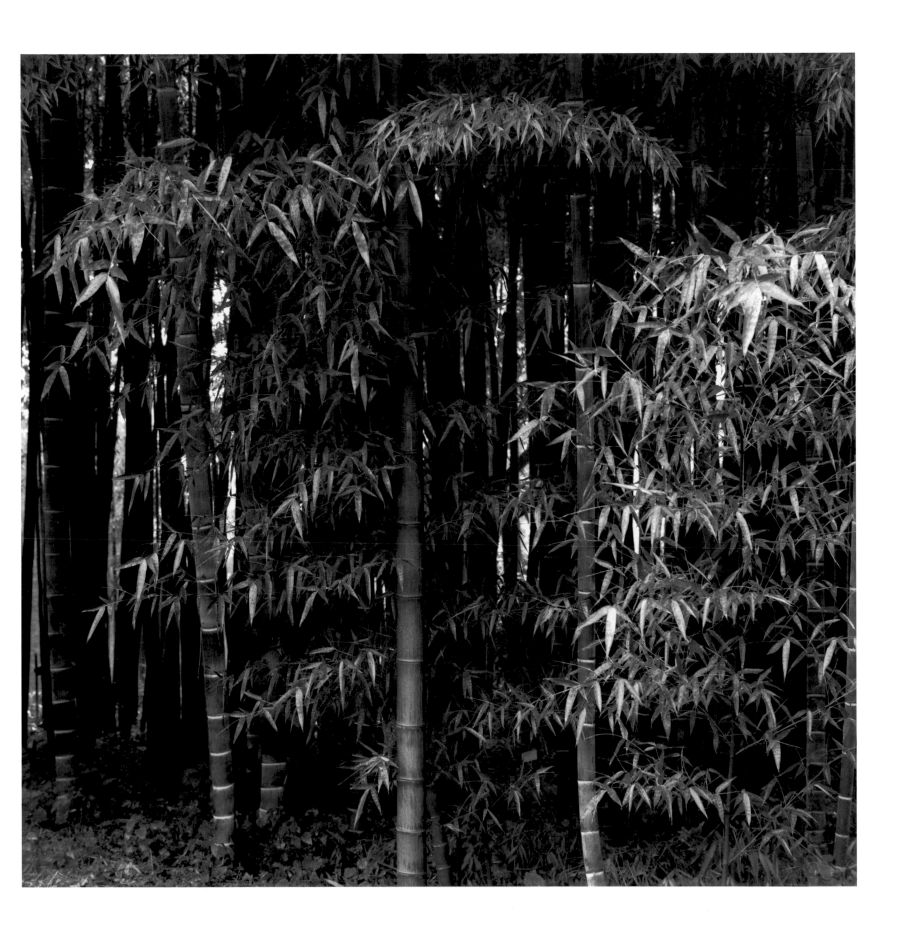

Bambus, 1990/91

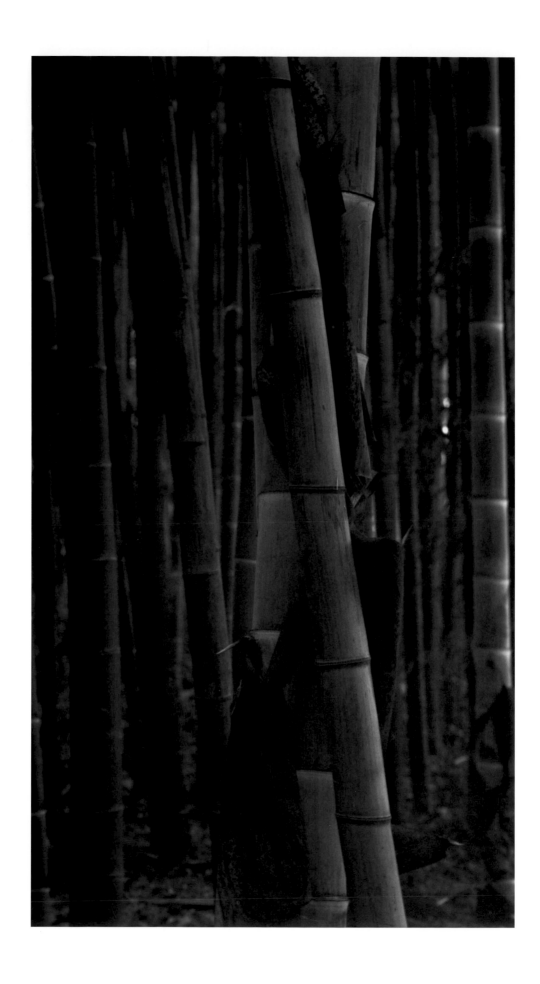

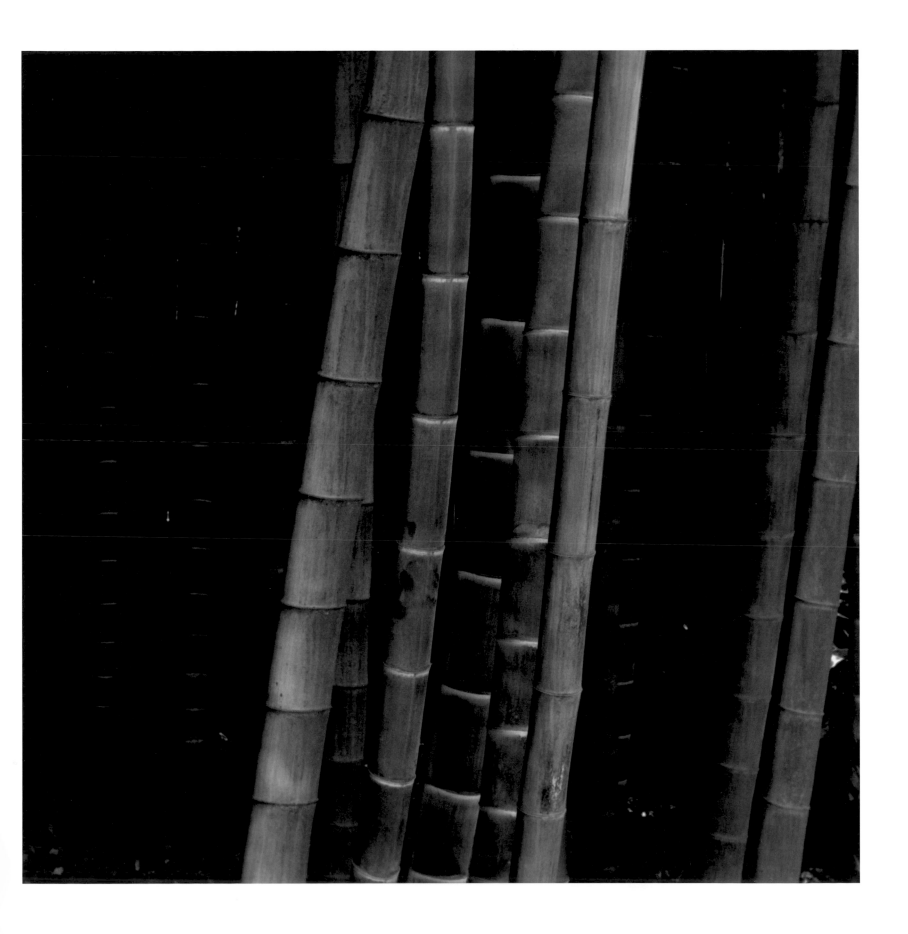

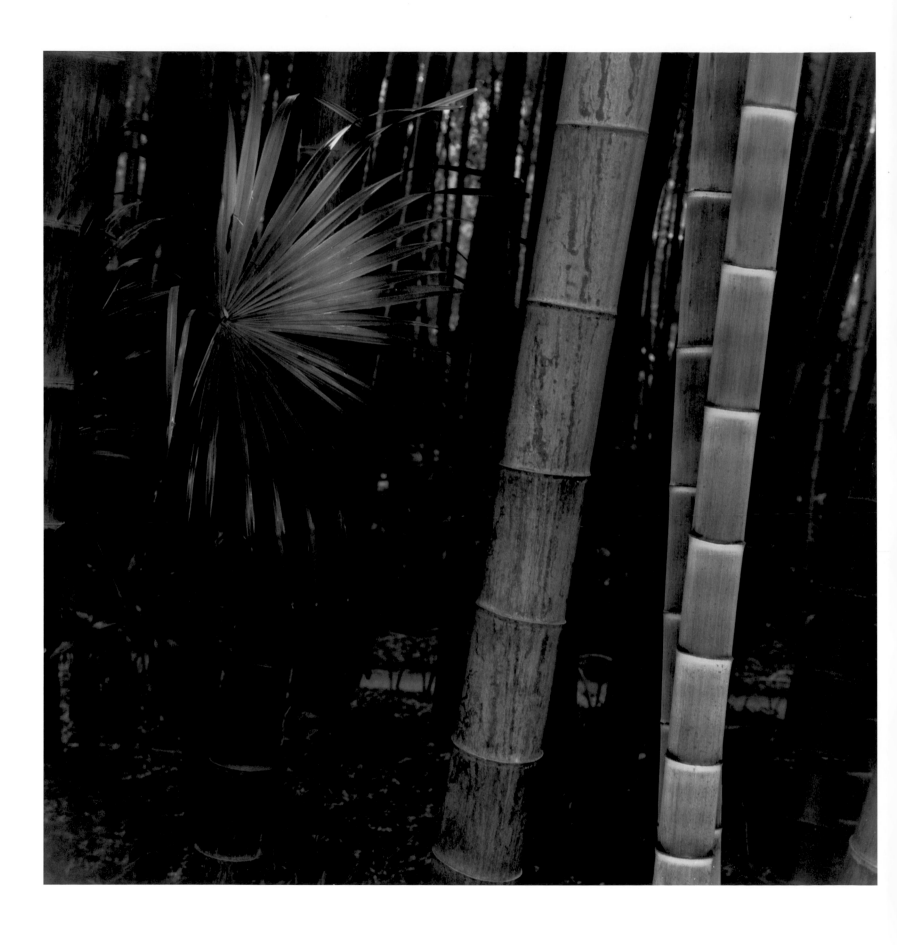

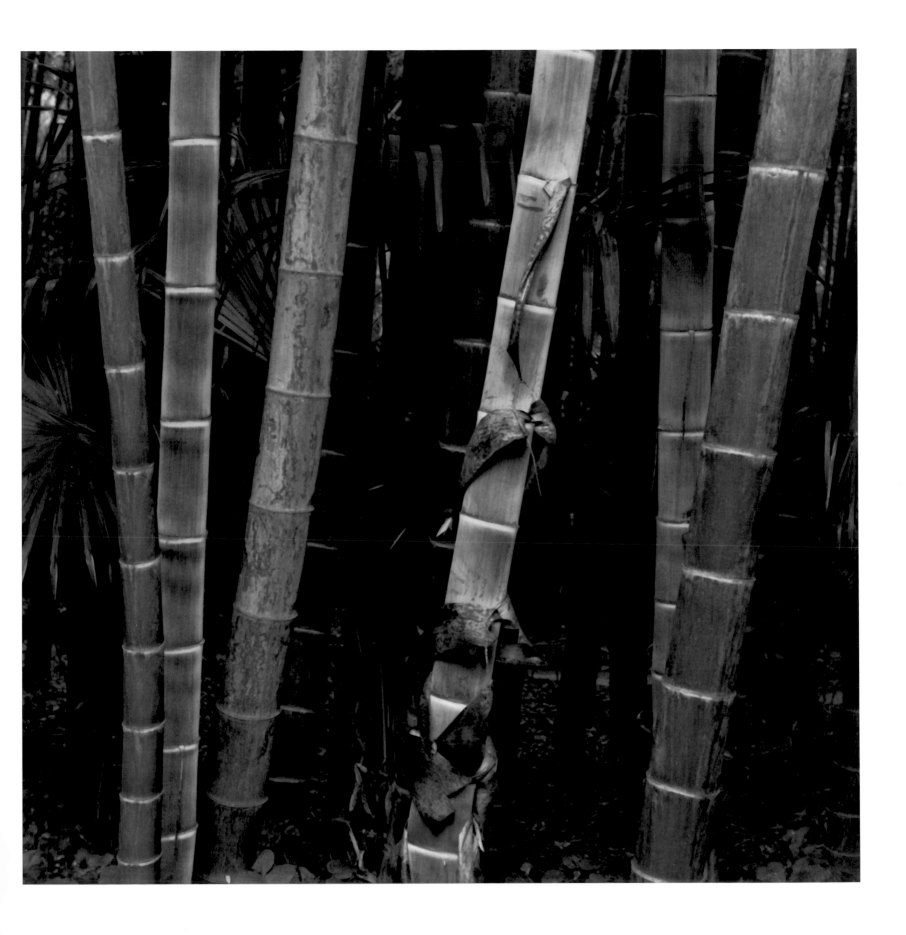

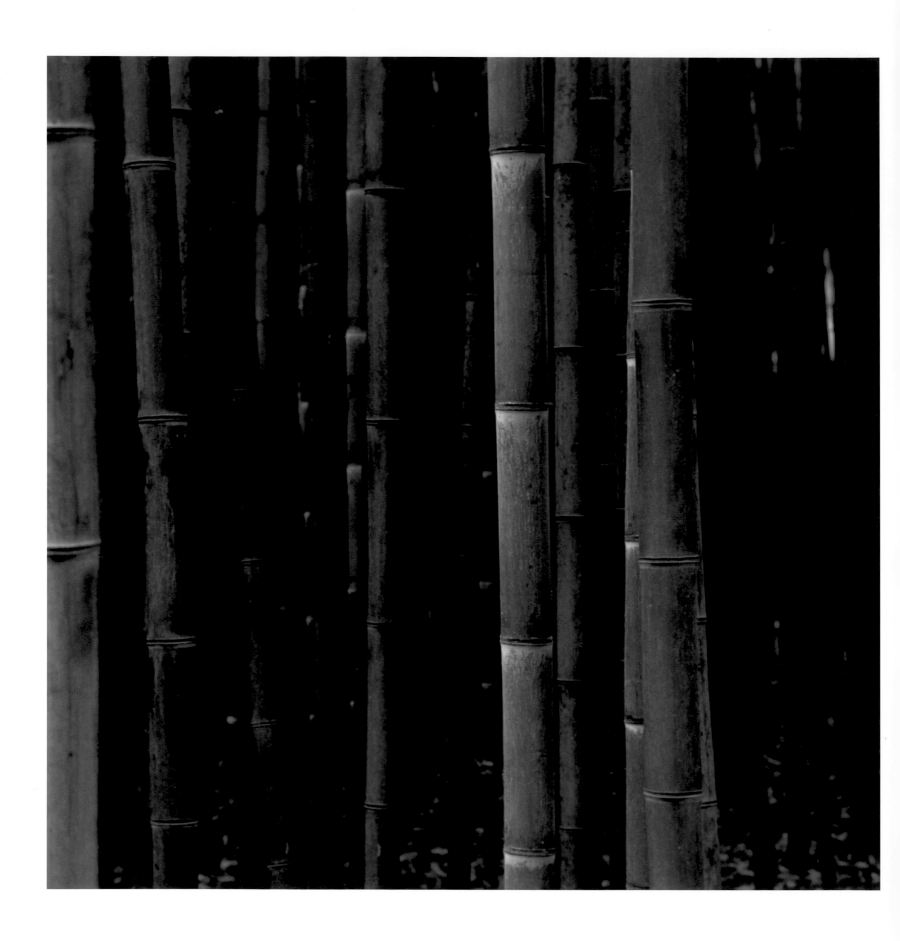

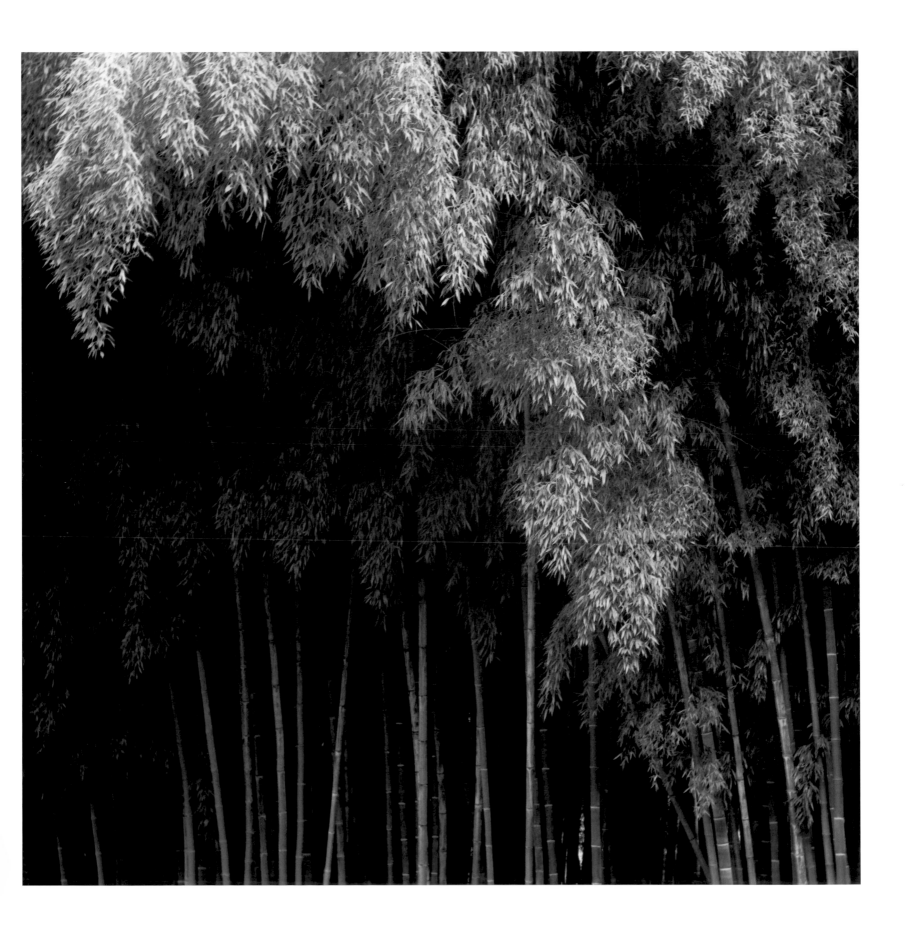

Darligan, 1990

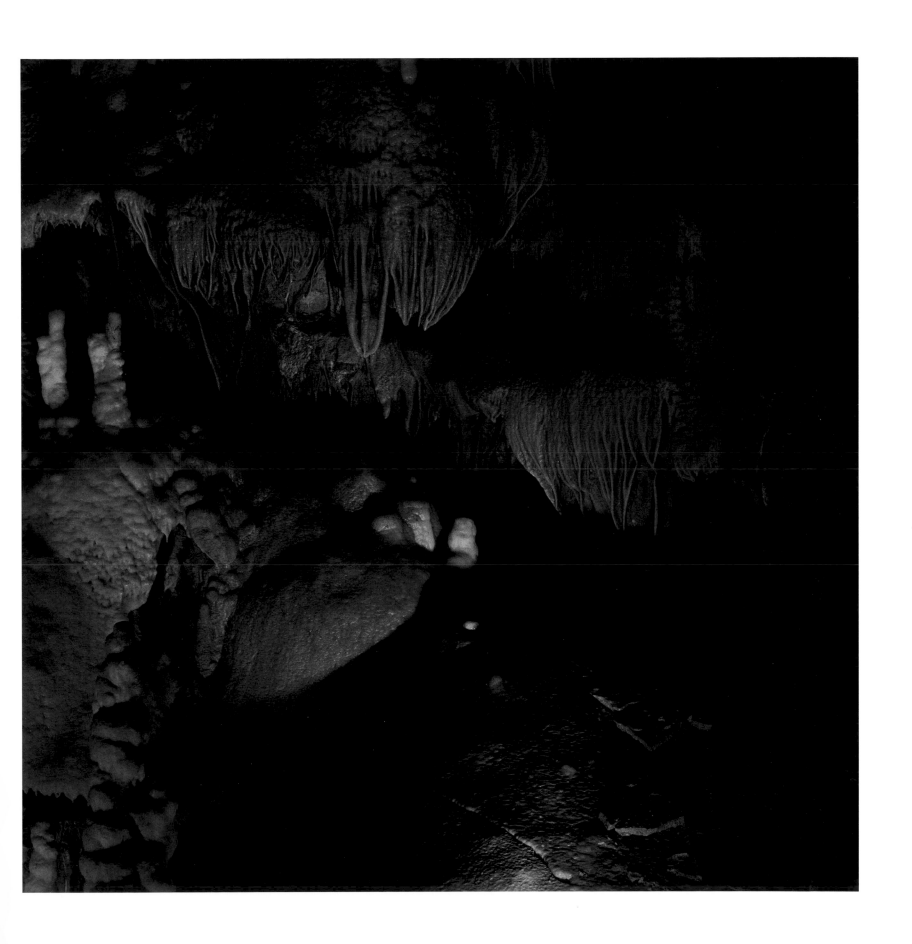

Darligan, 1990

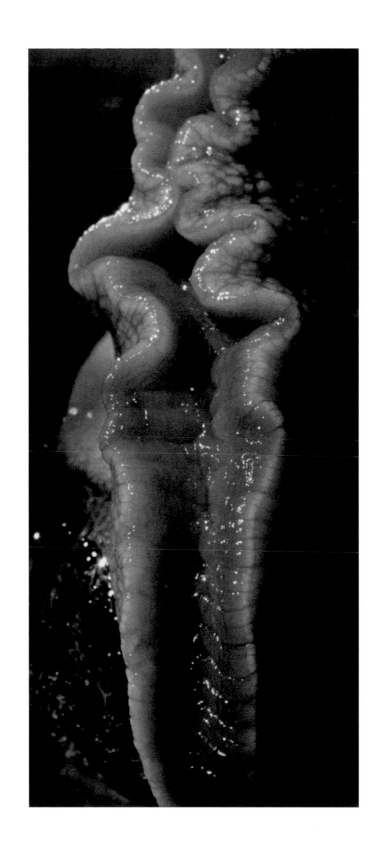

Escargot, 1991

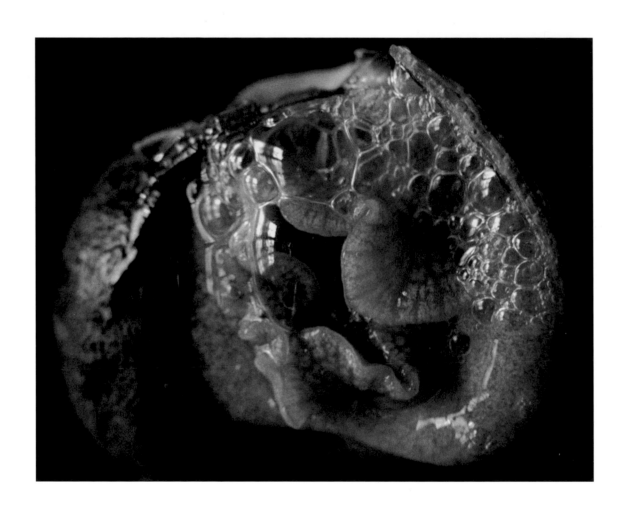

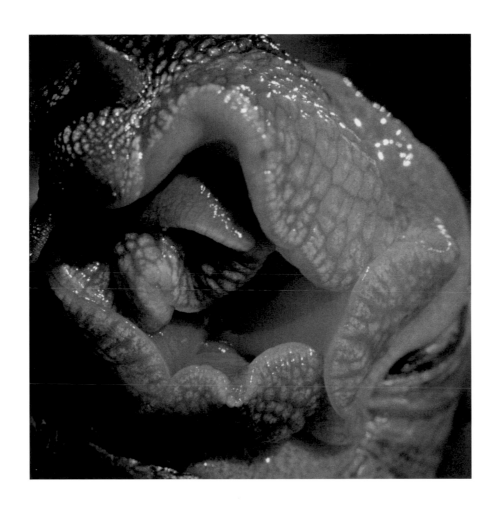

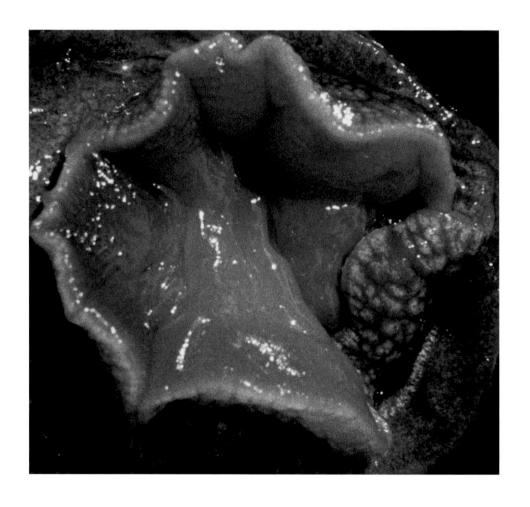

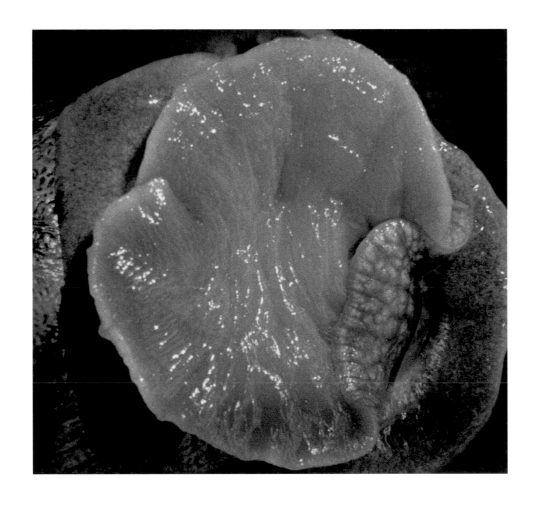

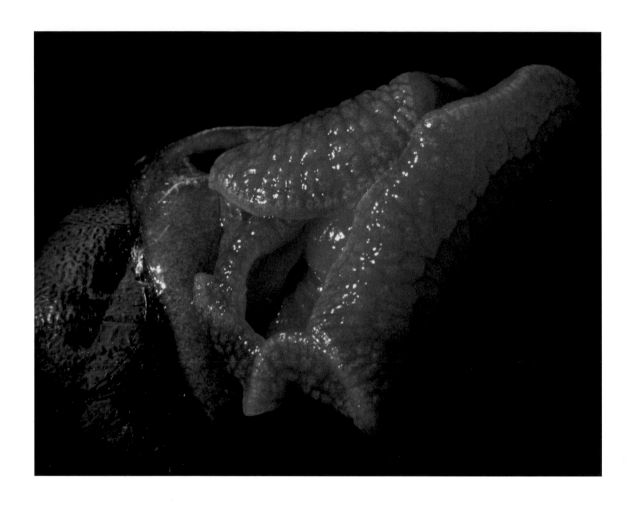

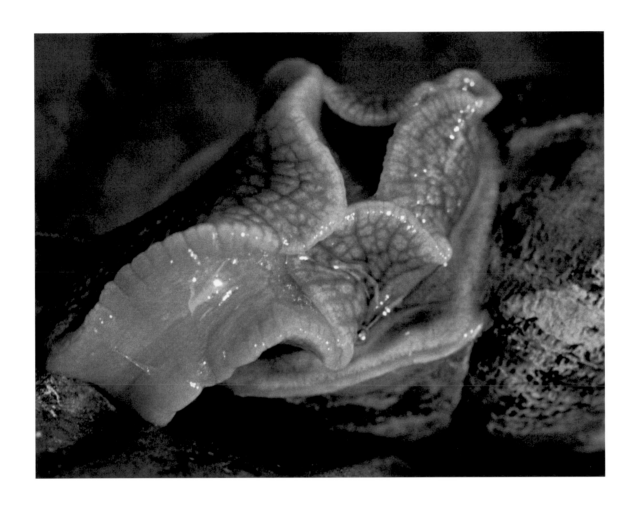

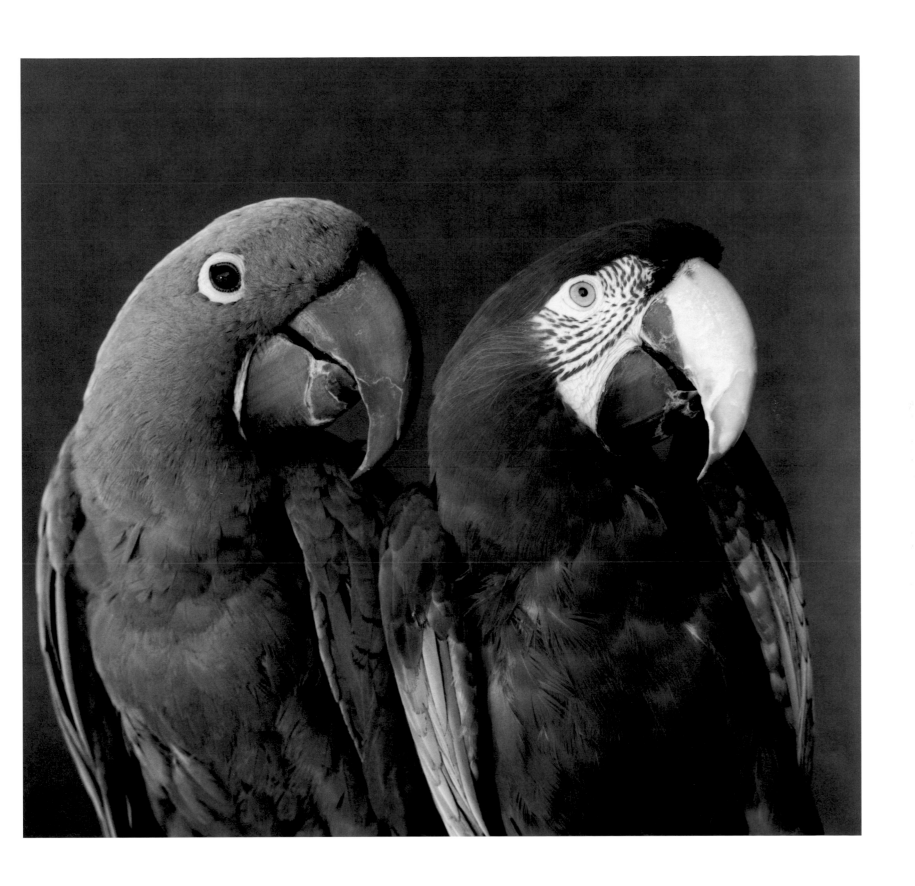

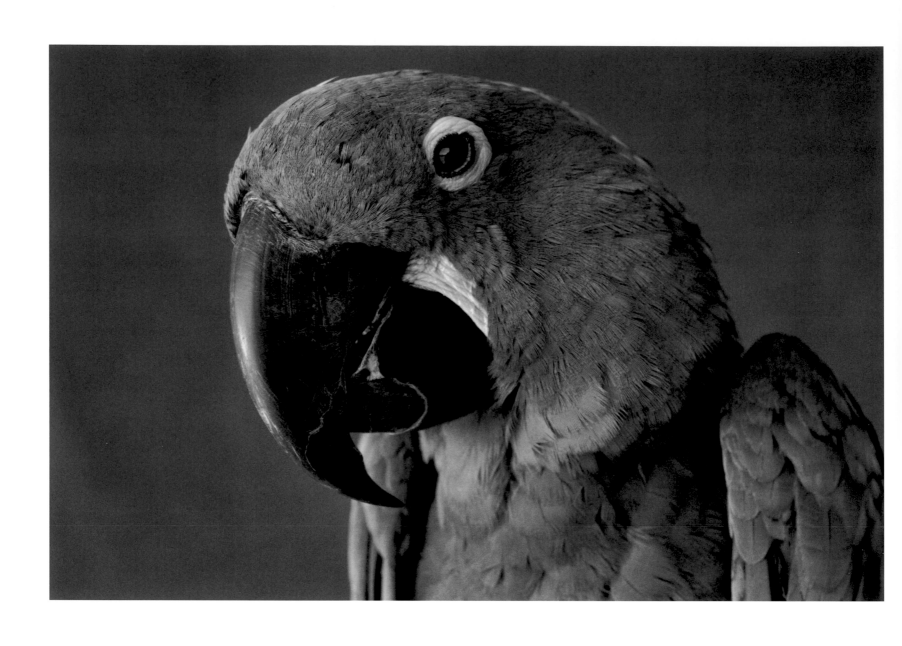

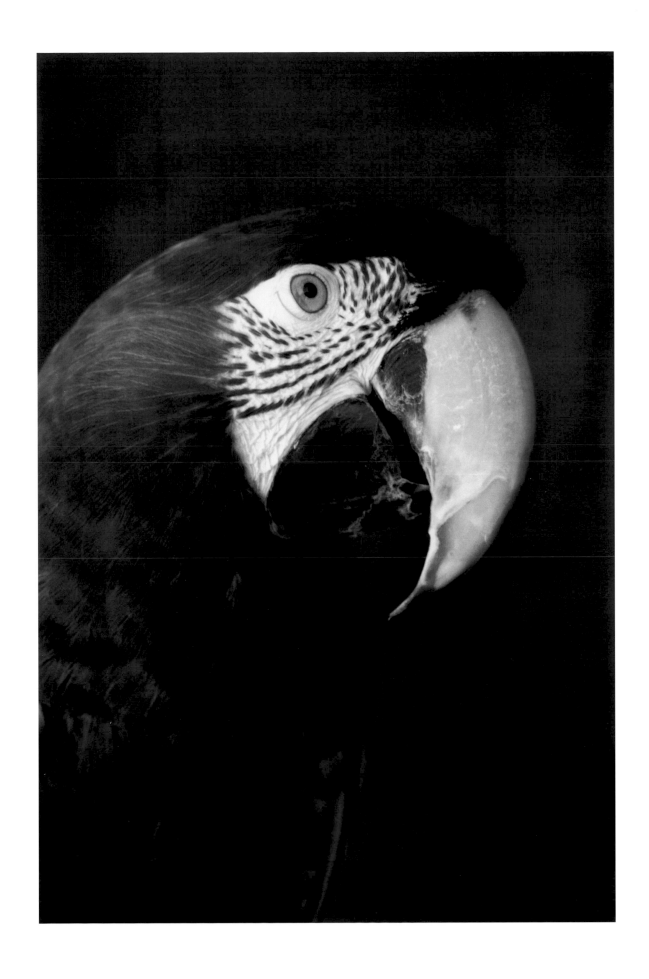

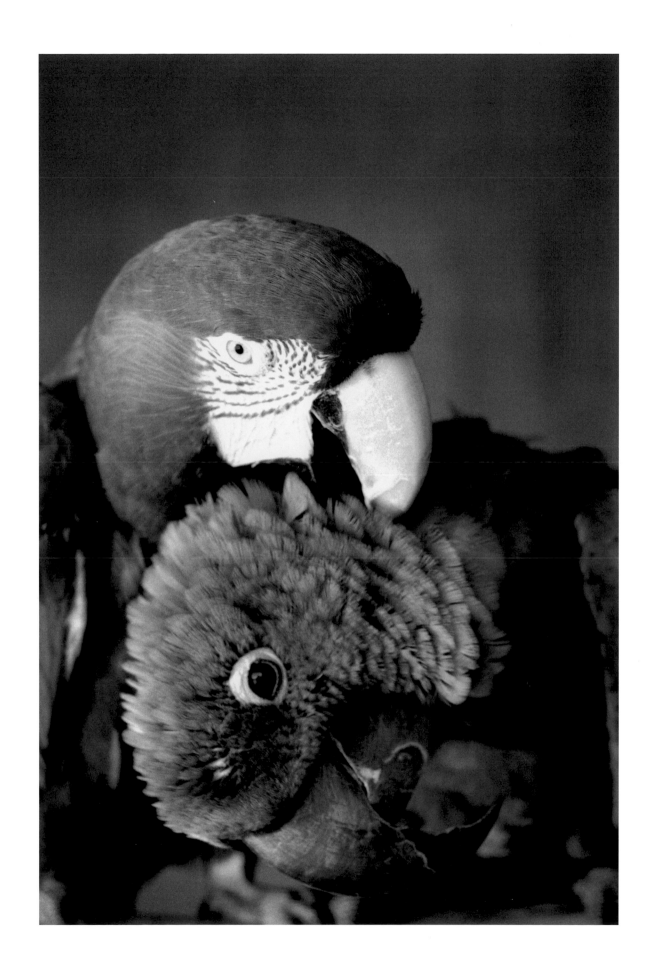

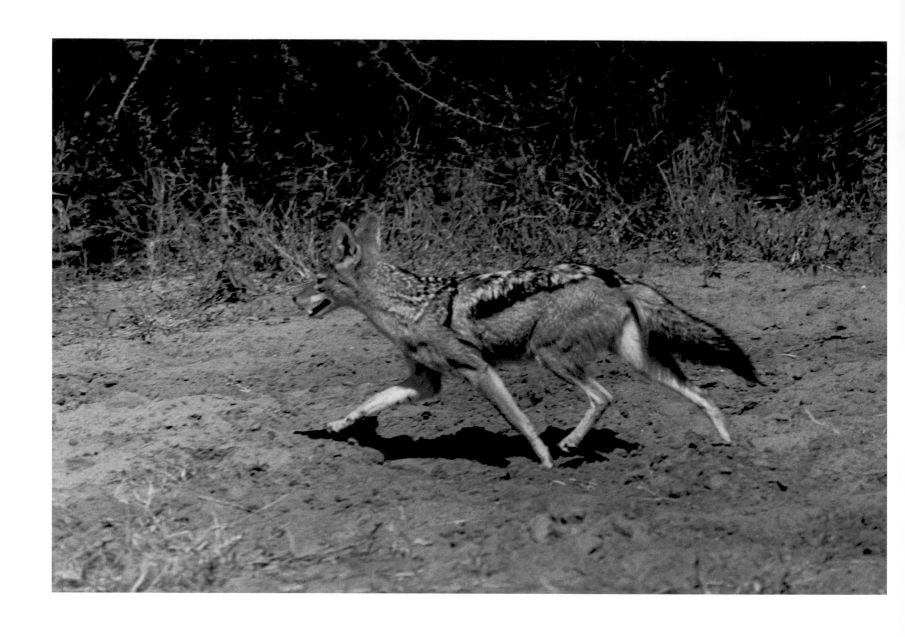

Namibia, 2000

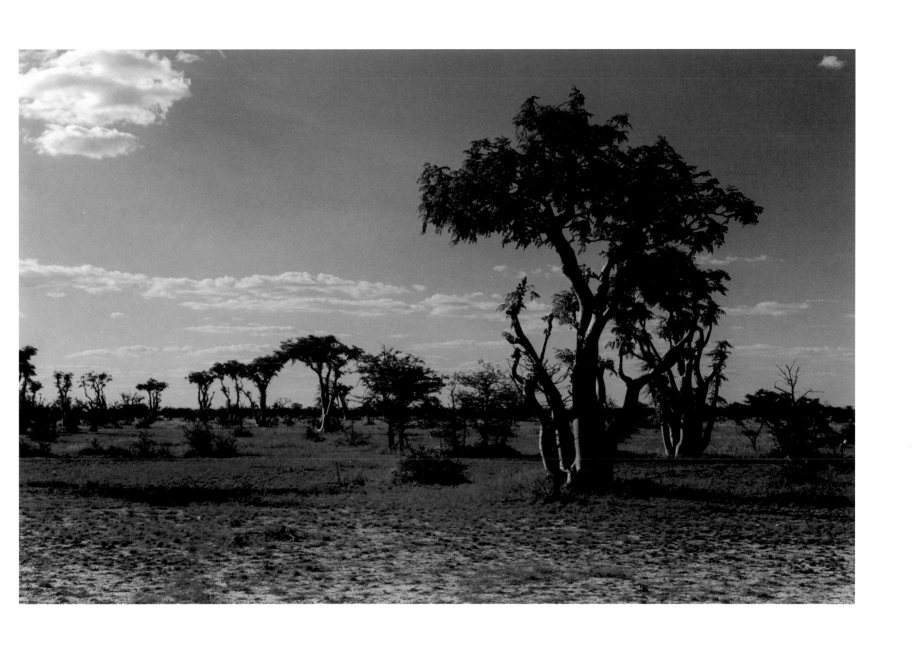

Namibia, 2000

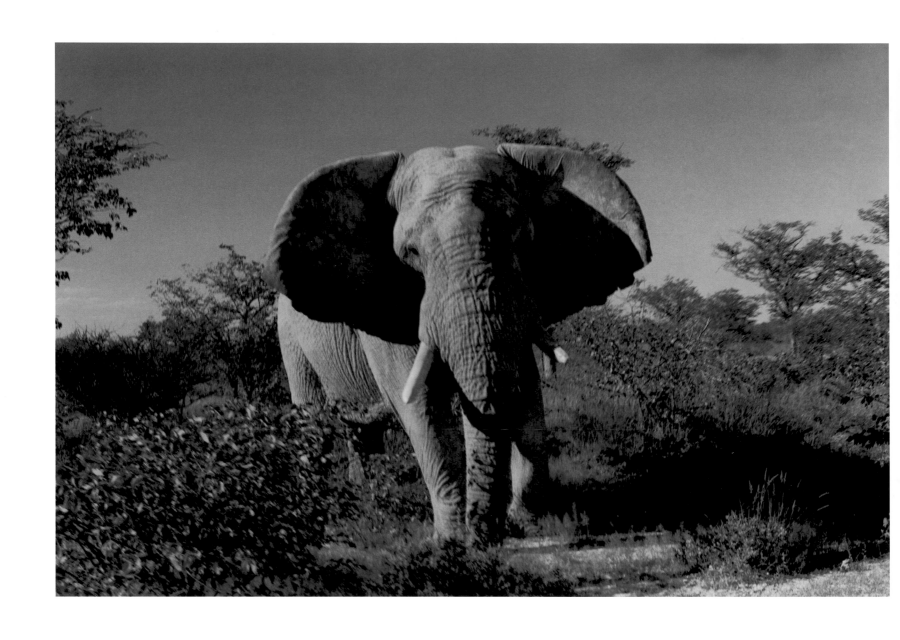

Namibia, 2000

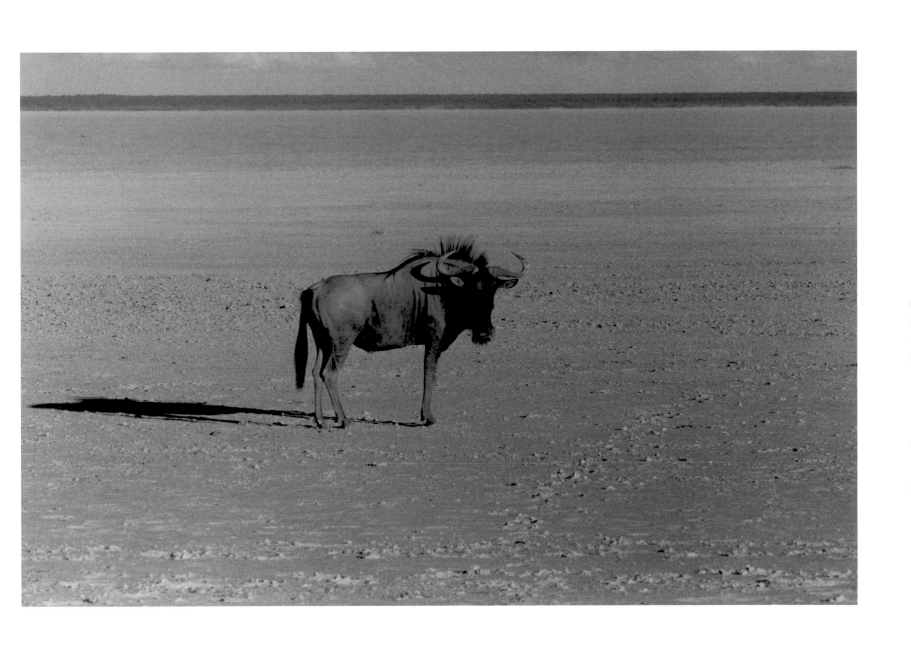

Namibia, 2000

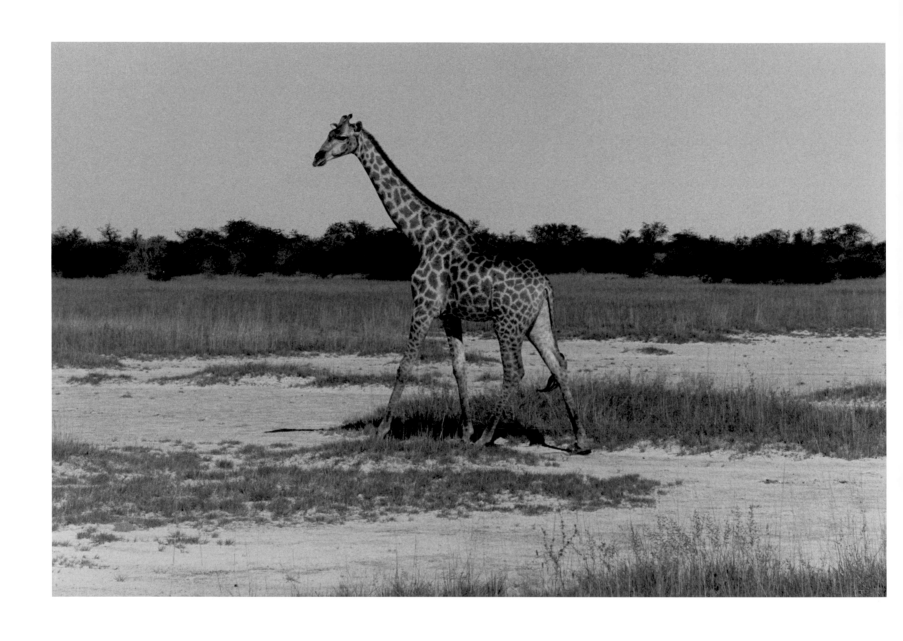

Namibia, 2000

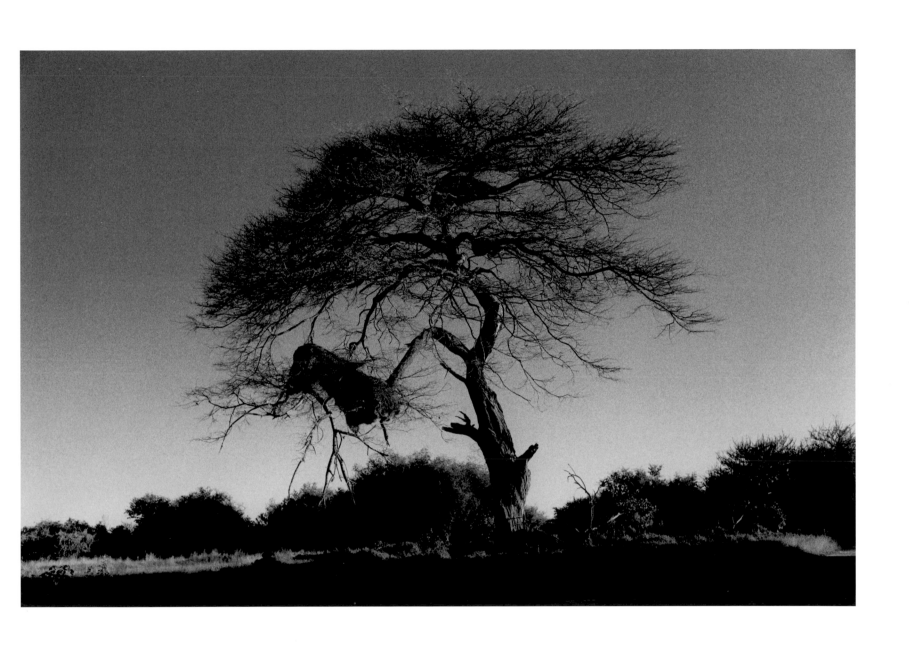

Namibia, 2000

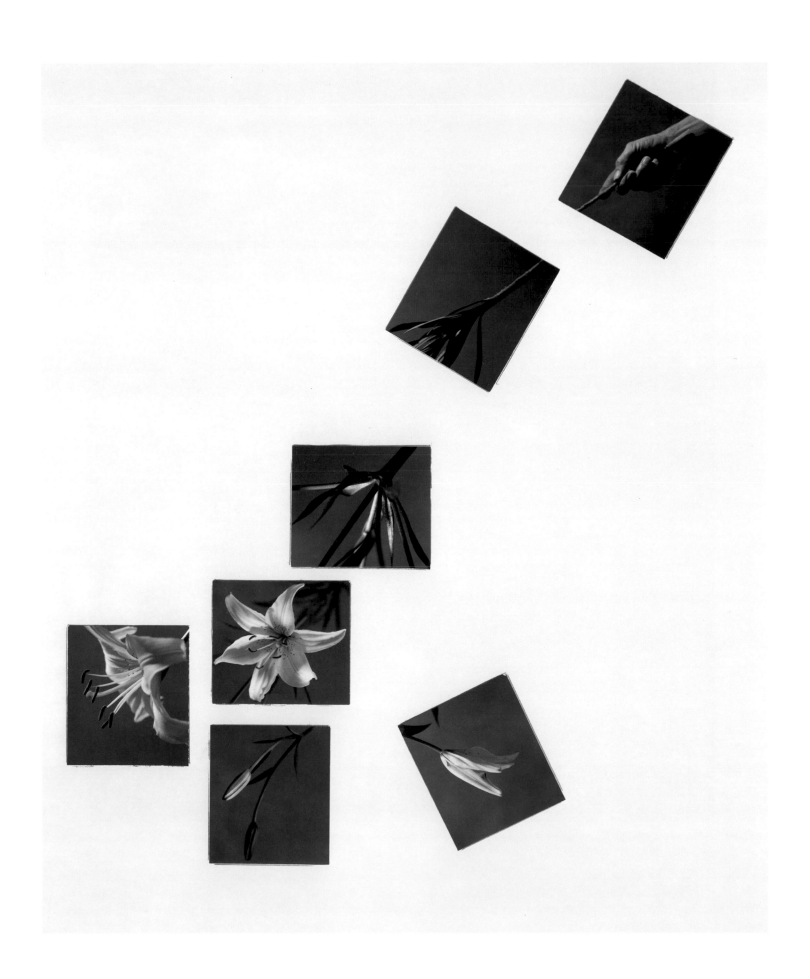

Une Fleur pour Hendel, 1984

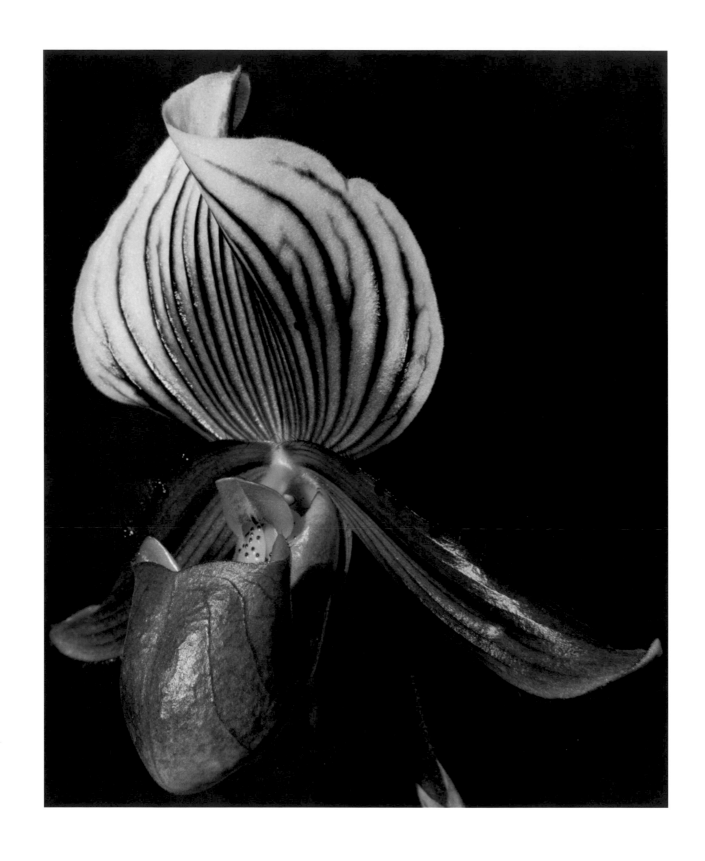

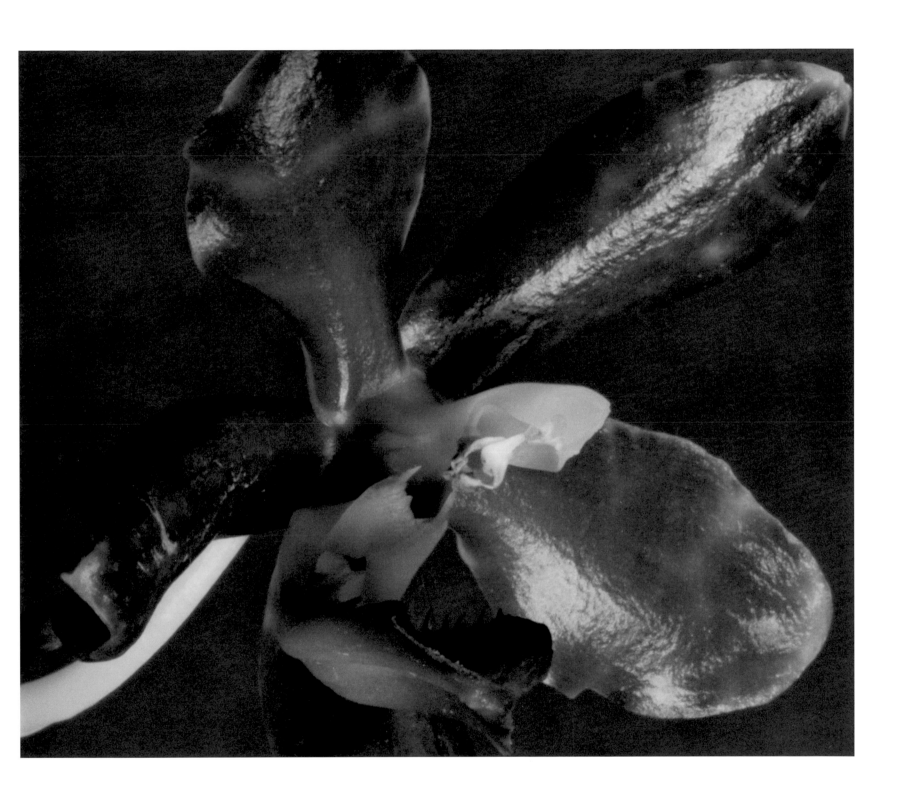

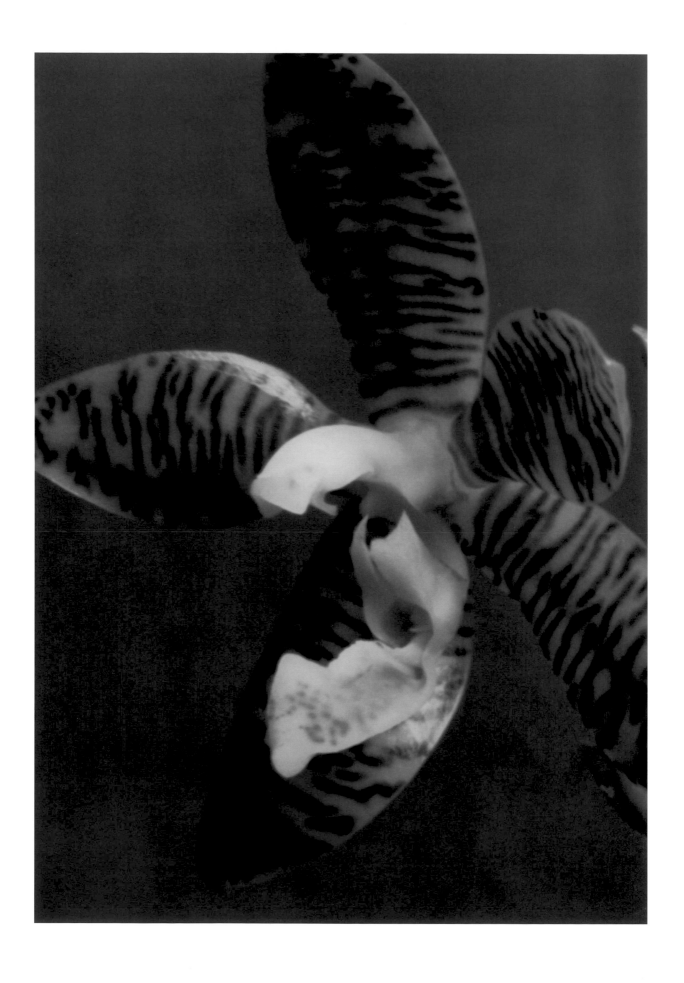

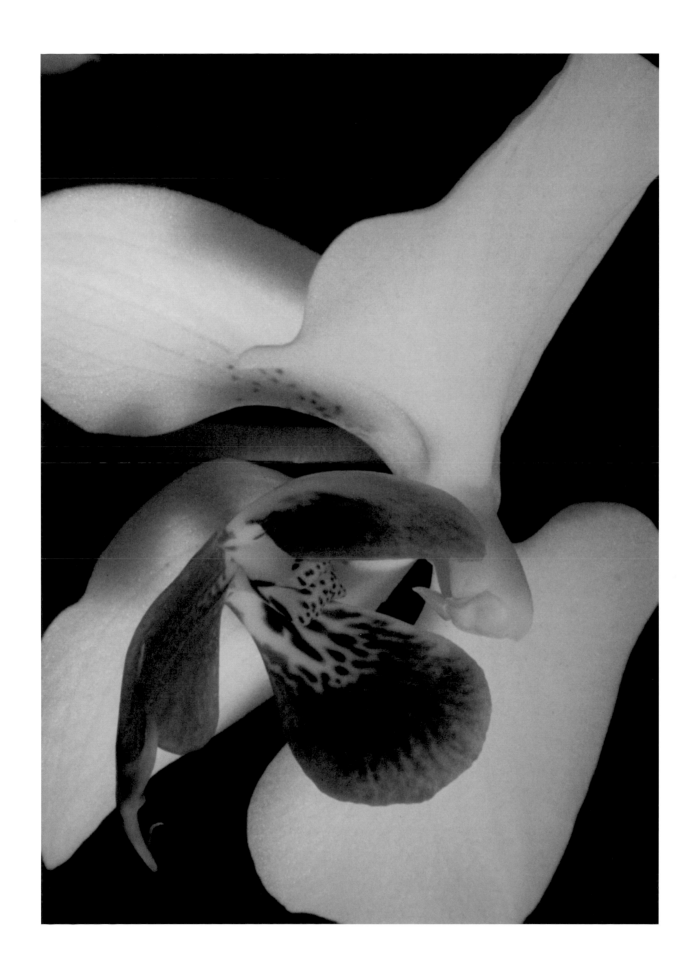

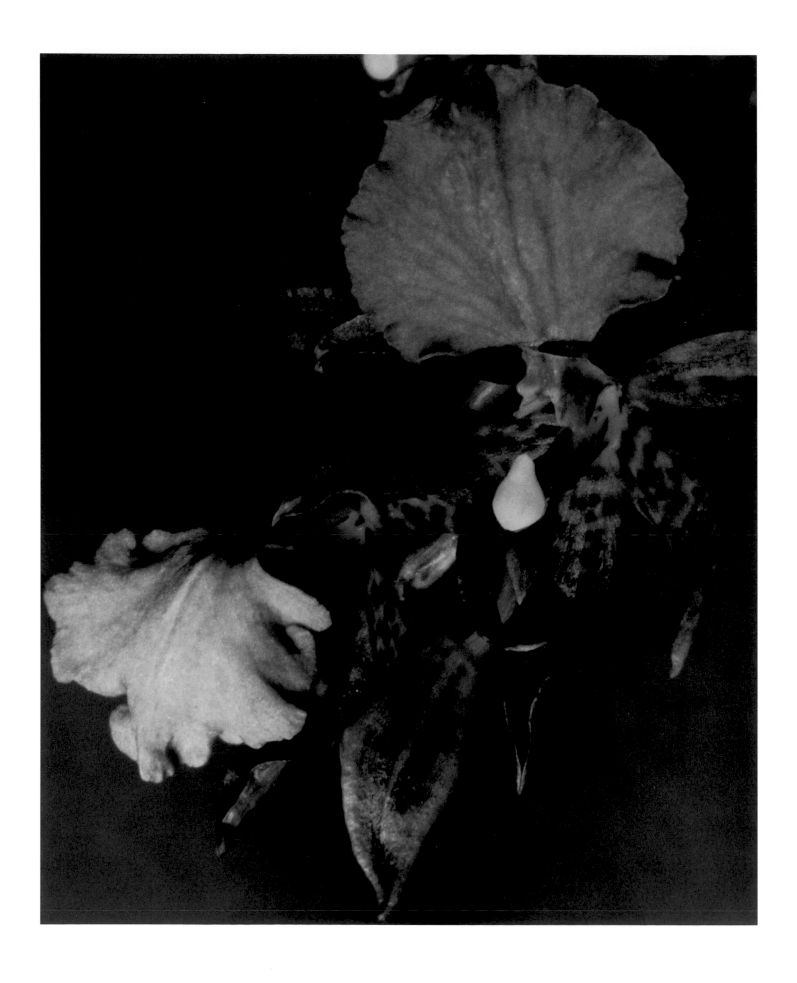

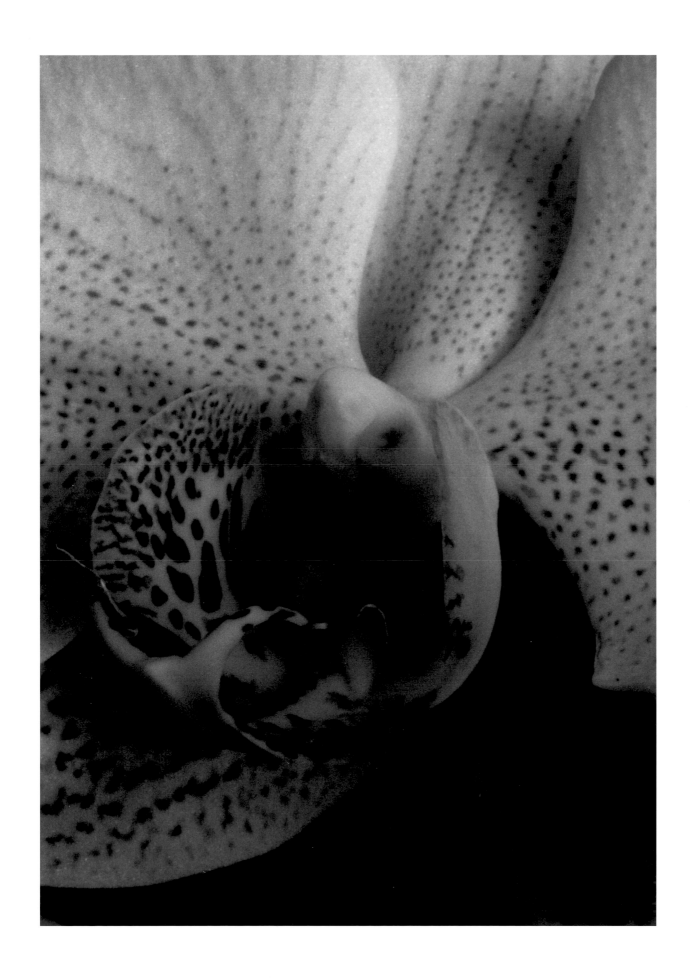

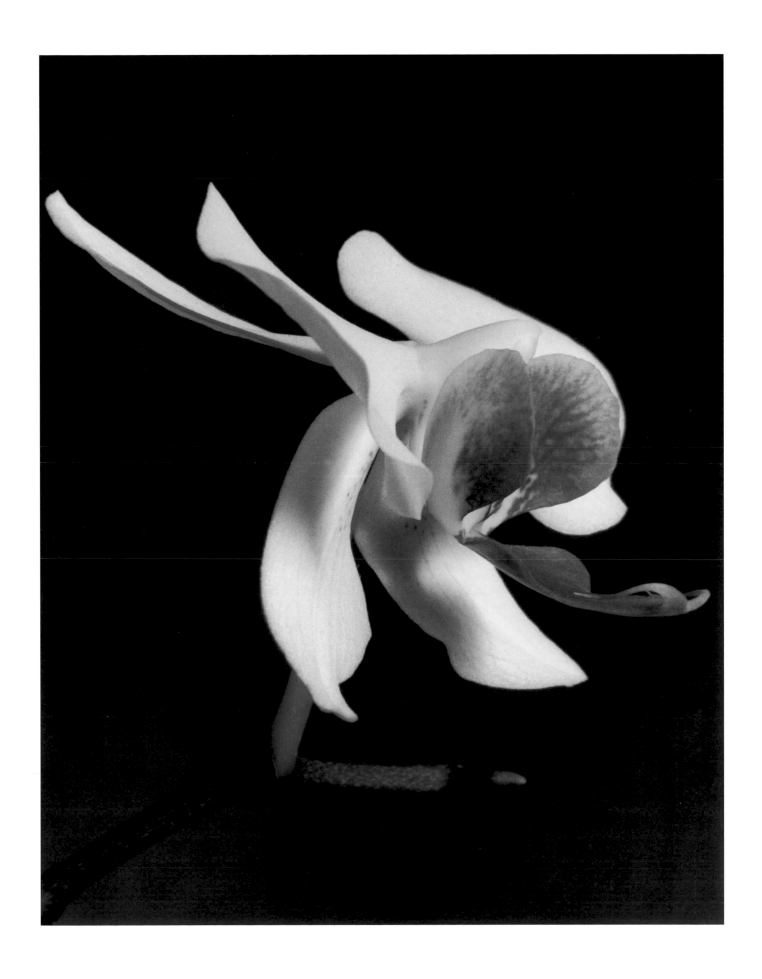

Egypt, 1989

Venice, 1991

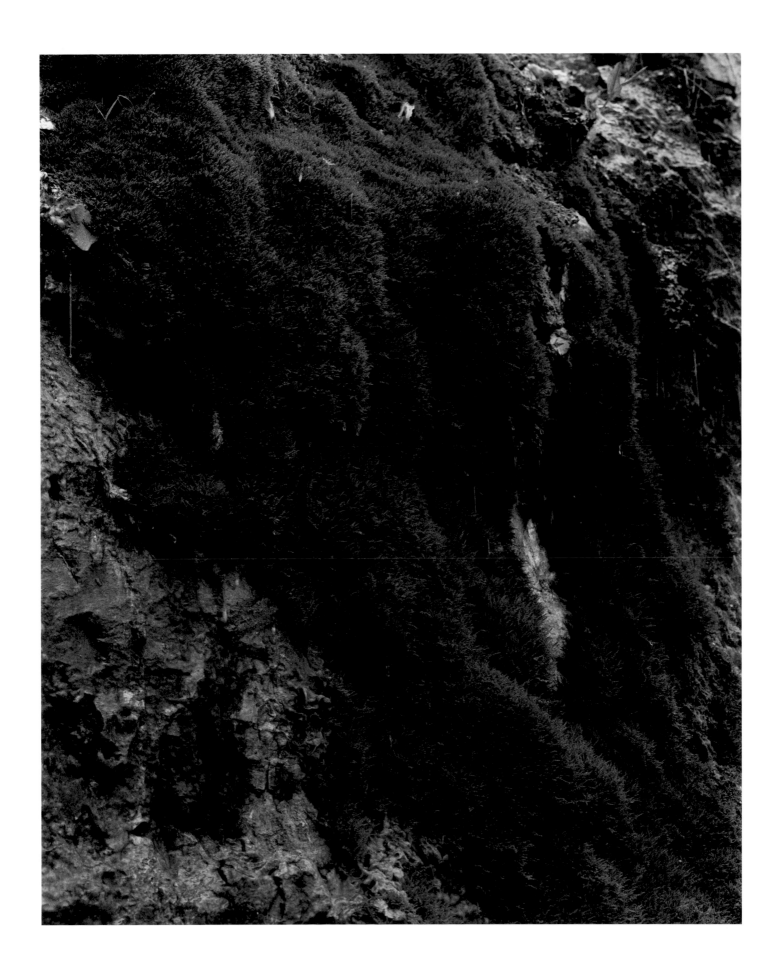

La Source, 1988

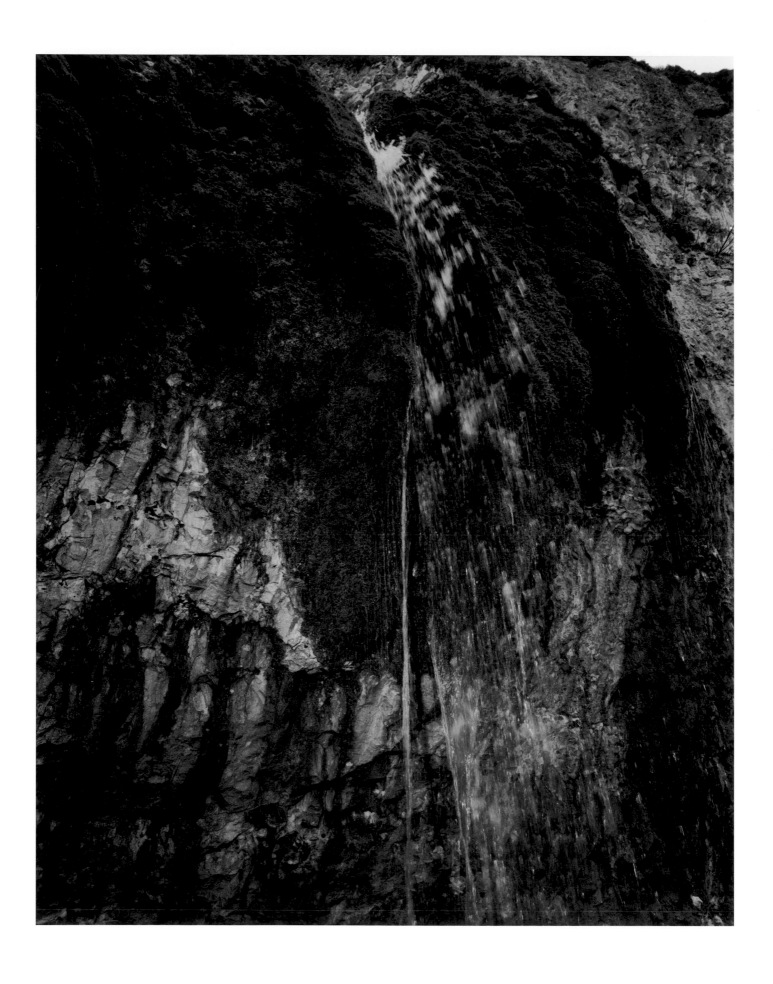

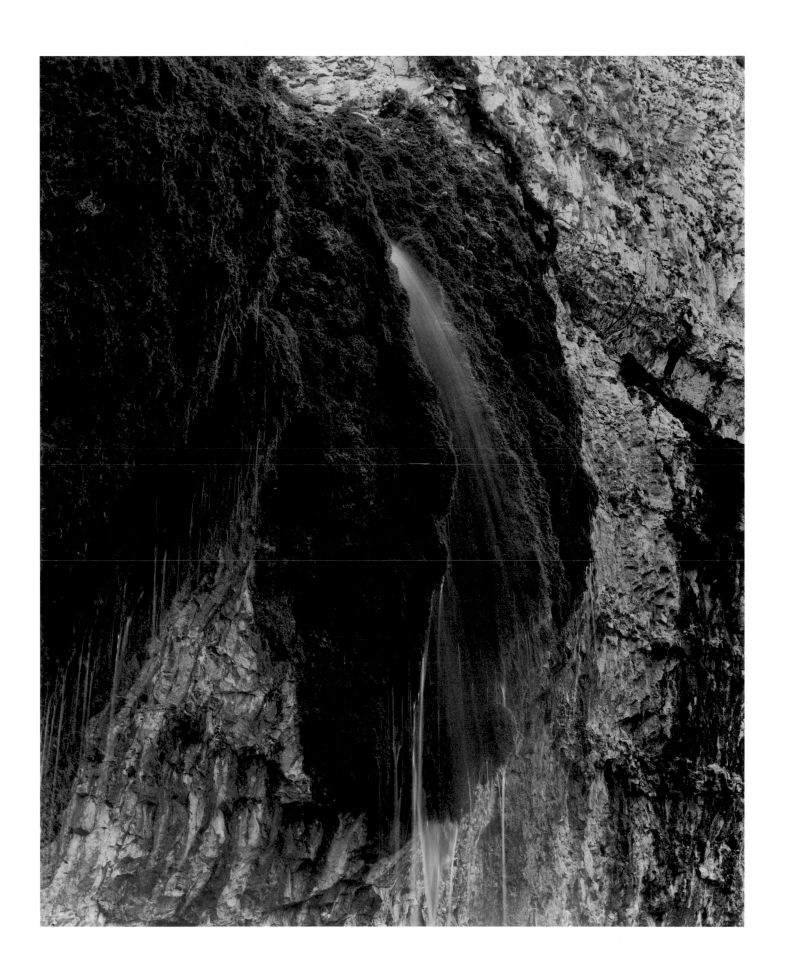

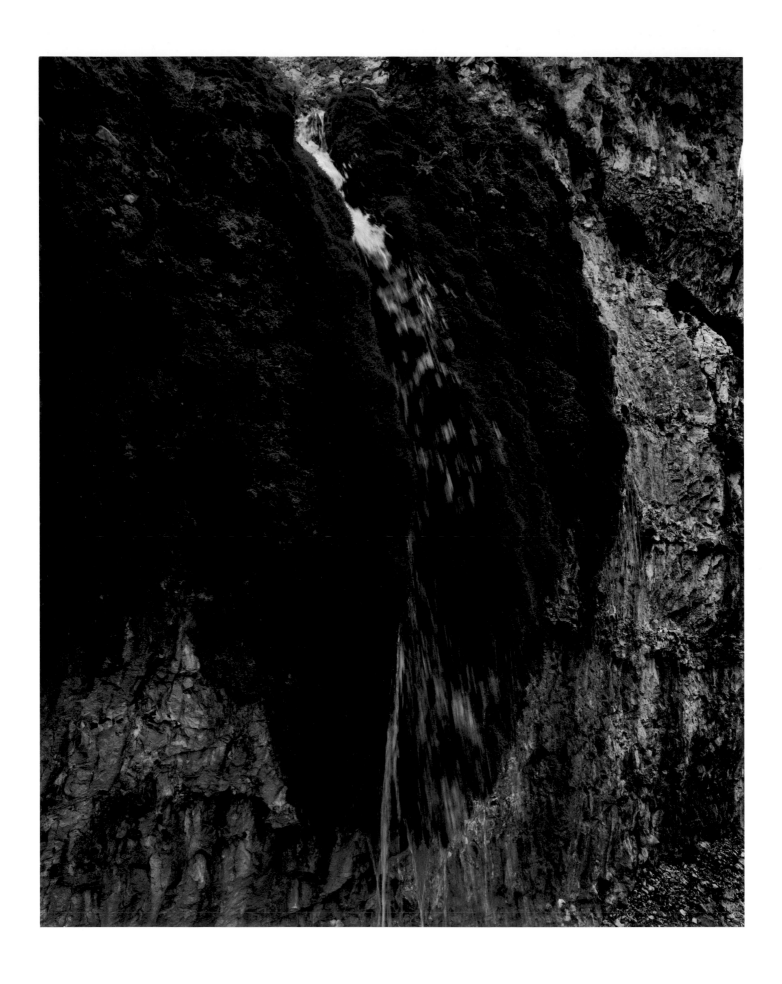

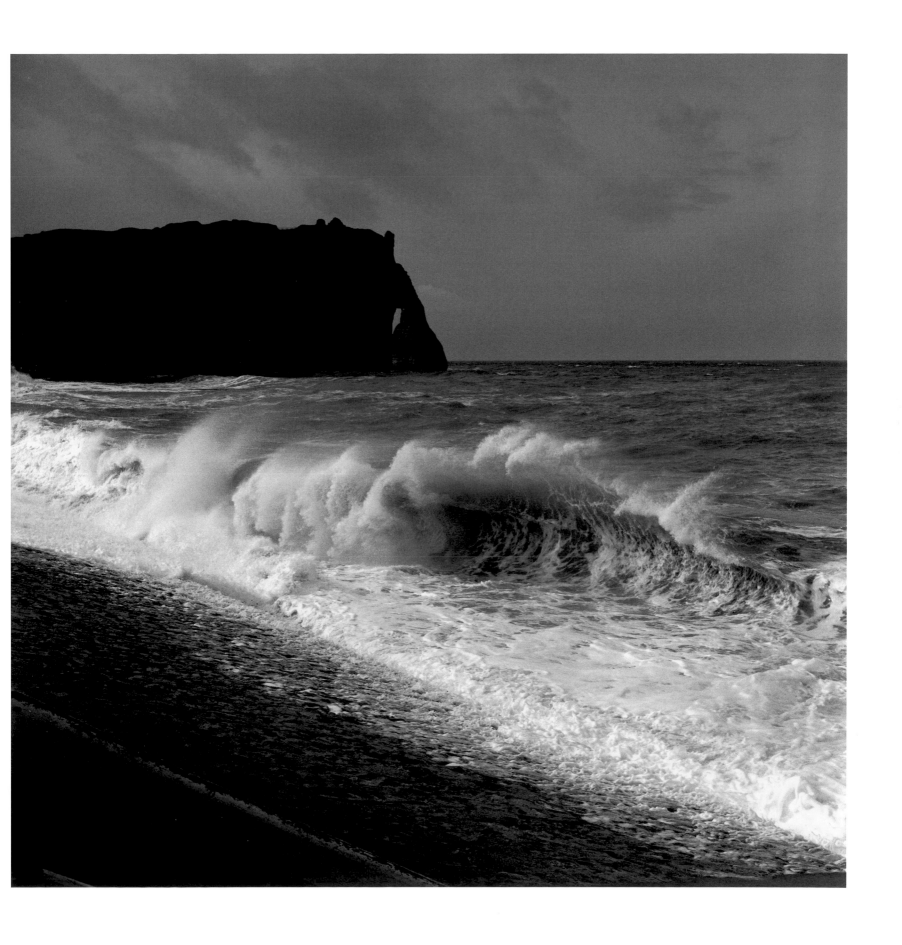

Normandy, 1995

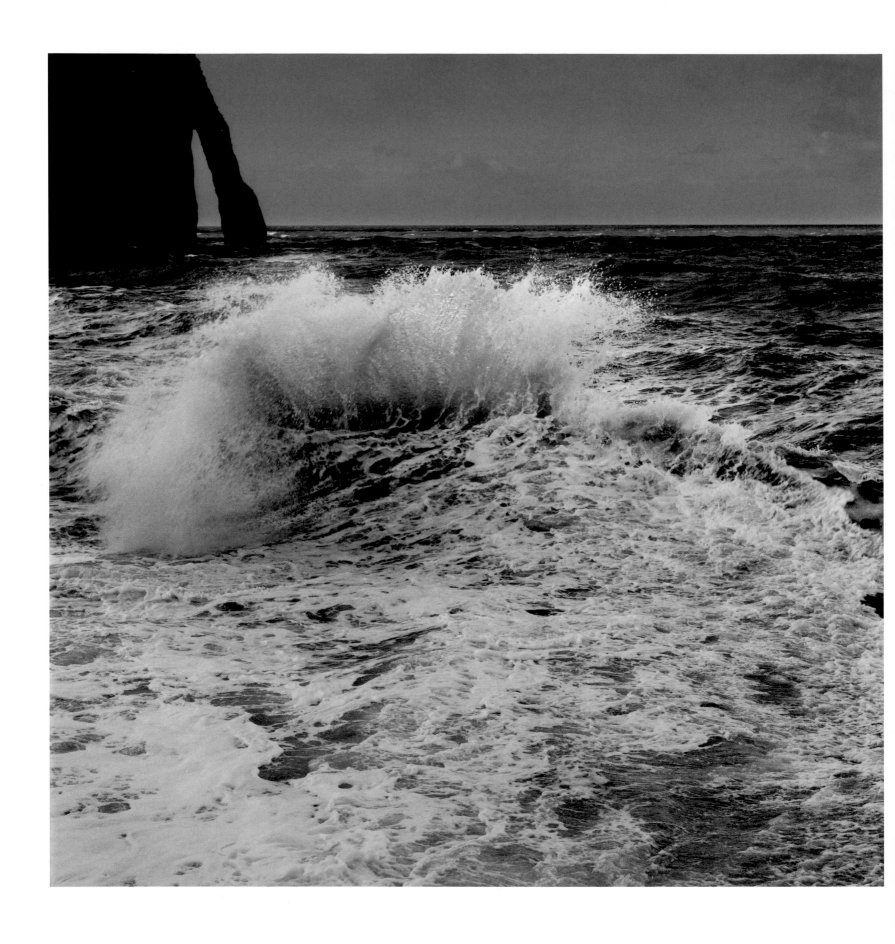

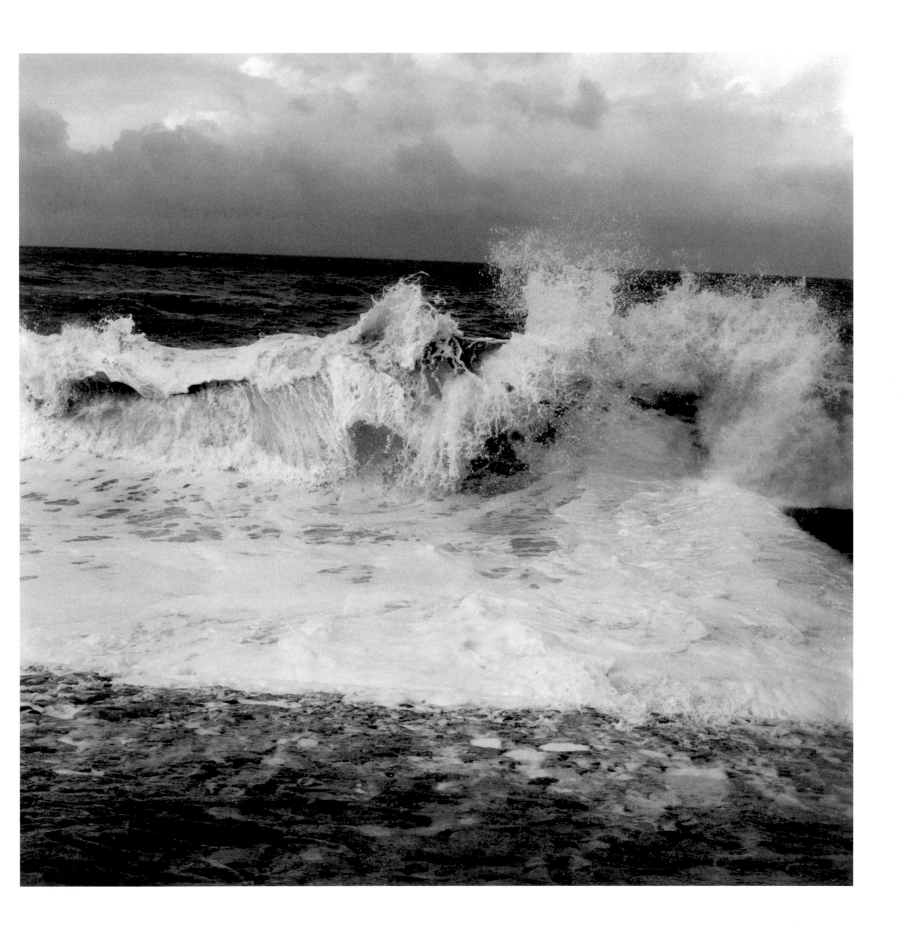

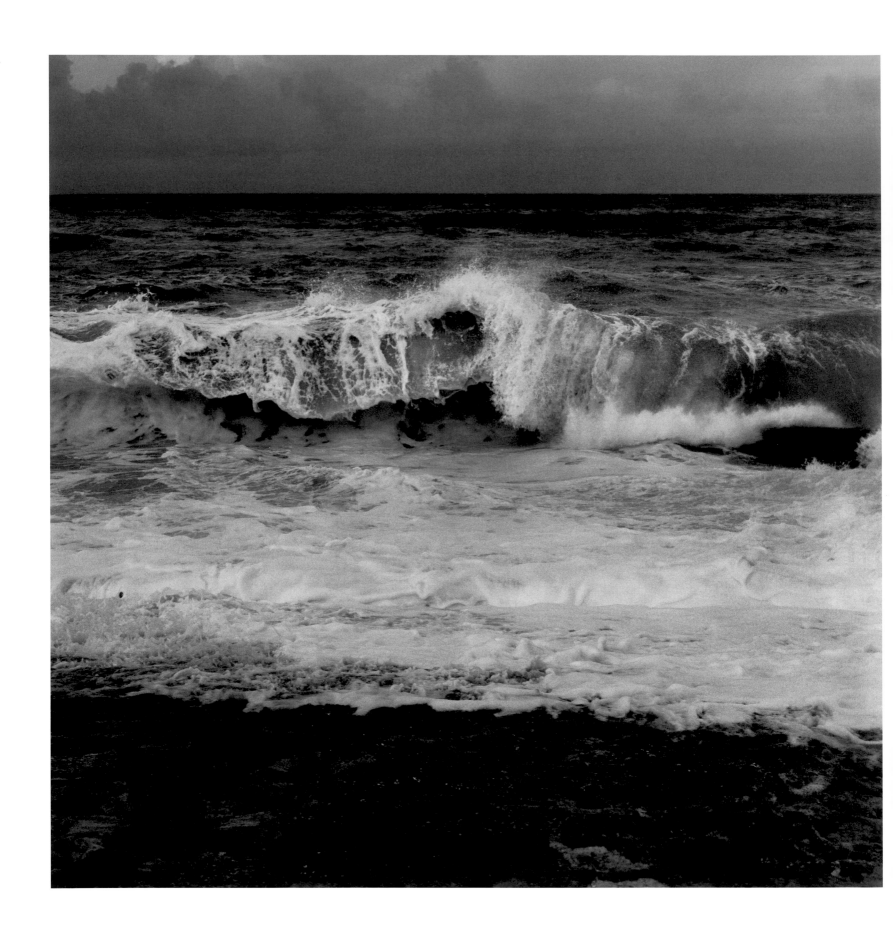

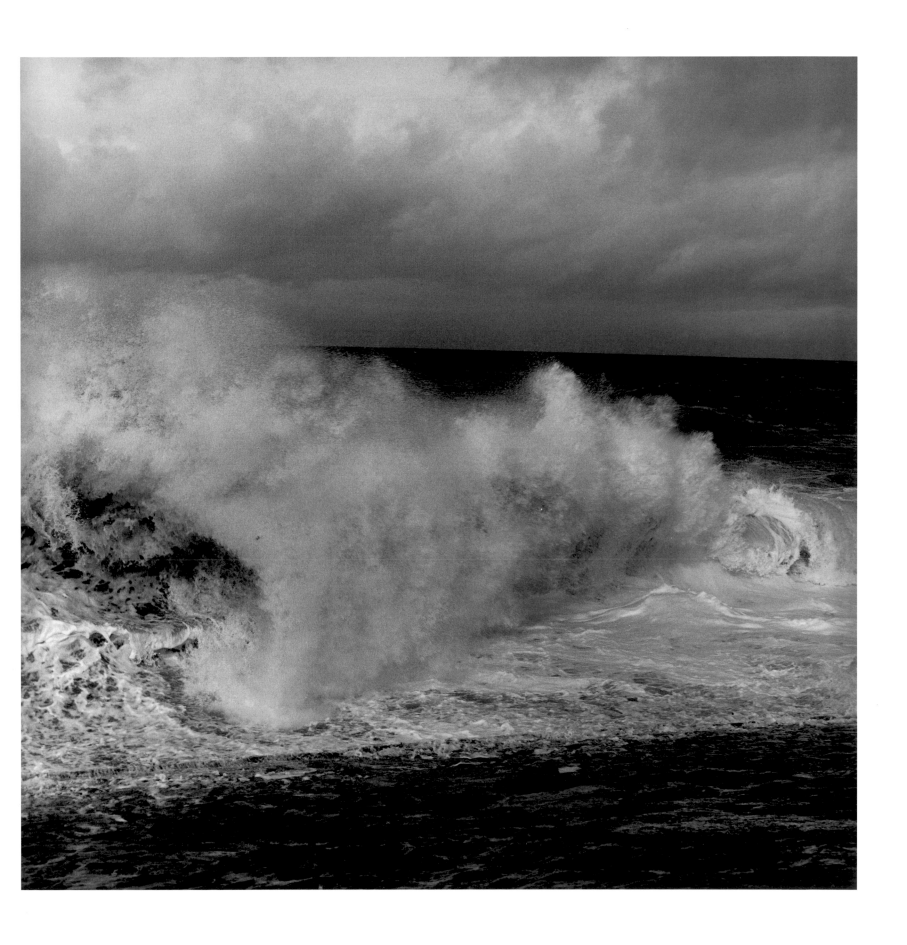

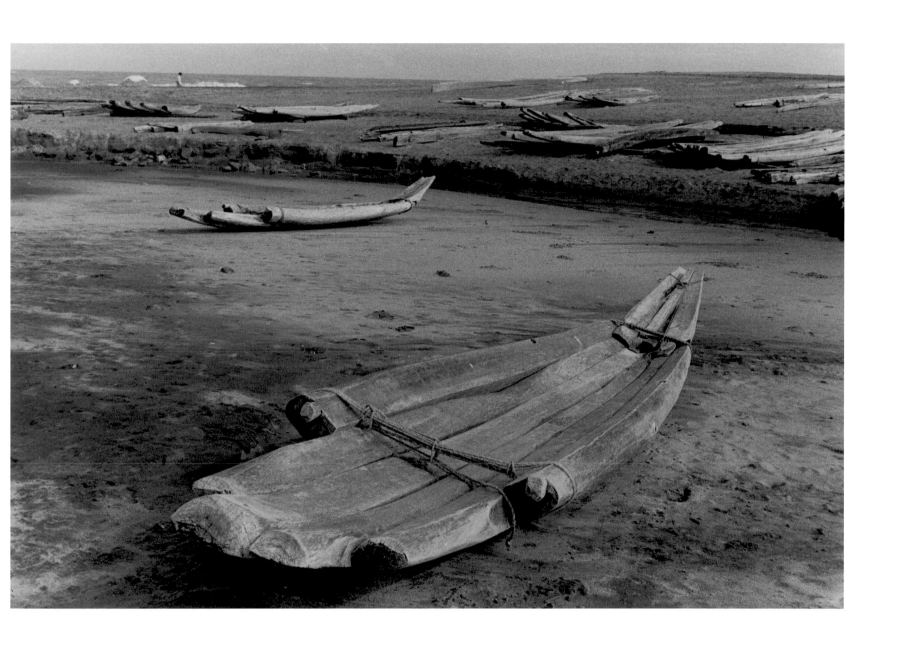

Madras, 1985

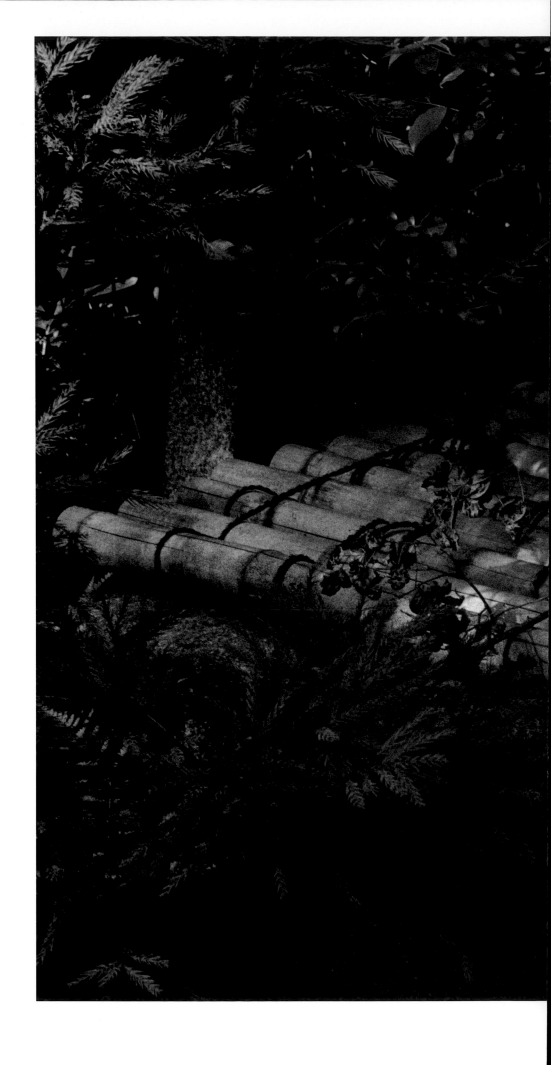

Japan, 1987

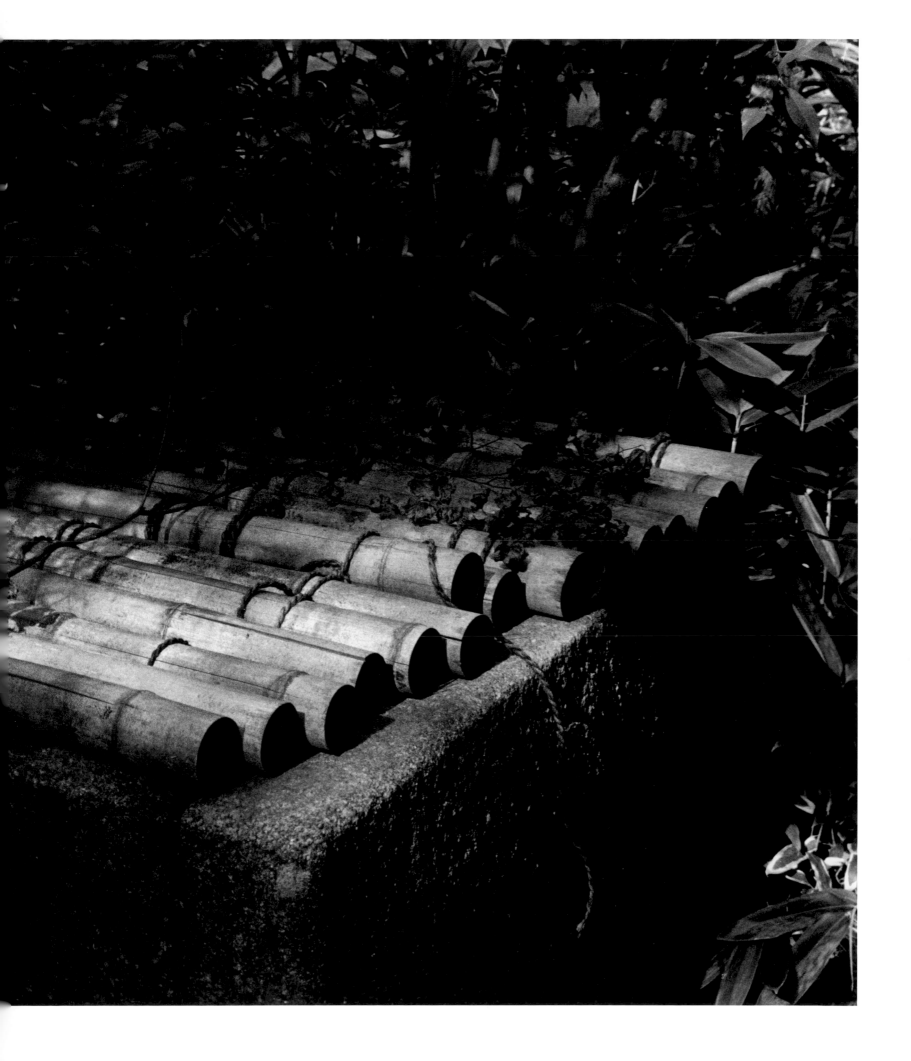

Japan, 1987

Japan, 1984

Japan, 1987

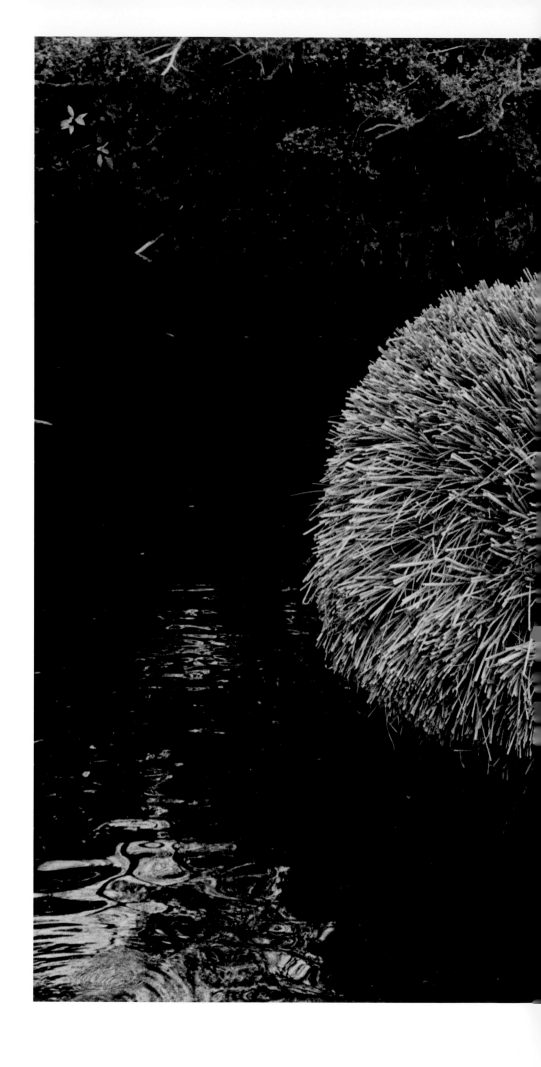

Japan, 1984

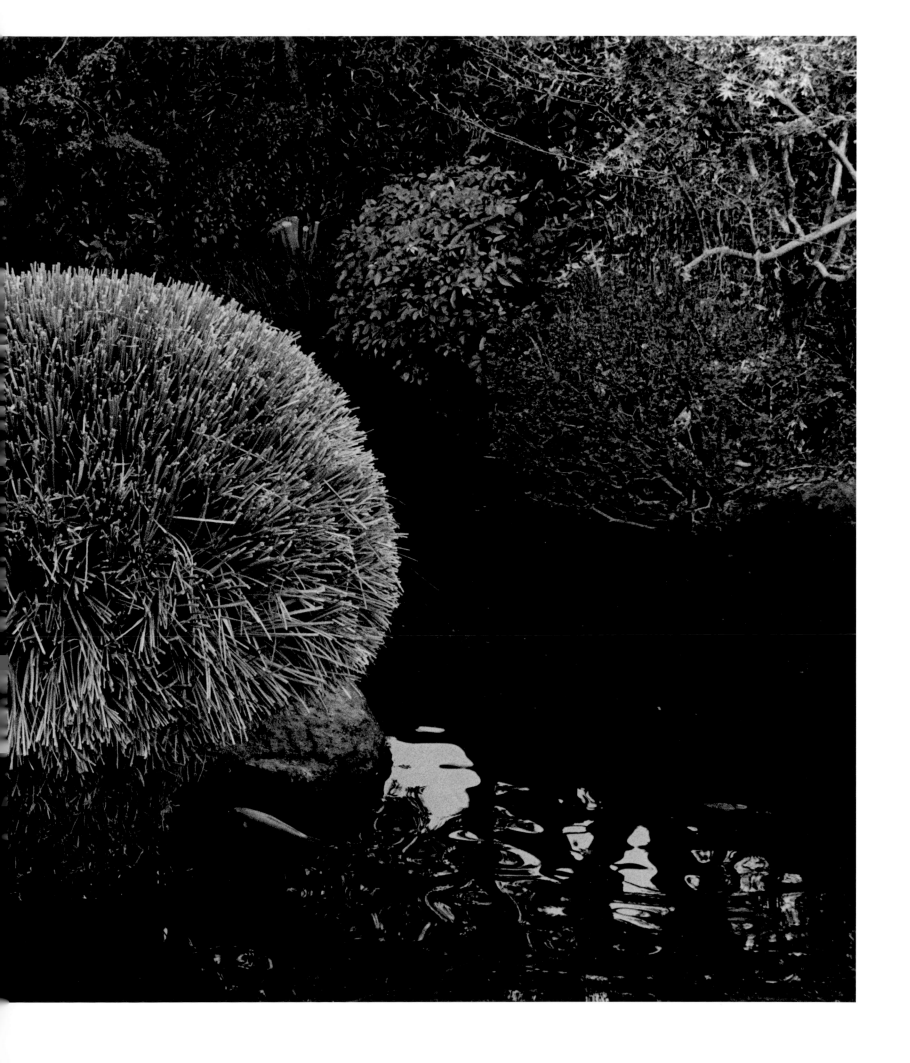

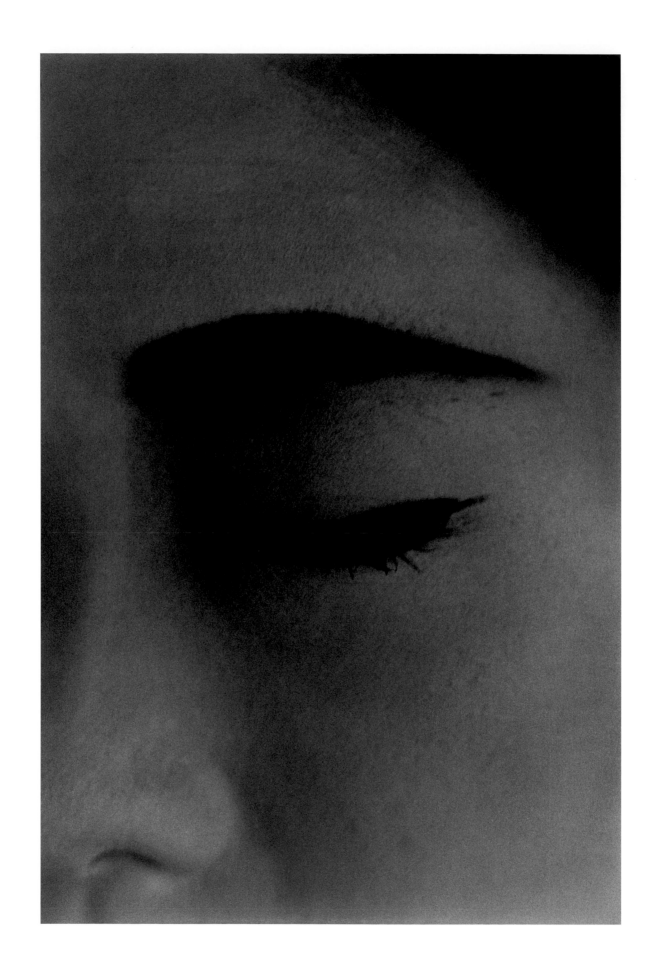

Maiko, 1987

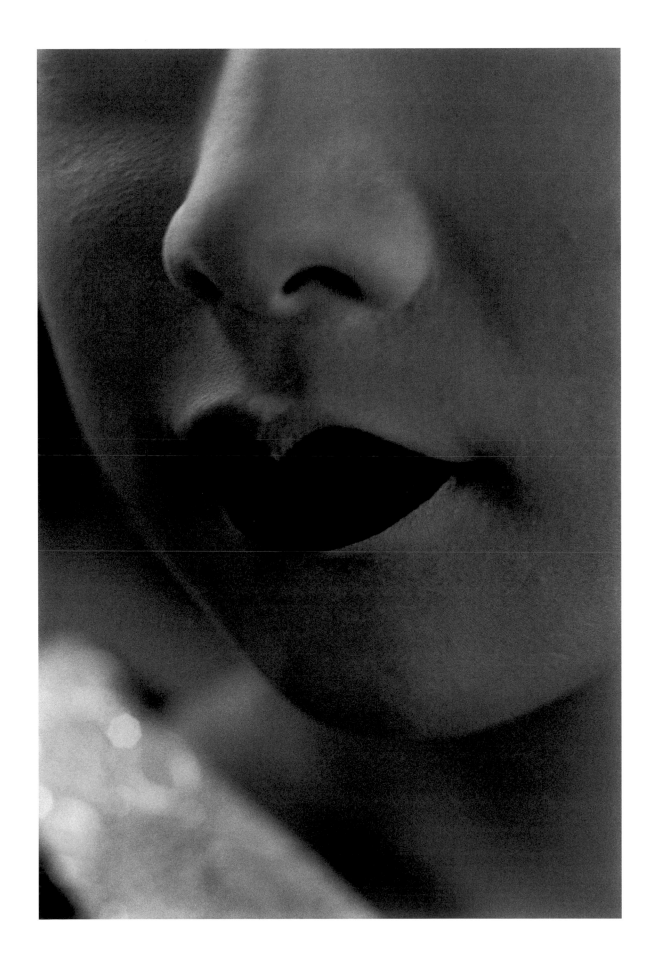

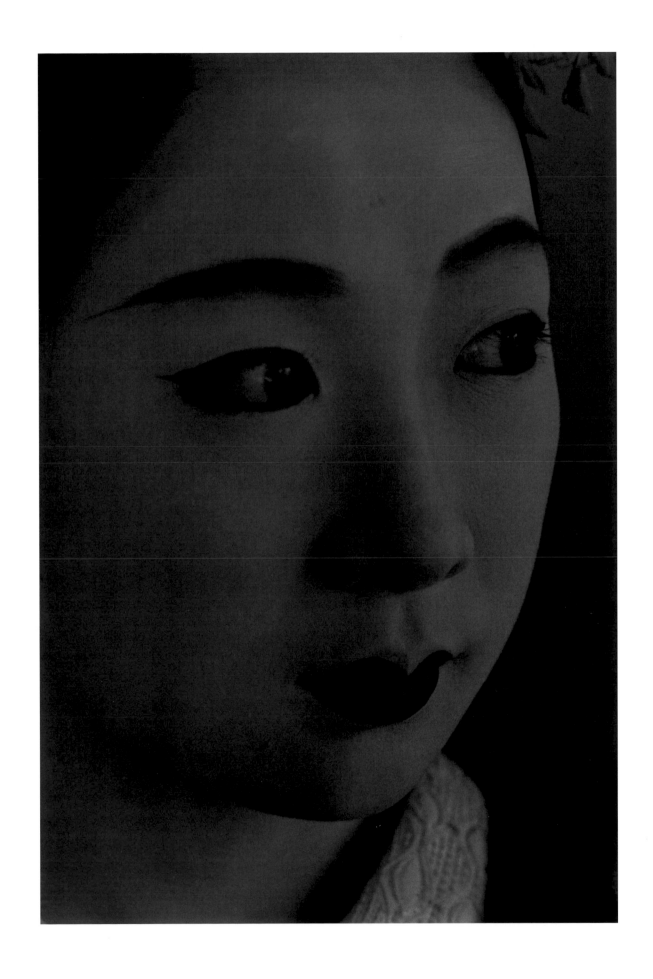

Japan, 1987

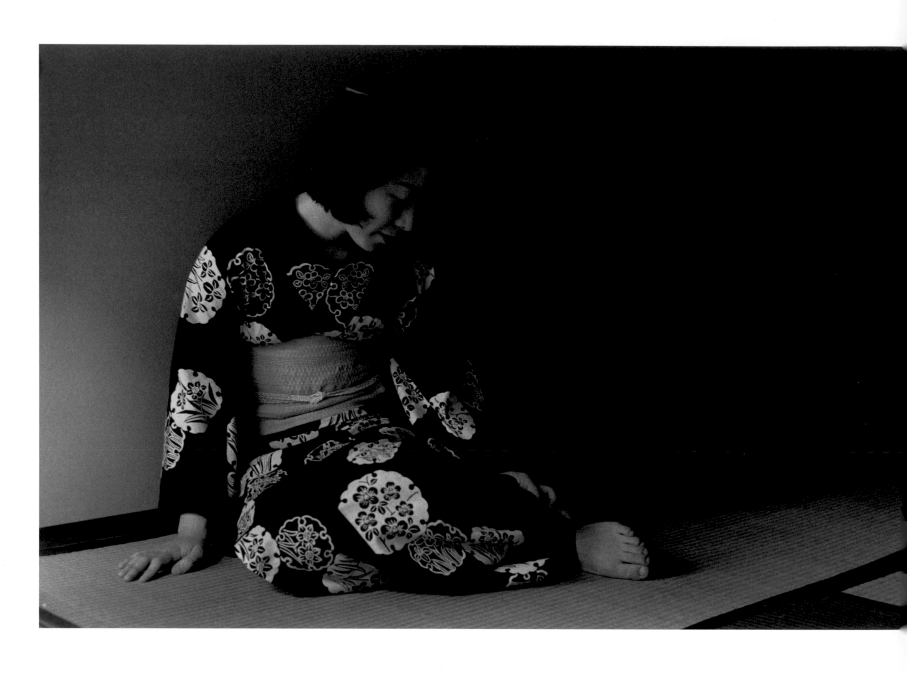

Japan, 1987

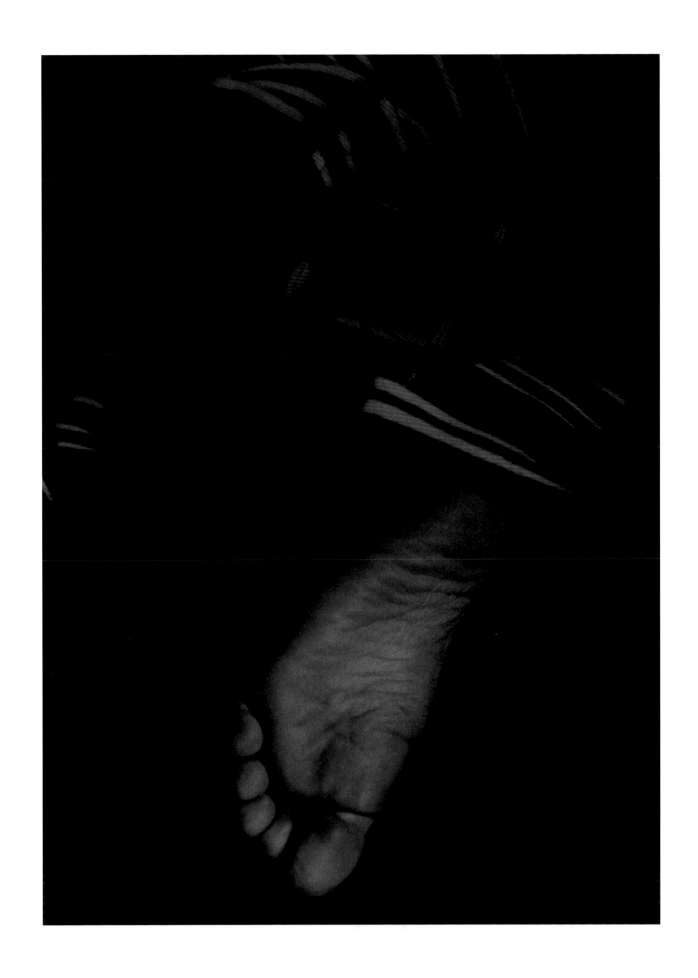

Japan, 1987

Japan, 1987

Japan, 1987

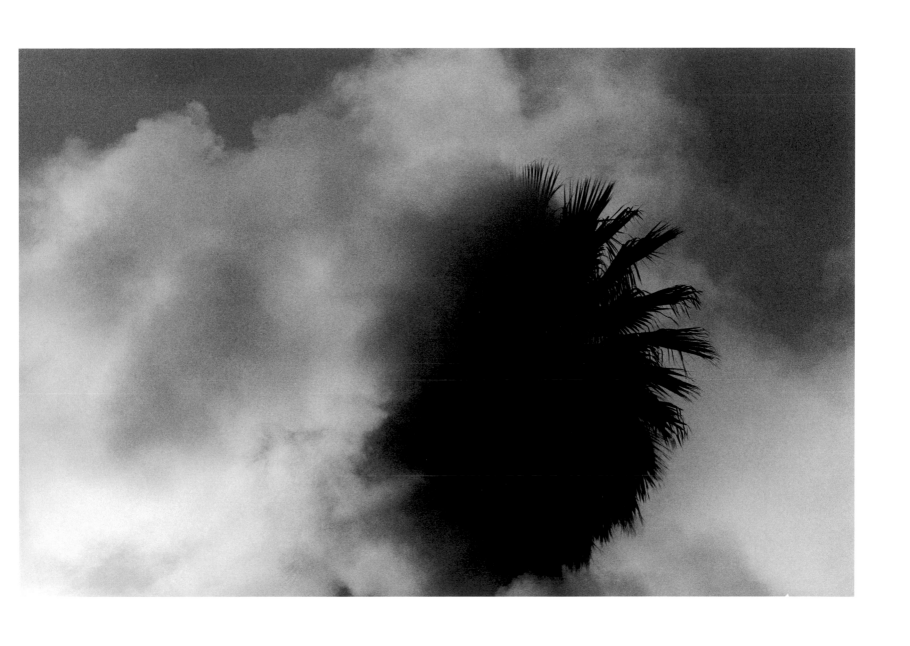

Japan, 1984

Beginning of the 1990s

On chronology: This is a comment on the chronology of the Burkhard oeuvre inserted as a methodological parenthetical remark. For a long time the artist was intensively occupied with the same themes. Interiors, nudes, landscapes, still life, portraits, and animals were often approached parallel to each other, and it is typical for Burkhard to pick up an idea years or decades later as if he had been dealing with it just yesterday. He himself does not keep an index of his work, and archiving prints and negatives was, at least in the early years, seldom systematic. Nor is Burkhard interested in approaching his work under strict chronological criteria. Although he can be consulted, the chronology in his work often remains open. Thus a discussion here of theme and motif is at times given priority over a strictly chronological approach.

The similarity of the dissimilar: A reference that plays an eminently important role, in this work as in that of many of his contemporaries, has not yet been mentioned: Albert Renger-Patzsch. This master of New Objectivity photography was a model above all for Burkhard's microcosmic series about snails, flowers, and bird wings. He also plays a role in Burkhard's morphological investigations. Intriguing parallels can be found between his interpretations of nudes with his calyxes, fields of snow, glacial crevasses, cloud formations, as well as with his study of living snails. In these relationships, contradicting everything systematic, the impartial vision of Renger-Patzsch – for whom it was about structure of form and not its encoded meaning – was of guidance to him. Burkhard however has no encyclopedic interest in phenomena; he does not create a new ordering system. Nor is he an archivist. Analogies pull him magnetically when dead forms like a snail shell, flower petals, or a landscape formation obsessively refer back to the theme of the human body. Thus it comes to equally unexpected as well as astounding displacement and fusion. The objectifying restraint that he imposes in front of naked, breathing women to prevent photographic reason from appearing soft in front of erotic sensation is thrown overboard in the face of landscapes or images of snails' crimped bellies. Here he is the sensualist who cannot infiltrate the arcane erotic of inherently banal and profane phenomena far enough. His photographs always concede to him. His *stilwollen*, his ability to discover and adjust magical moods of light, and his ability to create details with expressive intensity enable Burkhard to impart these analogies with credibility and the strength of persuasion. He did not advance art theory like Ferdinand Hodler who in his Parallelism assumed that recurrent structures make existential constants of life visible. The formal and atmospheric parallels between man, landscape, animal, and object are just as pronounced in him as with Hodler. They are however not an expression of a subjective pantheistic explanation of the world, but rather testify to Burkhard's erotic position to it: his curiosity to experience people, landscapes, animals, things beyond all categorization as something absolutely natural, enabling him to discover new connections.

Paneroticism: Werner Hofmann compared Courbet's realistically distant painting of a spring with the painter's female torso with thighs spread open, "What Courbet's eye draws in over and again in hollows, crevices, and caves is the fascination that comes from the secluded and impenetrable, but also the longing for security. Hidden behind it is a panerotic experience that sees a feminine creature in nature and projects the experience of hollows and caves on the female body. At this point 'Realism' changes into 'Symbolism.'"[18] Hofmann writes further of a "regressus ad uterum" in his deeply psychological interpretation of Courbet's "carnal fantasies."[19] I would not venture to diagnose Balthasar Burkhard with a similar obsession, although the right combination of images would be by all means of value as evidence. They share the "panerotic experience" and furthermore both have a penchant for the fundamental strength of the "wave." Burkhard's *Quellen* (1988) – created in Etretat, where Courbet too addressed the elementary force of the sea – like his *Grottes* (1990), are arguably the most striking examples of upending a crystal-clear Realism in a chain of

association, launching symbolism into the photo art of these years. How did Burkhard accomplish this? On no account through narrative elements. If there is anything that he hates, then it is genre. His symbolism is determined purely through formal criteria.

Why snails? Burkhard's paneroticism relates to flora and fauna – snails, flowers, bird wings… Eroticism, says the artist himself, is the base element of his art. In selecting a motif he does not proceed systematically. He does not look for them, they come to him. He secures a motif only when it is one that lets itself grow into a perfect, innately complete image. As Burkhard is not searching for anything in particular, but rather is completely open to whatever comes next, one should not look too deeply for reasons or profound analogies between individual motifs. What do snails have to do with orchids? Whoever meditates over superficial relationships will be crestfallen: "In Burkhard's photographs associated references appear in place of necessary loyalty to external appearance: the crest of the wave, the labium spread open, the slimy fringe of a snail belly, and the curly edge of an orchid blossom are all variations of similar situations."[20] Burkhard's objectives can be explained more easily through a fundamental consideration of American photographer Paul Strand. In 1917 Strand defined objectivity as the true "essence" of photography. What is important in reference to Burkhard is the realization that photography provides information about the represented object, but at the same time also appears as "abstract form": "The objects can be organized in a way that expresses the causes whose results they are, or they can be used as abstract forms to generate a feeling that is not connected to its objectivity as such."[21] Burkhard always does both. He provides information about the essence of the object he photographs and transports his feelings in the abstract formal content of his photos, stimulating the emotionality of the viewers of his works. Why snails? Because he grew up in the countryside and like other children cultivated and cared for them. Later, he always had snails in the refrigerator, because he likes eating them. And then he turns the discussion to his "erotic affection for nature." Burkhard's paneroticism can only be followed descriptively. In which direction he will turn next is unforeseeable.

Who hasn't as a child caught a garden snail by its shell, and with a small tug pulled it off its leaf and turned it over. The underside curls up, pulls itself in. Burkhard pressed the shell of the turned-over snail in plasticine and captured close-ups of the pharyngeal-like contracting body, or he let it crawl on a sheet of glass and photographed the stretched out body stuck to the glass from underneath. That the Surrealists never came up with this idea! Their sexual obsessions would have opened up fantastic speculations. Burkhard is however not a late-blooming Surrealist. For him it is about the discovery of the snail – the snail as a snail as a snail.

Orchids: When hobby photographers deal with flowers then it has to do with withdrawal into a world of pure beauty; beauty that in modern everyday life can only be found on islands of retreat. The idyll in miniature is celebrated in intensified colors. One describes this optical Biedermeier effect naturally as the opposite of what Burkhard does when he deals with orchids. But he does not go out into nature to search out rare orchids under shady trees. He brings flowers into his atelier, and at one point cared for over fifty pots of orchids at the same time. Botanical names made no difference to him; they triggered obsessive thoughts. Robert Mapplethorpe was dealing with orchids at the same time, remained however with "normal" formats creating morbid still lifes in refined light. Burkhard draws even closer. Usually he concentrates completely on the flower, which he enlarges to monumental "Wallflowers."[22] The blossom appears like a phantom in front of the black that possesses the same vacuum effect that detached his large nudes from profane daily life. When Mapplethorpe concentrates on a blossom like in his late work *Calla Lily* (1988), then it is about sexual allusion

and stabilizing image symmetry. Burkhard's tightly framed details do not seek static equilibrium. The blossoms become full-scale intangible constructs. Reduced in black and white, the body of the flower appears more animal-like than in nature. Leaves turn like the fanfins of tropical fish. The flowers metamorphose through Burkhard's play with the camera like Edward Weston's nude details. Burkhard's innovation in traditional subject presentation is revealed by comparing his contribution to flower still lifes with Mapplethorpe's. Burkhard's lily is not in a vase. It is held by a hand. The flower is not upright, but rather is pointed diagonally toward the floor. Altogether seven individual photographs convey the scene in fragments. Unlike the large *Nude*, Burkhard did not join the images together to form a new complete image. This time he leaves it to individual images, the white wall gaping between fragments.

Japan – In praise of shadows: Burkhard travels to Japan in 1984 at first for only one month. His first photos are taken in temples and gardens. He returns in 1987 invited by the newly opened Meguro Museum of Art in Tokyo as an artist-in-residence together with Gianfredo Camesi, Marianne Eigenheer, and Niele Toroni. His knowledge about Japan is rudimentary. His image of the country is defined exclusively by Japanese black and white films and contemporary Japanese literature. The pictures that he brings back with him from his first two trips communicate no information at all about the time period in which they were taken. He shows "only" what from the western point of view has always constituted Japan: temples, moss gardens, geishas. As a photographer he is always extremely selective. What he photographs are pictures that he already had in his head, as Madeleine Schuppli formulated, "The pictures exist in his imagination before they are given a real existence as a photograph."[23] Modern, big-city Japan, as he effectively saw it in 1987, becomes a theme only in 1999 after a long incubation period. The early Japan photos make particularly clear that Burkhard acts on archetypes brought with him during his travels in order to find those pre-existing images again in reality. His photos show an ideal enhanced Japan as can only be articulated by the distillate of an extremely focused gaze. Topography, historical, and art historical facts play no role. His photos are the exact opposite of travel guide pictures. If asked where he took the pictures and which temple is shown, he does not provide an exact answer, "It is about the idea of a temple." The Japan photographs are in line with the Straight Photography tradition of a Weston, Stieglitz, or Strand. Above all, as the photographs of the temple neighborhood in Kyoto reveal, there are also direct references to the dyewood carvings from Hokusai and Hiroshige. The mode of framing that Burkhard applies can be emphasized as an evident Japanism, and the diagonal vanishing lines aimed toward points far outside of the picture could be an homage to Japanese parallel perspective. The staggered roofs of the temple piled one upon the other, the narrow alley between old wood houses where the geishas live, the damp stones, moss-covered rocks, and exposed tree roots in the temple garden slice narrow scenes from the normal field of vision, as if we were peering through a crack in the door or a slit in the wall. This constellation may explain the feeling of being excluded from the scene or secretly peering into a forbidden world. Typical of these photos (as it often is with Burkhard) is the absence of a foreground: one falls diagonally from above into the picture or gazes without solid footing into the vertiginous, nested timber beams.

The secret of these photographs are however the shadows that arguably contribute the most to the timelessness of these pictures. Burkhard's image of Japan was decisively shaped by Tanizaki Jun'Ichiro's book *In Praise of Shadows*. Burkhard's photographs serve as a congenial counterpart. In 1993 the non-conformist Tanizaki penned this unique essay explaining the difference between the Orient and the Occident on the basis of a comparison of candlelit dwellings of the past and modern houses flooded with electric light. The nuances of the softly illuminated space lead to an immense charging of the rooms and their objects with an immensely erotic atmosphere.

In Burkhard's daylight photos of temple roofs "cavelike darkness" and "compact gloominess" (which the poet emphasized as a specifically Japanese aesthetic)[24] gape from under the protruding roof gutter. Key passages from this poetic text are also a key to the essence of Burkhard's art. In exceptionally poetic images "the secret," "the mystery," and "the magic of shadows" are envisioned by means of spatial situations that one believes to identify from Burkhard's photographs. Time and again the poet evokes rooms in which diffuse day- and crepuscular half-light enter through paper walls. In such places a heightened attentiveness is necessary to orient oneself. This additional sensory effort enables new and unusual perceptions: "Have you," Tanizaki Jun'Ichiro asks a reader, "not also had the feeling upon entering such a space that the floating light there is not a normal light, but rather has something especially awe-inspiring, grave to it? Or does a shiver in front of the "eternal" have you gathered in thoughts; that you could lose sense of time during your stay in this space, that years elapse unnoticed and you could emerge as a white-haired old man?"[25] Searching for a direct correspondence between text and image is difficult. Matter of fact is, however, that Burkhard let himself be deeply impressed by the text and it determined his reception of Japan to a large degree. As a counterpart the timelessness of his photographs is certainly worthy of mention, the impression of an unshakeable stasis that lends a magical presence to the pictures.

Geisha: Attracted by the mysterious rooms in old houses, it was also Burkhard's intention to make contact with a geisha – an endlessly difficult undertaking, more so when he proposed to take photographs. In the narrow alleys of the temple neighborhood of Kyoto, where he photographed teahouse facades with deeply shadowed entryways in oblique perspective, he encountered for the first time the woman who would later become his model, as she (herself like a shadow) glided by. Contact was established with the help of others; alone he could not make himself understood. The geisha was, however, ready to be photographed. As he comes with his camera so close to her face to touch, she closes her eyes. In detail the face stylized through make-up becomes a living sculpture or mask. "In this way he records her conspiratorially and respectfully in her artificiality which has become – as tradition intends – part of her own nature."[26] The view of the neck and the naked foot of "Maiko" are for the Japanese highly erotic parts of the body. As Burkhard created a ne plus ultra in objectification of the body through the details of the geisha's face (the envisioned person becomes the ideal mask of herself, the mask into a breathing face), the foot remains an inscrutable riddle. Earlier the body parts appeared clearly as volumes. The dramatic Caravaggio-shadowing models the body, lends it life. The Foot is similarly alive, but it appears to us only as a plane or rather the sole of the foot. The billowing Yukata swirls around the ankle. The foot detached from the leg seems to float in the black space. Such an intensification of black circumfluent around the foot is only possible in photography. The black however, in contrast to the foot, is not a plane. It is exactly the active dark space that Jun'Ichiro described enveloping women like fragrance, "Darkness enshrouds these women certainly ten, twenty times over, and fills all the interstices and openings of their clothing, at the collar, sleeves, seams, wherever. In a way it would actually like to be the opposite: They let darkness flow out (…) from their bodies (…)."[27] The foot is both moment and symbol at the same time.

The palms: The palm in the clouds is a rare work. Also taken in Japan, this photograph is the irrational suspension of Burkhard's dialectic of light and dark from his Japanese *In Praise of Shadows*. Black shadows and white light encounter each other, without the light illuminating or the shadow taking away. A unique constellation: the dense crown of a fan palm emerges from a mass of clouds, completely cut off from the ground. Spatially the image provides no orientation

aids. From the perimeter to the center the crown of the palm tree becomes denser turning into an unfathomable black spot pushing itself completely into the foreground, just as it extends in depth. Like the white of the clouds: close, but infinitely far, so that it comes to a permanent tilting effect. Black and white, near and far, are only perceivable in this spatial ambivalence. Appropriately it also behaves with temporality: the airiness of the clouds suggests change, transience, the black ribs of the palm branches as well as the black of the tree crown melting to an area of depth all refer to unalterable stasis and continuity. In Japan Burkhard is not only an interpreter of Tanizakis; he is capable of conveying Tanizakis' thoughts onto his own completely individual thematic inventions.

Portraits: Following his return from Japan, Burkhard occupied himself with large-format portraits of his friends. After posing the complex artistic problem of the Geisha photographs, these photographic portraits are conventional. Instead of the extreme artificiality that the geisha produces as a statue brought to life, the photos of friends are shaped by a self-evident naturalness. Eye contact is made with the photographer or, as the case may be, the viewer of the images. These gazes embrace whoever consents to them. Burkhard took photographs in passport photo format, which the contact sheets make clear. For the large formats he chose to frame the images so closely that the heads fill almost the entire photo. The figures are not illuminated like in a passport photo. The light comes from the side in varying intensity, generating Rembrandt-like shadows and light-dark contrast. Each portrait acquires a high degree of individuality simply through the lighting. The drama of light intensifies the personal expression of the sitter opposite the photographer: Mario Merz's defensive sullenness, Mendes Bürgis' mischievous dandyism, Jacques Caumont's sombre introversion, Christian Boltanski's ironic roguishness, Violette Pini's melancholic scepticism, Béatrice Tschumi's wise self-knowledge. The faces are character studies without Burkhard intending it; density of expression reminiscent of Jakob Tuggener's reportage portraits. But Burkhard's portraits are as large as Thomas Ruff's portrait series begun in 1985 that continued the line of August Sander–Bernd and Hilla Becher using objectifying systematics. Ruff forces, levels, by imposing the same absolutely frontal pose – like criminals in front of the police – and illuminates them uniformly without any atmospheric lighting. Burkhard lets his figures keep their individual freedom of movement; he eliminates it only later through tight framing. Ruff pursues (with his encyclopedic investigation presented in systematic sequence) completely different goals than Burkhard in his portraits of friends. Burkhard highlights the individual; Ruff tries to obliterate it: "The sequence of portraits makes the people look like exemplary surfaces without any real depth or physicality; it relieves all individual subjectivity from the side of the portrayed as well as the portrayer."[28] Interesting is the fact that Ruff's color photography which is a priori much closer to reality than Burkhard's black and white, contributes less to the visualization of individuality than Burkhard's subtle nuances of gray. Psyche communicates only indirectly. A one-to-one reflection renders only surfaces. The possibilities of interpretation play the photographs, composed through methods of framing and light, into the hands of the artist. In their portraits Ruff and Burkhard mark out extreme positions: one the mirror; the other the oracle.

Bird wings: It is almost a rule without exception in this oeuvre – when Burkhard dedicates himself to a new object, it turns into expansion of the nature of the task in question. Identification with the new motif is always a total one. Burkhard obsessively searches out physical structures and responds to feelings that these structures trigger in him. Thus unlike New Objectivity, he seeks to represent them as unobjectively as possible so that they kindle associations. When Balthasar Burkhard deals with wings, the bird is not involved, nor does flying come to the fore, just as the geisha's foot

had little to do with anatomy. For the photographs of the snail shell spirals reference can be made to Renger-Patzsch; here Burkhard reproduced an object as a whole. With the wings however, he chose the principle of tightly framing the image lending it a new autonomy independent from the whole. Burkhard unhinges the rule of *pars pro toto* with his framing method. On the wing surfaces we are in a new world that has absolutely nothing to do with pure ornithology. Every time Burkhard elevates a detail to be an image, it becomes an autonomous whole. The new picture is no longer a puzzle piece that lets itself be inserted somewhere, because Burkhard illuminates and portrays it in a way so that it loses its original attributes and functions. To Burkhard the geisha foot is the embodiment of weightlessness that he reincarnates as a symbolic sign. Unthinkable is that this foot is put to profane walking.

In the same way the close-ups of birds' wings have nothing to do with their original purpose of flying. The wings Burkhard separates from the bird become irrational body landscapes in the light that intensifies brightness and darkness to polar extremes. Individual feathers sparkle crystal-clear, emerge body-like in the streak of light as the plumage closes up every precision weightlessly like clouds. Burkhard's models were tame falcons that spread their wings when offered pieces of meat, and dead swans obtained from hunters (swans are secretly shot in Berne to avoid overpopulation). Burkhard hung the heavy animals in his atelier and brought them, as they quickly began to smell putrid, packed in garbage bags to the city collecting point for carcasses. The wings are not a memento mori. As always, he stops time. The light and even more the shadows become material. Like Caravaggio the objects seem encircled, like with ice, yet remain undamaged. With the exception of very few images – his playing dogs seduced him to impressionistic studies – one never thinks of snapshots, that is of instantaneousness. He always cuts his pictures from time and space in moments of definitive validity.

Bamboo: Burkhard addressed the theme of bamboo not in Japan, as the soft, glossy shoots in front of the unfathomable dark shadow could make one believe, but rather during subsequent years in Nîmes where he taught photography at the Academy. In Anduze at the foot of the Cevennes is a tourist attraction, an artificially cultivated bamboo forest. It is hard to understand how these photographs could have been taken at such a place of hectic activity when one sees the images. Again timelessness in the intersection of hyperrealistic visualization with diffuse inscrutability. The stalks with their horizontal swellings appear in the soft light like old wood in Japanese houses polished from use, while the darkness in between stretches into the infinite like the color spaces of Mark Rothko. The vertical stalks create rhythm in spatial depth like Rothko's horizontal elements, reaching over and above to a structure of magical density.

Mountains: Looking onto mountains from airplanes was part of Burkhard's formative childhood experience. Both his father and uncle were pilots. His father, in addition to being a military and commercial pilot with Swissair, also flew on land topographical flights. Balthasar accompanied him from time to time. His father, who knew the name of every mountain peak, annoyed Balthasar with his lectures. The panorama-like view of the landscape from above as well as its inverse, the view from the ground into the sky, can be found already in his early work. The mountain photographs begun in 1992 are taken from the open door of a helicopter. Burkhard set his totally subjective sight in opposition to his father's survey flights. Occupied earlier with birds' wings, he depicts here what a falcon can see during its flight. Bird wings and the Alps cross even more directly. The ridges revealed by the melted ice impart a speckled – though in comparison to the feathers completely irregular – structure to the mountain views. On some photographs misty clouds descend as a disconcerting second structural layer. The goal was not to create postcard subjects, but rather bad weather photos that

eliminate any tourist elements. Burkhard's challenge was to restore the archaic presence of the mountain, as in Hodler's visionary Alpine paintings. In each case he flew from Zermatt to the Valais Alps. Which mountain he had in front of him was, it goes without saying, unimportant.

Waves: Waves do not have names. Perhaps the comparison of mountain ridges with ocean waves tumbling over the shore makes Burkhard's real interest most clear: it is not about a particular mountain, nor about tectonic-static immovability, but rather the elementary event of a mountain. They do not appear freely exposed in crystal clear air like Giovanni Segantini. Snow and clouds give them dynamic force, rob them of their clear structure, lend them their primordial nature. The wave, in the moment of its highest uprising, is considered the quintessence of change. The picture that Burkhard has captured exists for only a fraction of a second. The spray of the billow and the wisp of clouds over the mountains exerts a leveling effect: the mountain becomes an apparition that permanently mutates like the wave. Or to look at it another way: the wave is just as much an immovable archetype as the mountain range. Burkhard's symbolism is ambivalent. He always questions and refers to the opposite of what one automatically associates with the motif in question.

What is evident is Burkhard's recollection of Courbet. His waves were created in Etretat on the Atlantic, where as indicated earlier Courbet had already addressed the subject. On certain photographs even the dramatic rock arch that made the beach from Etretat the marine painter's favorite place is visible in the background. The art of photography consists of hitting the right moment – no motif expresses this fundamental rule more stringently than Burkhard's *Waves*. His series reads as a proper alphabet on the theme: the rising up, the apex of eruption, the unification of spray and clouds breaking in phases, the gradual diffusion – all that is gathered in grandiose clarity. The power of the wave here is even stronger than with Courbet, who depicts it as the gaping maw of the wide expanse of water. With Burkhard the framing is tighter; the wave becomes an individuum that he portrays with meticulous precision.

Animals: Burkhard's nearly life-size photograph of an elephant is disturbing. The animal is standing like a rock mass, fairly close, without barriers, at a right angle to its viewer with that strained inertia of the people on early Daguerrotypes when exposure time amounted to ten minutes and more. Why such an oppressive feeling in front of the monumental pachyderm? On the one hand it is the lack of distance: the animal is standing close enough to touch. On the other hand, it is the elephant's one eye that tensely fixates the photographer and thus us as well. One feels observed. The artist explains that the elephant is from the Swiss National Circus Knie. He made an agreement with the respective animal keepers so that he could set up his tent at particular stops of the tour in order to take more photographs. He always returned several times to win the trust of the animals. The elephant recognized him from a first unsuccessful attempt, and at the next encounter even stepped under the roof without hesitation, placed himself in front of the camera and did not move. Burkhard only had to press the shutter button, and the photograph turned out just as he had hoped. The rhinoceros also came from Circus Knie, and as it was especially unpredictable the keepers advised against photographing it without a barrier. Burkhard benefited from first acquainting himself with the rhinoceros, as with each of his motifs. He went several times to the animal show until the camel, rhinoceros, or elephant became accustomed to him. Burkhard's characteristic attitude toward his subjects is to wait so long until the subject "forgets" that is until the photographer standing opposite is no longer perceived as a disruption. Furthermore, he balks at both the effort and cost needed to realize an idea. He even traveled to Hollywood with his extensive equipment in order to photograph for his series a tame lion named Joseph, who was being used in a film at the time.

Claire Stoullig put the extraordinary quality of Burkhard's animal series in a nutshell with her analysis of the *Friesisches Pferd*, "In front of the life-size photograph of the horse, the viewer asks himself somewhat confusedly whether the animal is real or fake."[29] The animal photographed "in an absolutely motionless pose" imparts the impression of a statue, "Starting from a living model, Balthasar Burkhard tries to give the photograph the semblance of a fake. Therefore the photograph is no longer the reproduction of a living model, but rather the exact copy of a cast bronze."[30] This impression of a certain implausibility in light of the absolute stillness – the animals could also be stuffed – is believable, albeit the eye of the elephant could be used as counterevidence. Admittedly only a few of Burkhard's animals look as penetratingly as he. The fact, however, is that an animal photographer would have proceeded differently. He would have shown the animals if possible in motion and in a natural environment. Burkhard's animal photographs are "politically incorrect." He forced them into a pose: a motionless sideways stance in front of the photographer. In nature such images, particularly at such close proximity, would have been hardly possible even with the best telephoto lens. Stoullig believes nevertheless that it can hardly be Burkhard's intention to deceive us in such a complicated manner. Especially because in these photographs he is anything other than a Mannerist thinking in complicated twists, and his interest in conceptual questions of perception, with which he occupied himself in the seventies, has not been a theme for ages. Stoullig's credit however lies in having referred to the peculiarity of these animal photos. Many aspects are unusual: the size, inertia, and the elimination of each creature's individuality. The format on the other hand contradicts thoughts of a zoological encyclopedia: clarity and the ability to compare require uniform formats. The inertia does not match the behavior of animals. The photos were only possible because of their domestication. Size and motionlessness were necessary to photograph the presence of the animals. Comparison with the snapshots that Burkhard took of his frolicking dogs makes this clear. The dog photographs transform the animals into downright futuristic-abstract energy bundles that erase every individuality. In comparison the life-size animal photographs remind one of portrait galleries of early modern times where all – humans as well as animals – are depicted life-size. Particularly striking is the parallel to Giulio Romano's horses in the Palazzo Te in Mantua, similarly portrayed motionless in profile and with photographic precision. Paradoxically here as with Burkhard it is precisely the true-to-scale closeness to life that makes the pictures seem so artificial.

Markus Raetz, 1989

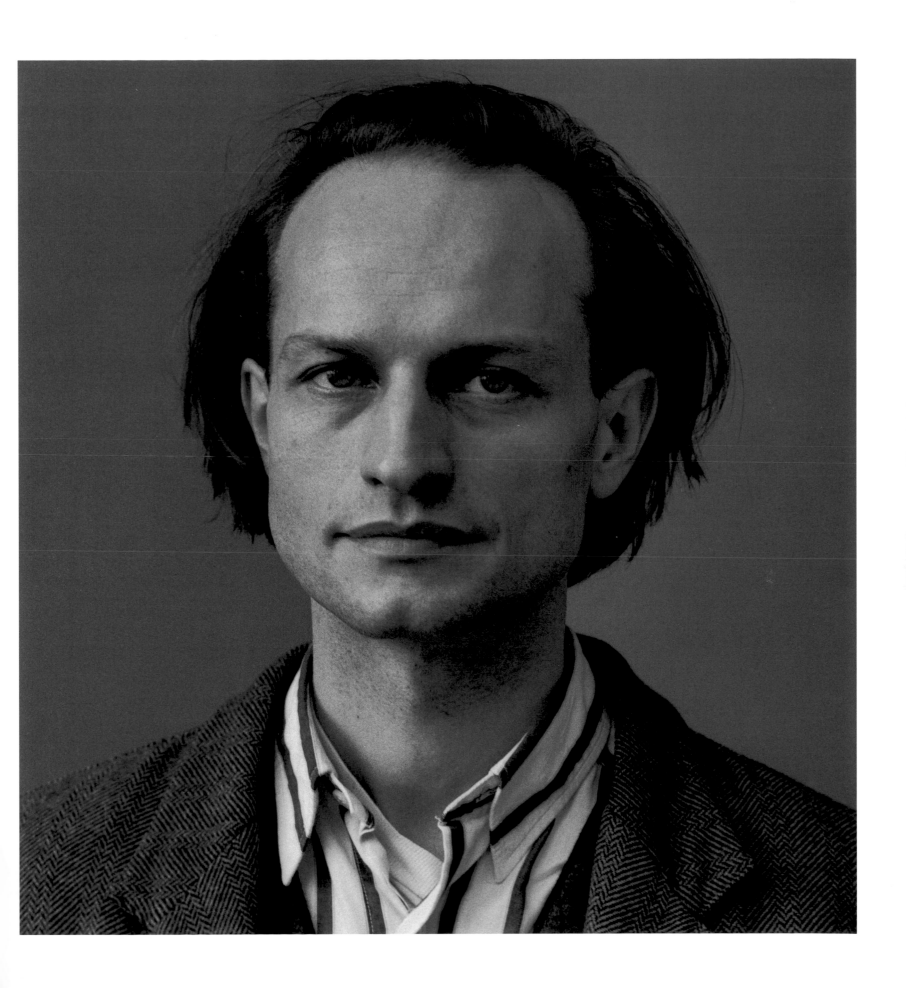

Mendes Bürgi, 1989

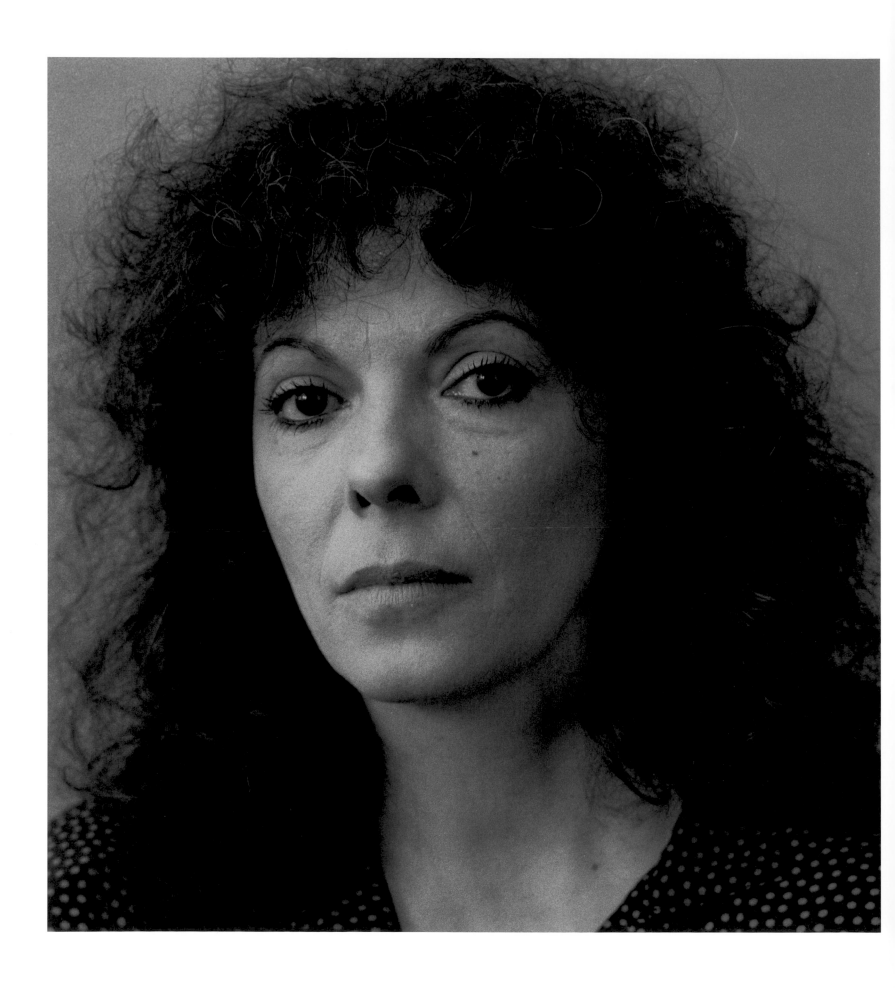

Violette Pini, 1989

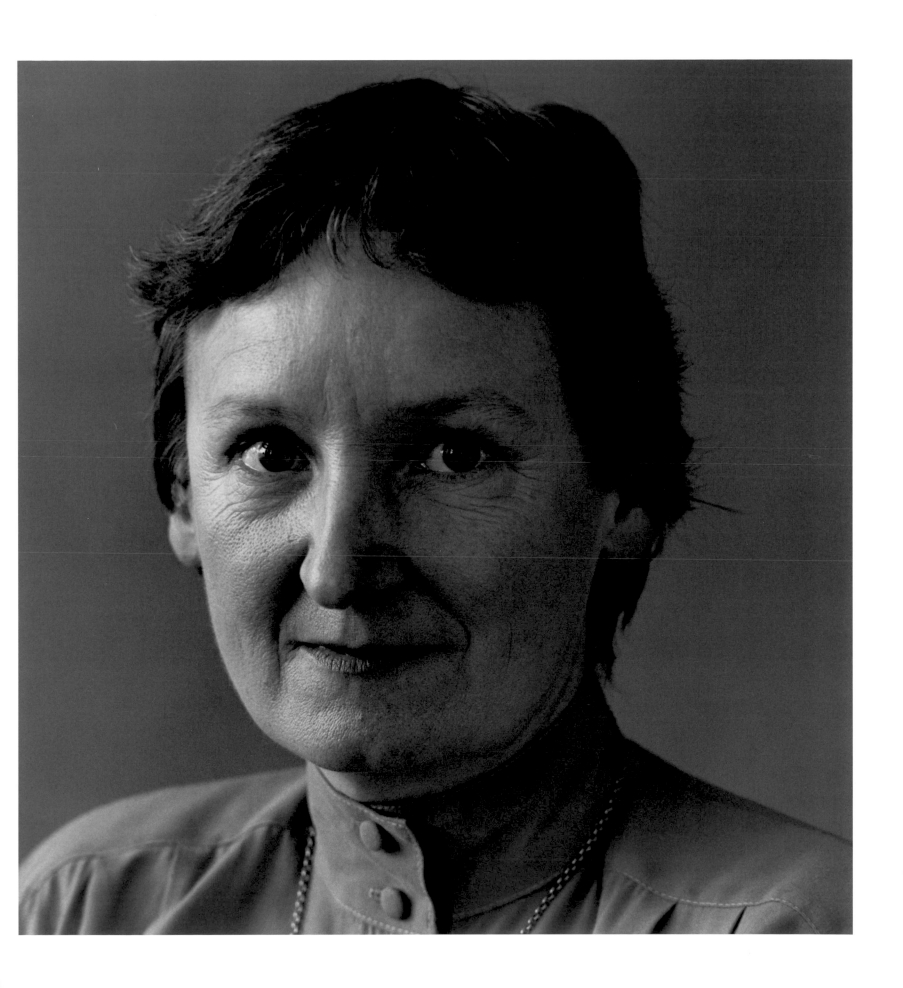

Jennifer Gough-Cooper, 1989

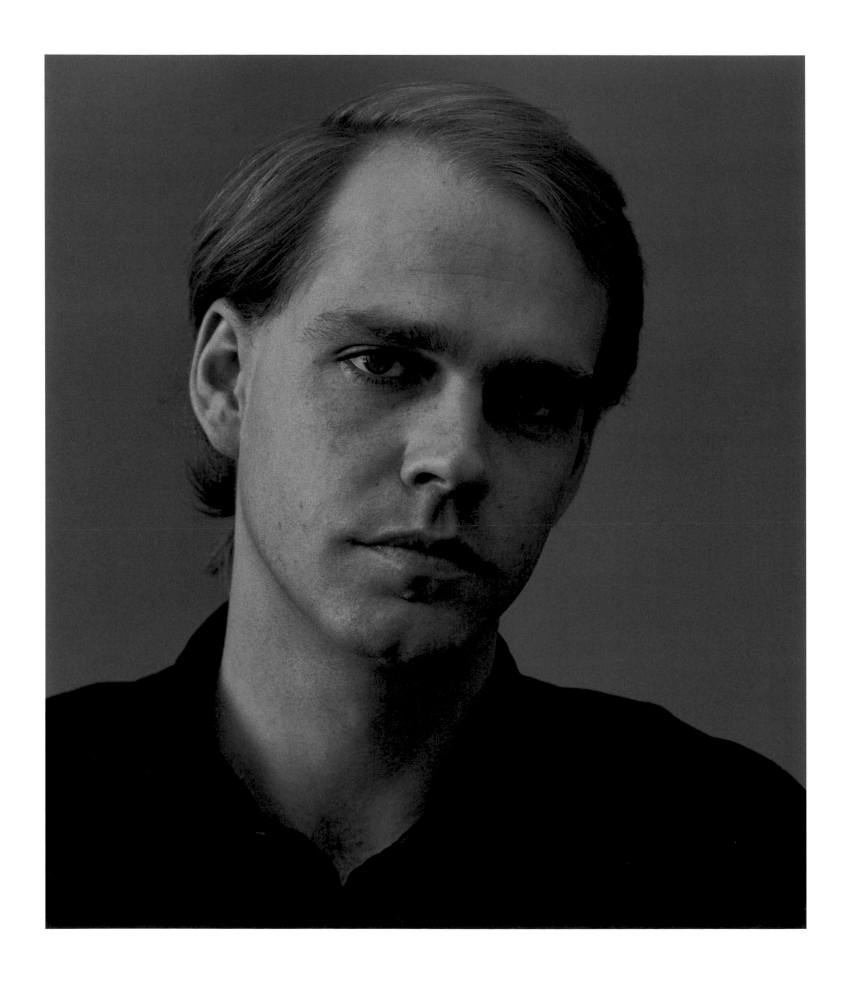

Georg Althaus, 1989

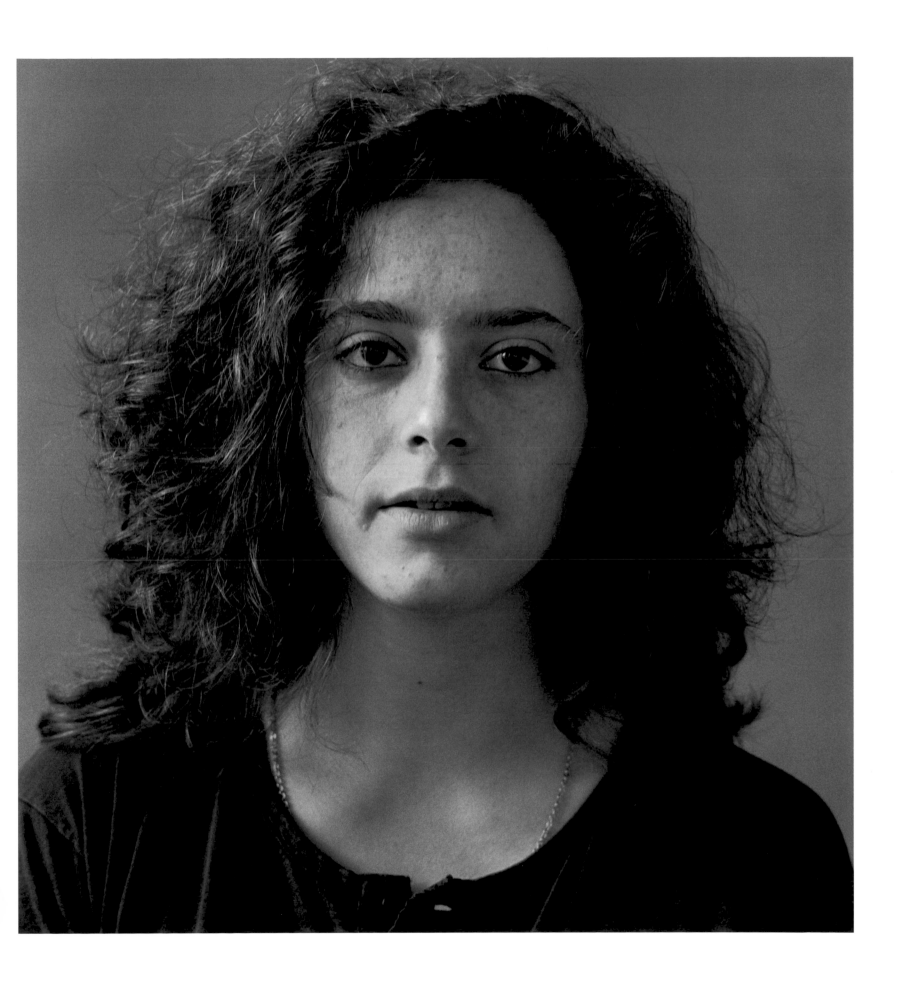

Jeanne Pini, 1989

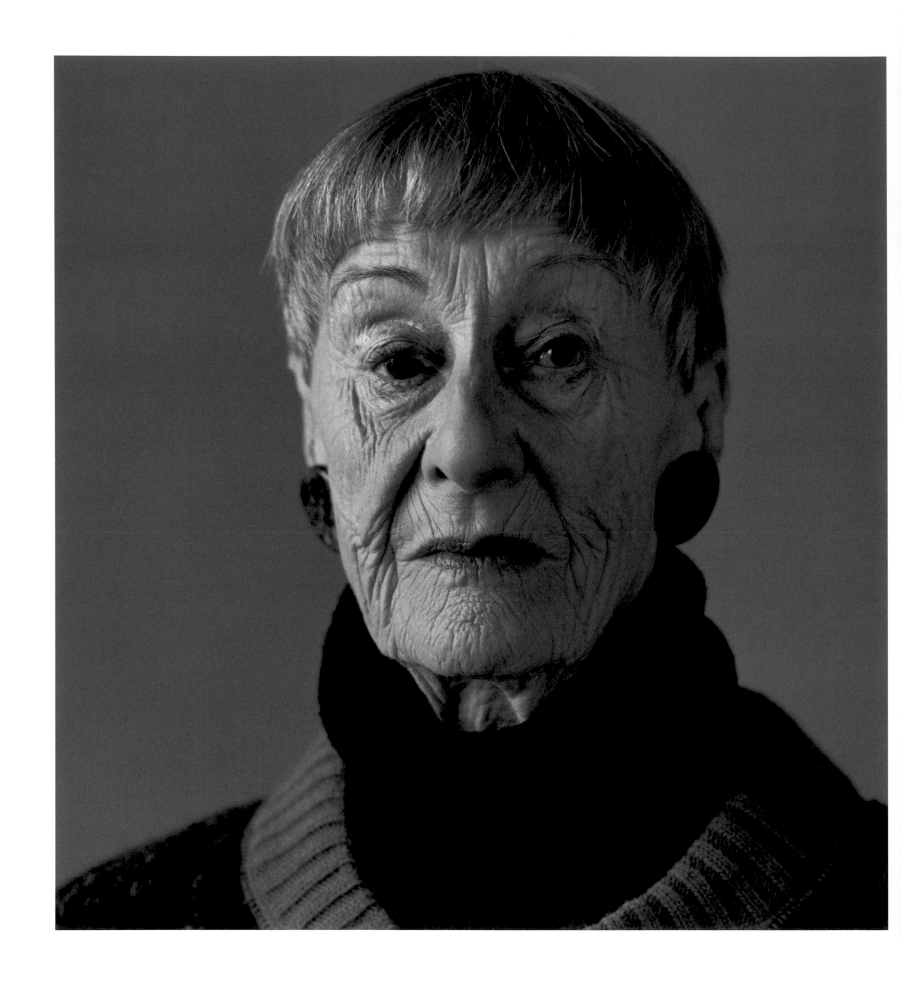

Béatrice Tschumi, 1989

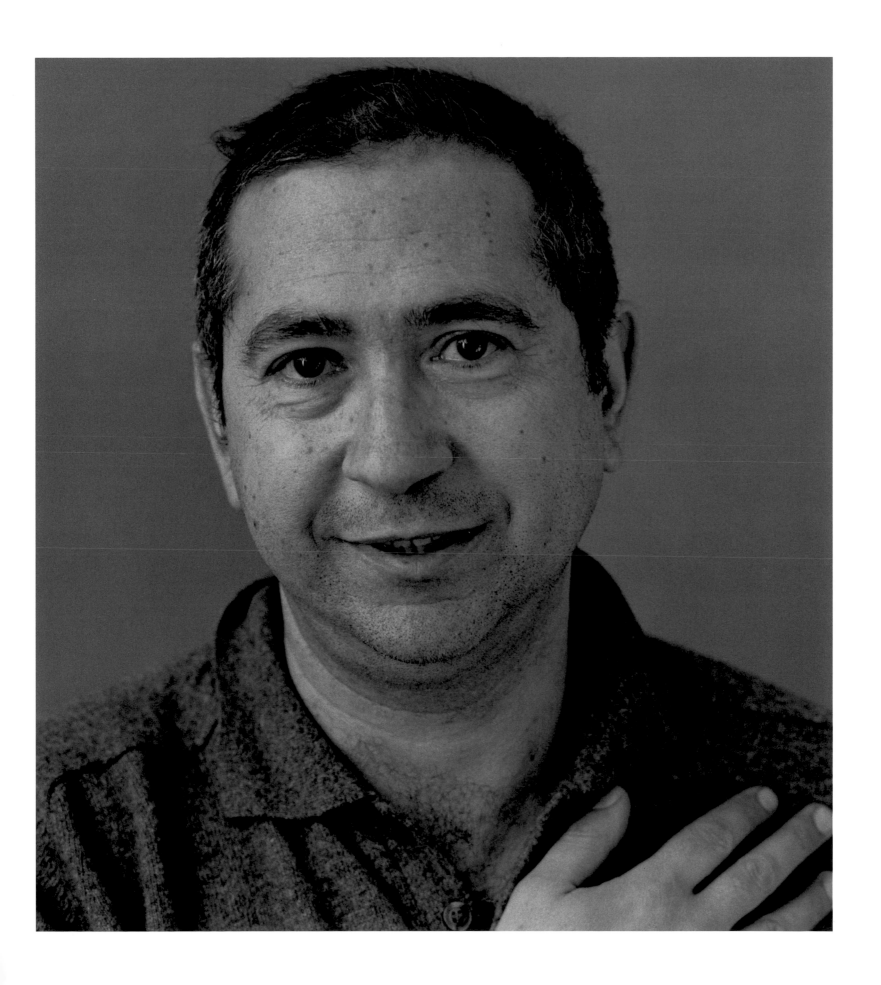

Christian Boltanski, 1989

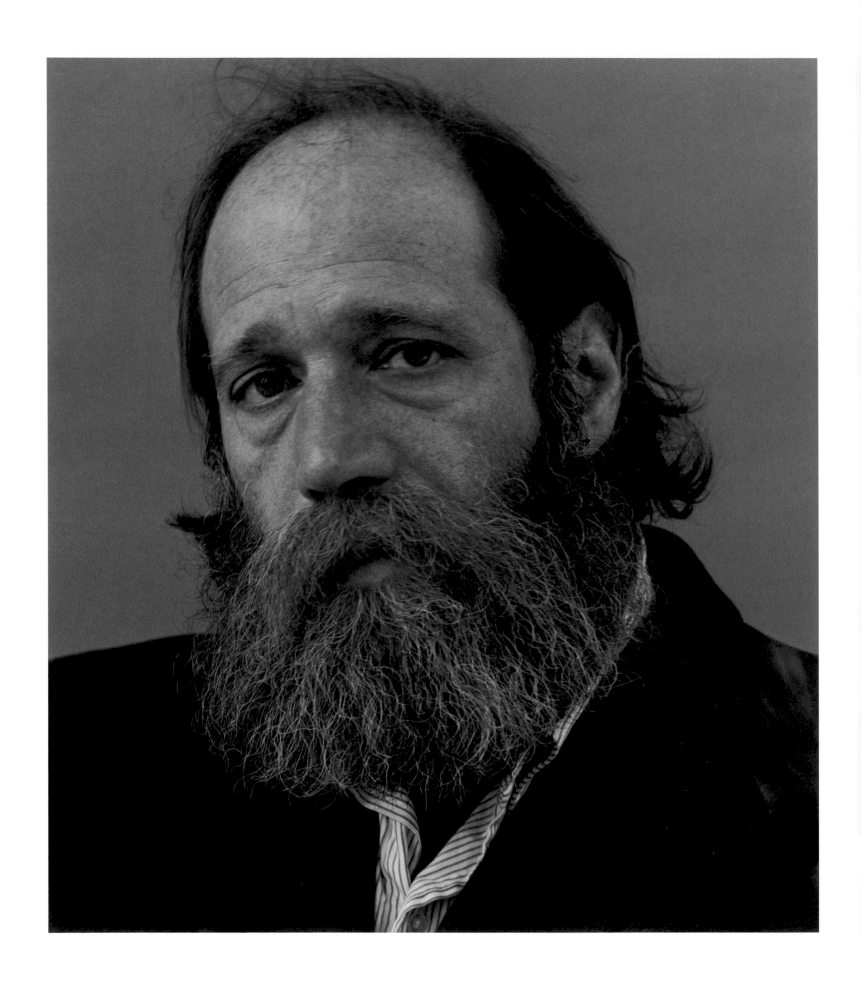

Lawrence Weiner, 1989

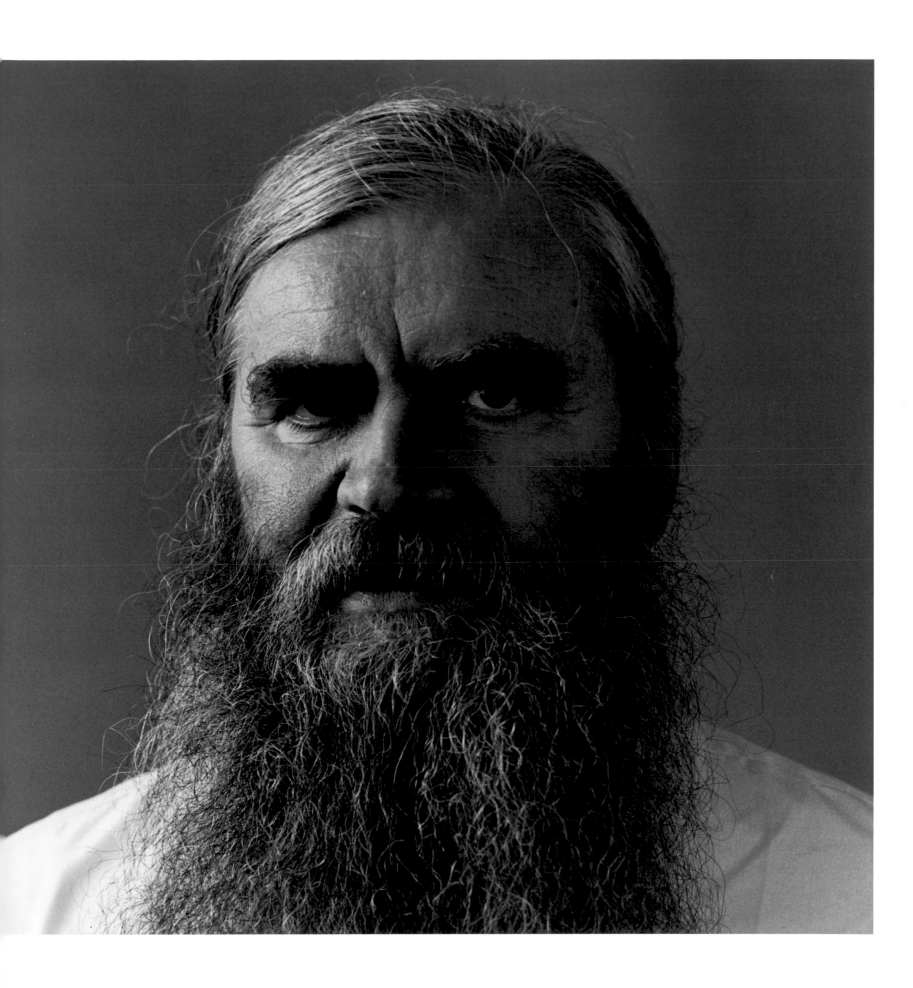

Jacques Caumont, 1989

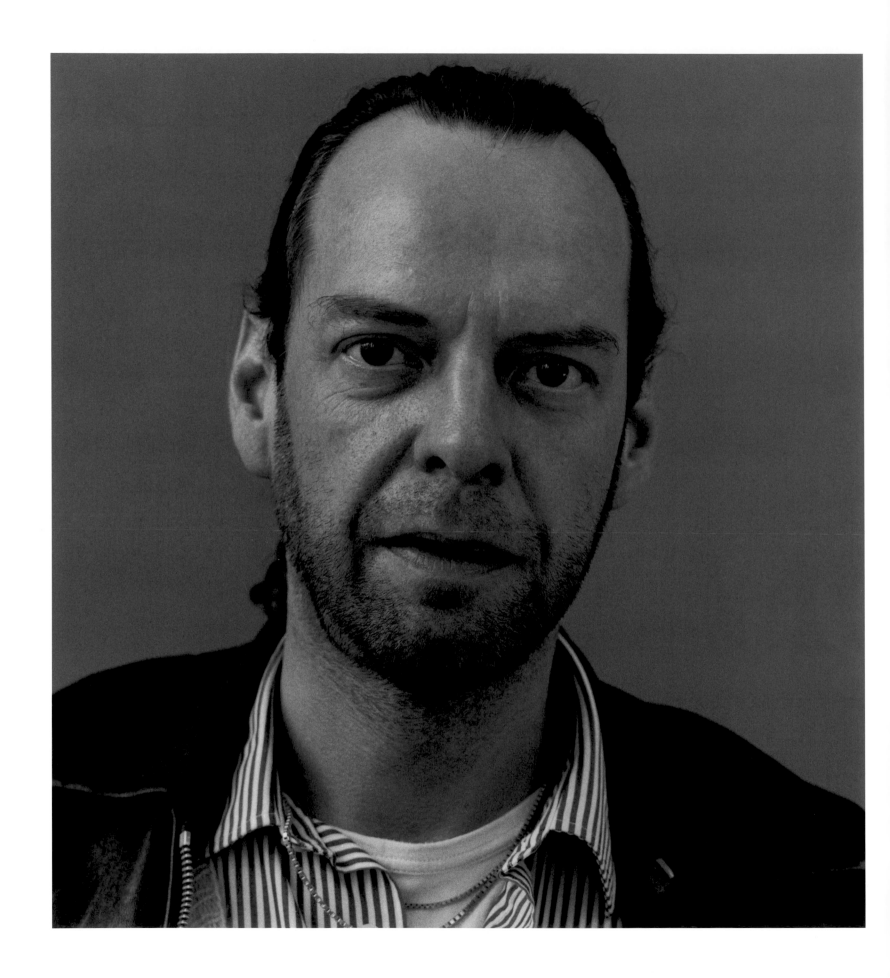

Josy Kraft, 1989

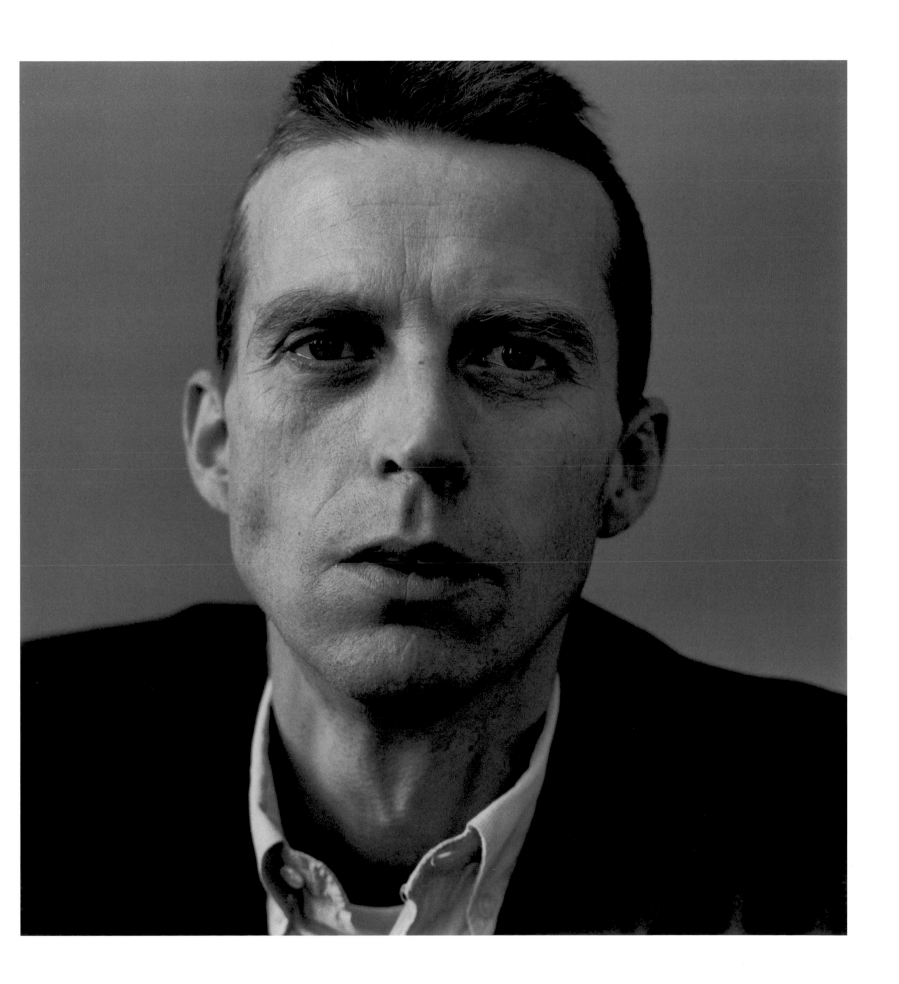

Christian Lindow, 1989

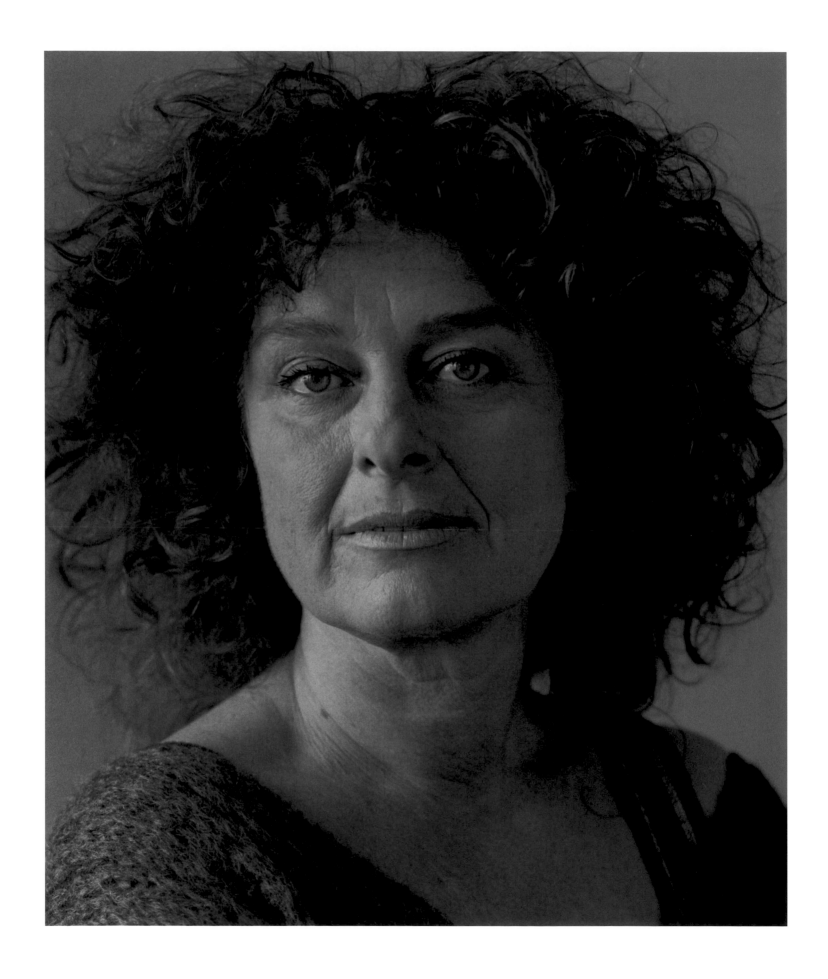

Ingeborg Lüscher, 1989

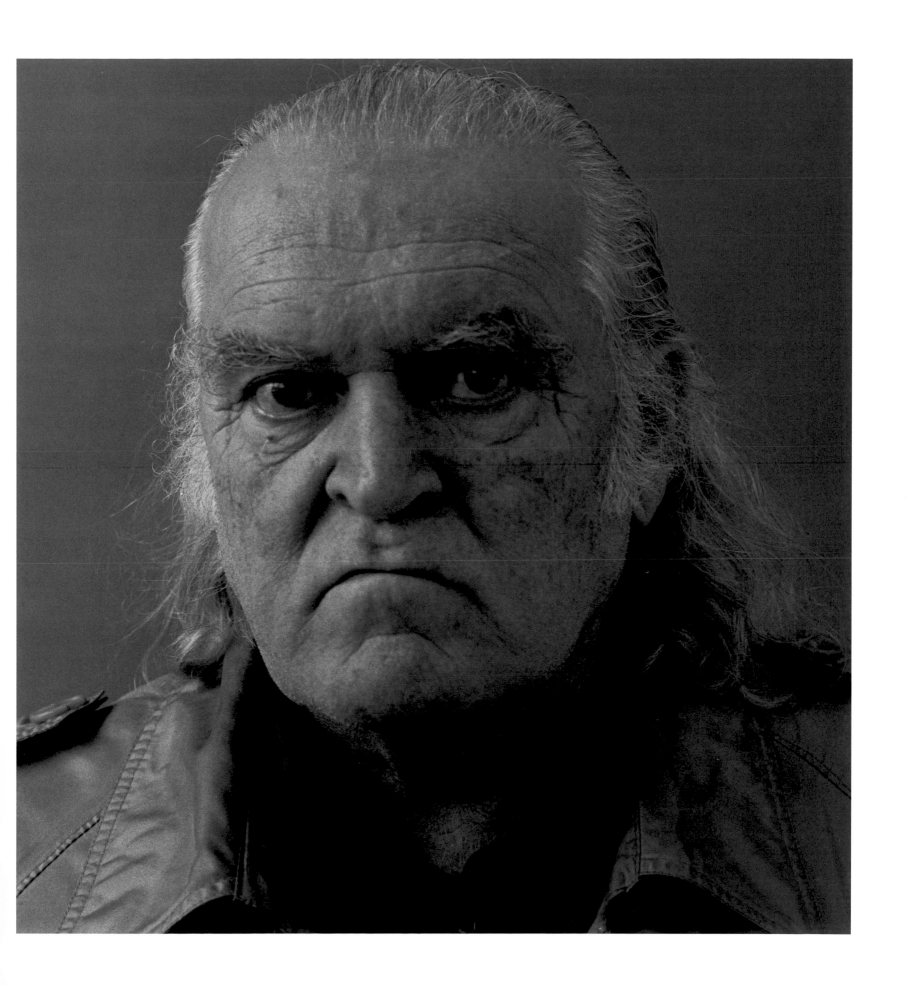

Mario Merz, 1989

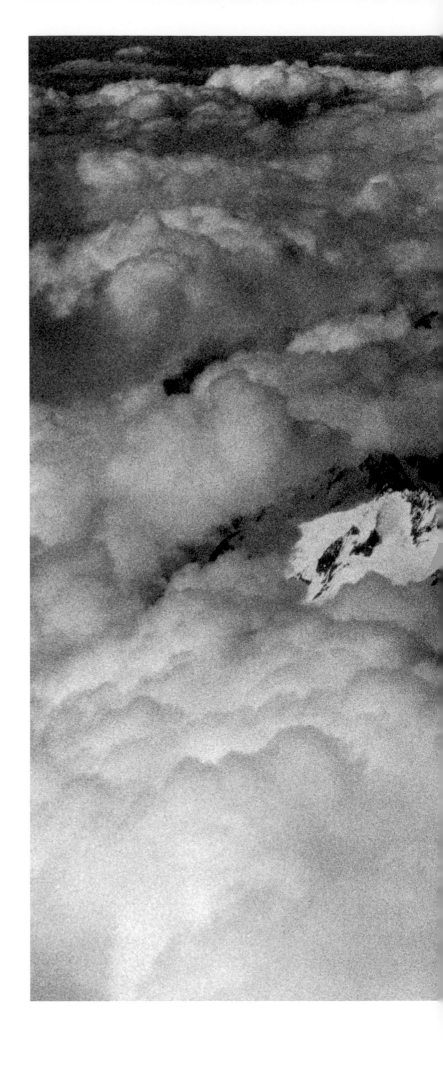

Beginning of the 1990s

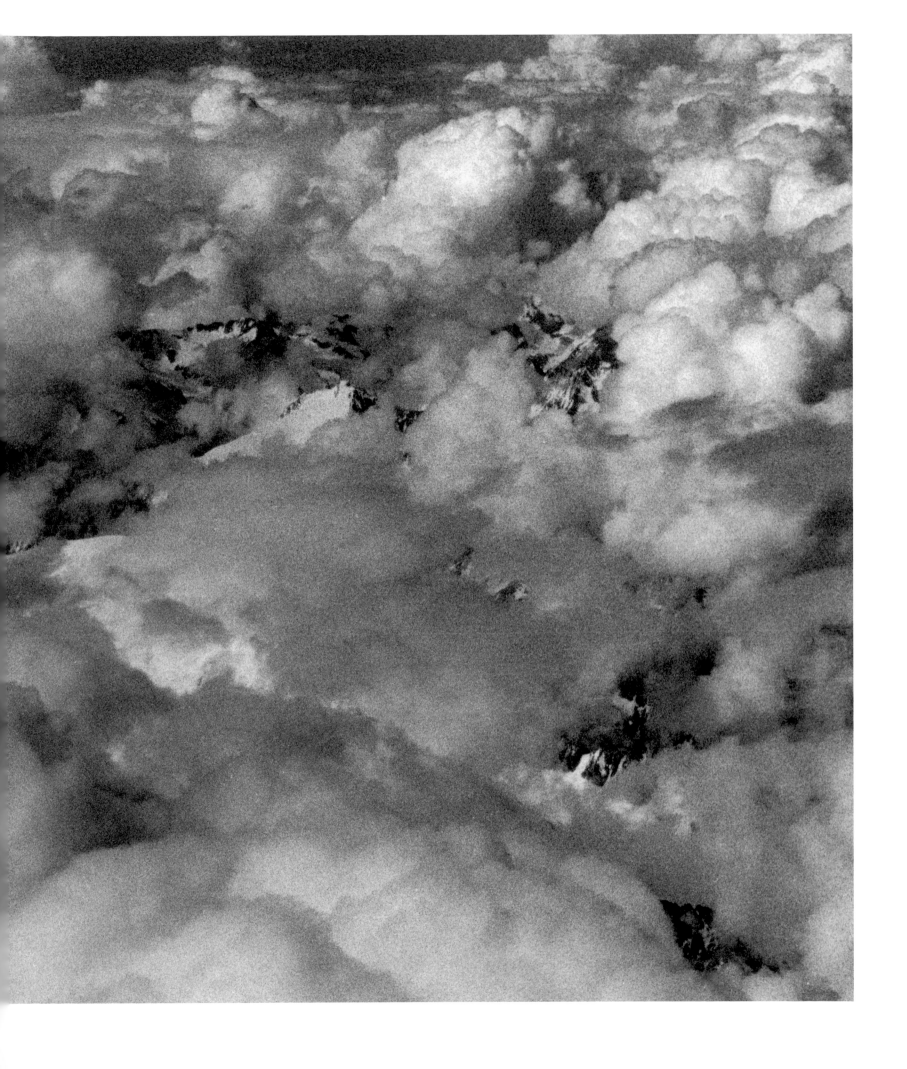

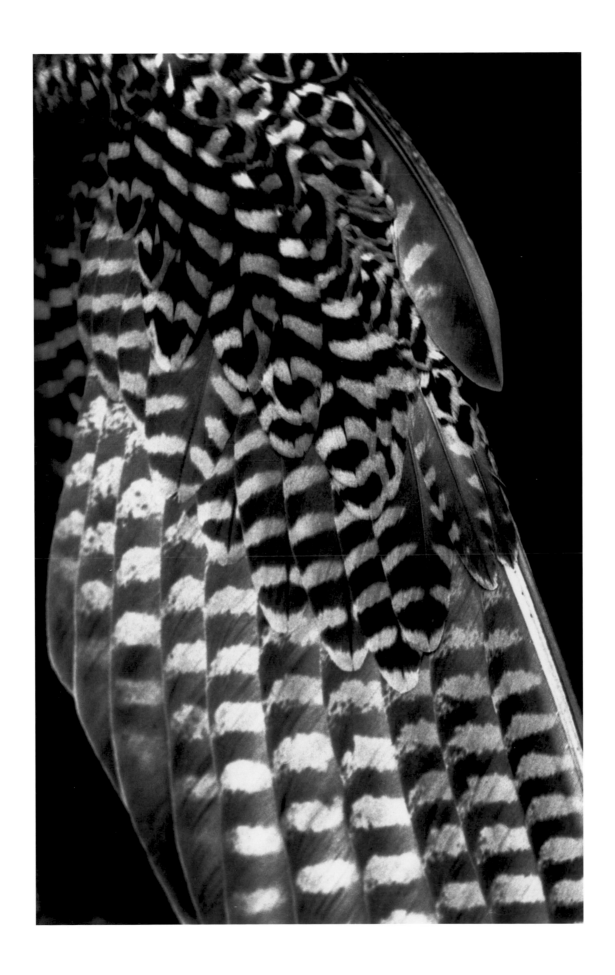

Aile de faucon, 1988

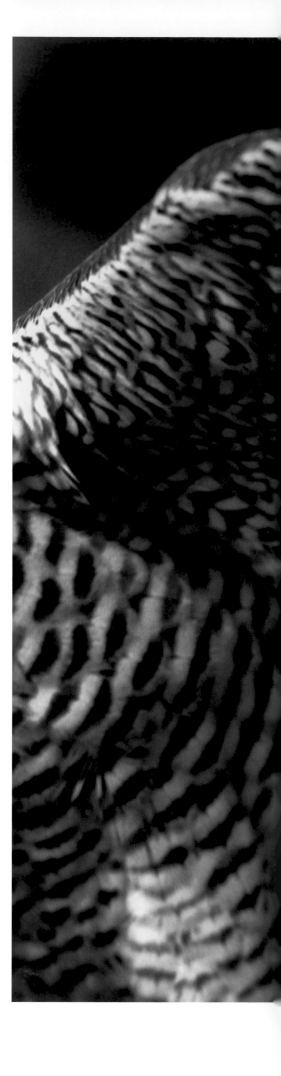

Aile de faucon, 1988

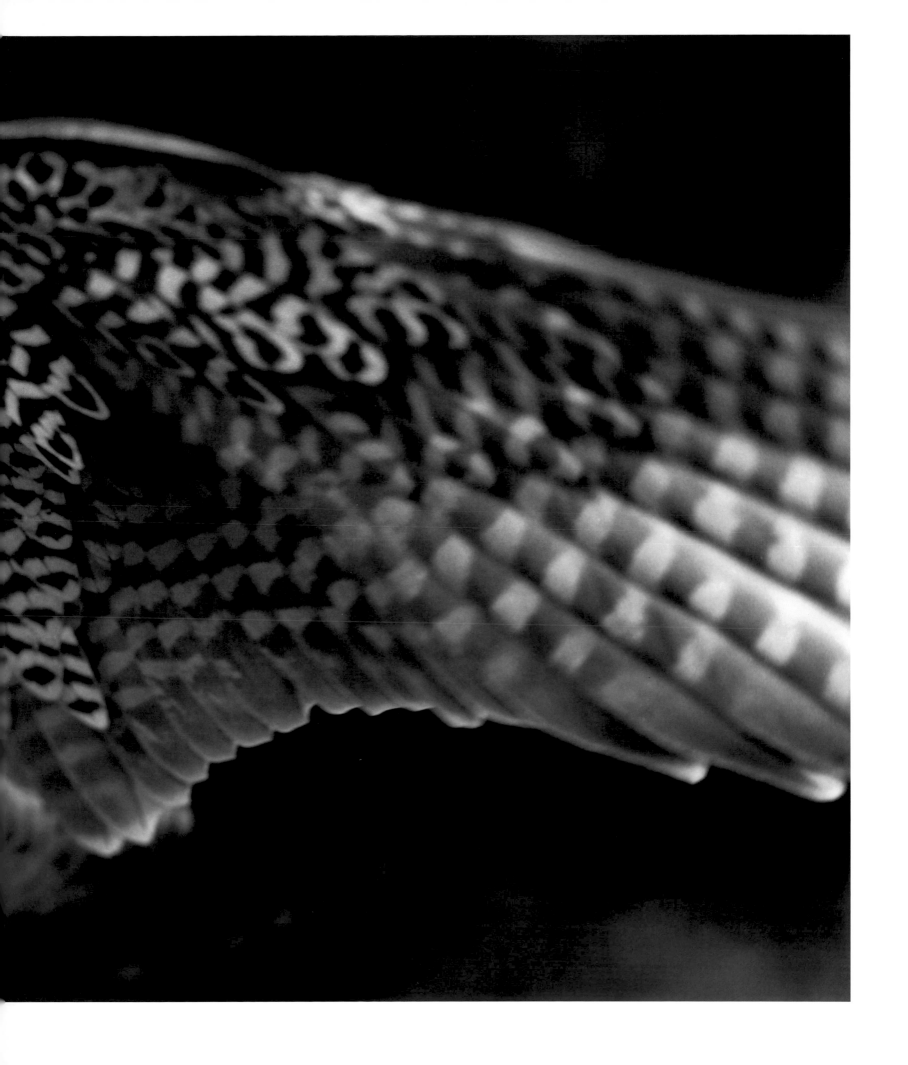

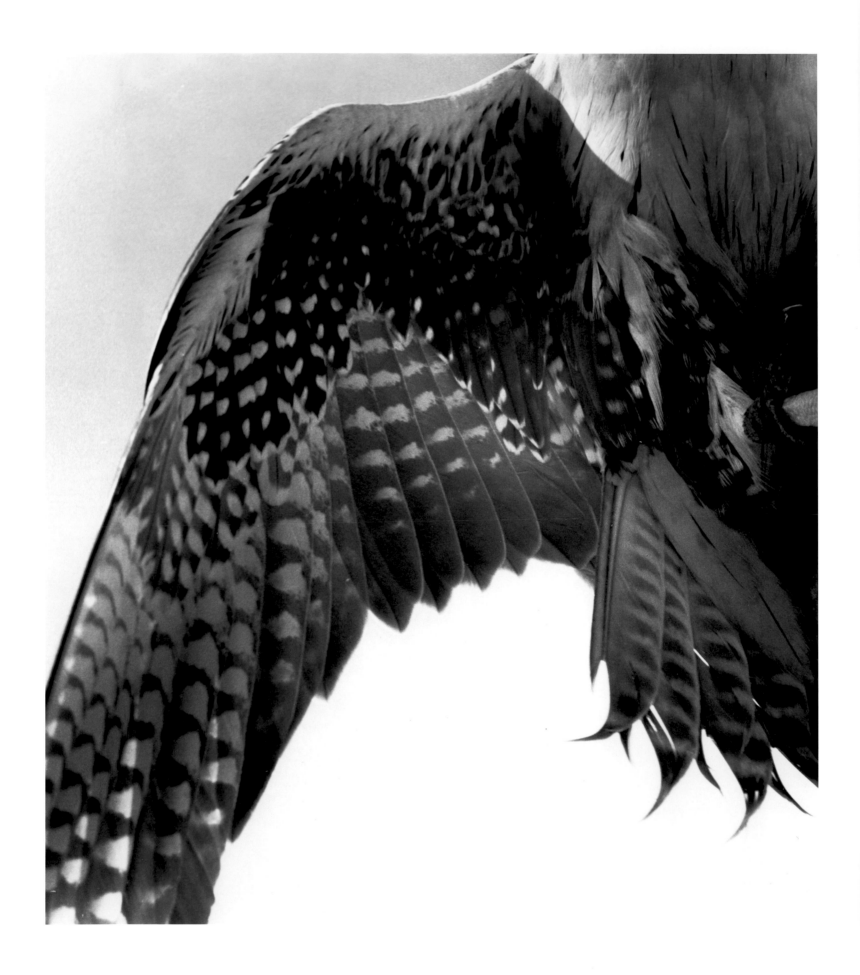

Aile, 1993

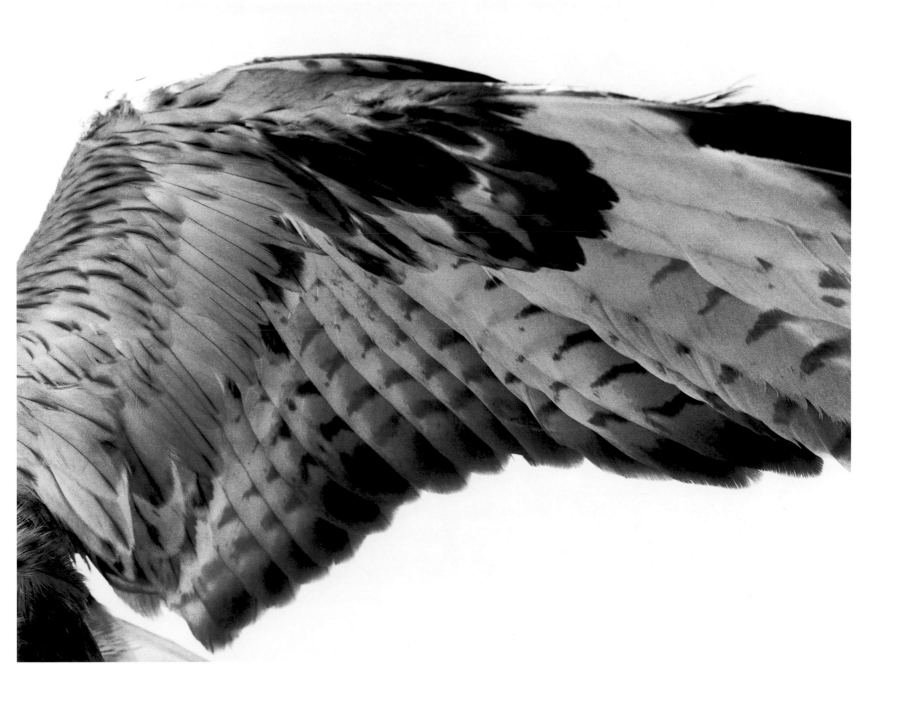

Aile, 1993

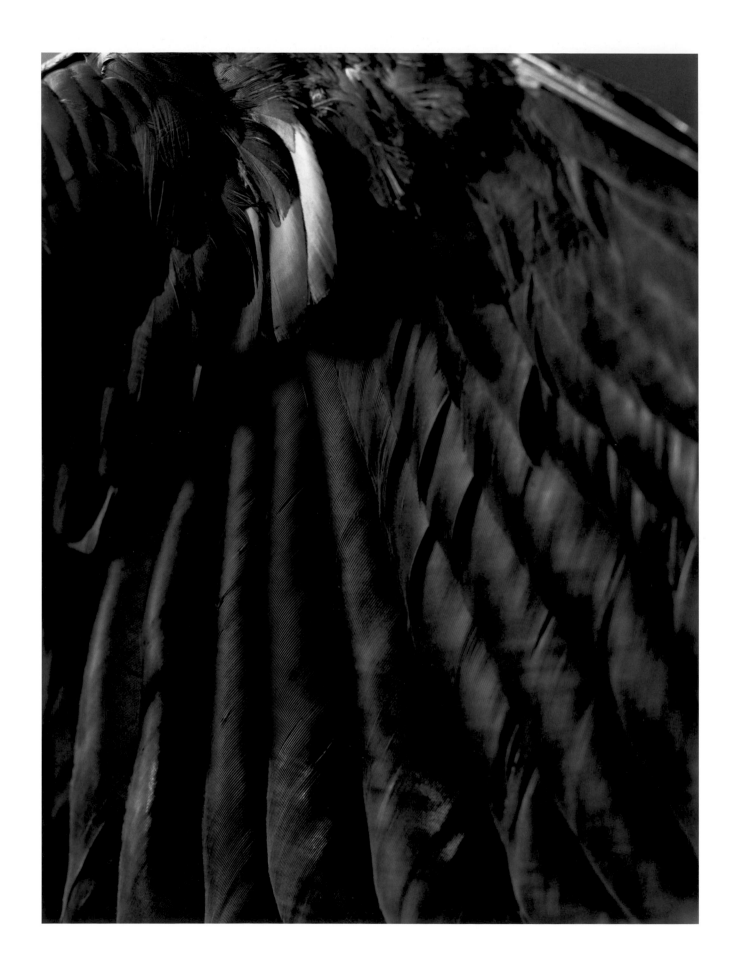

Aile de corbeau, 1988

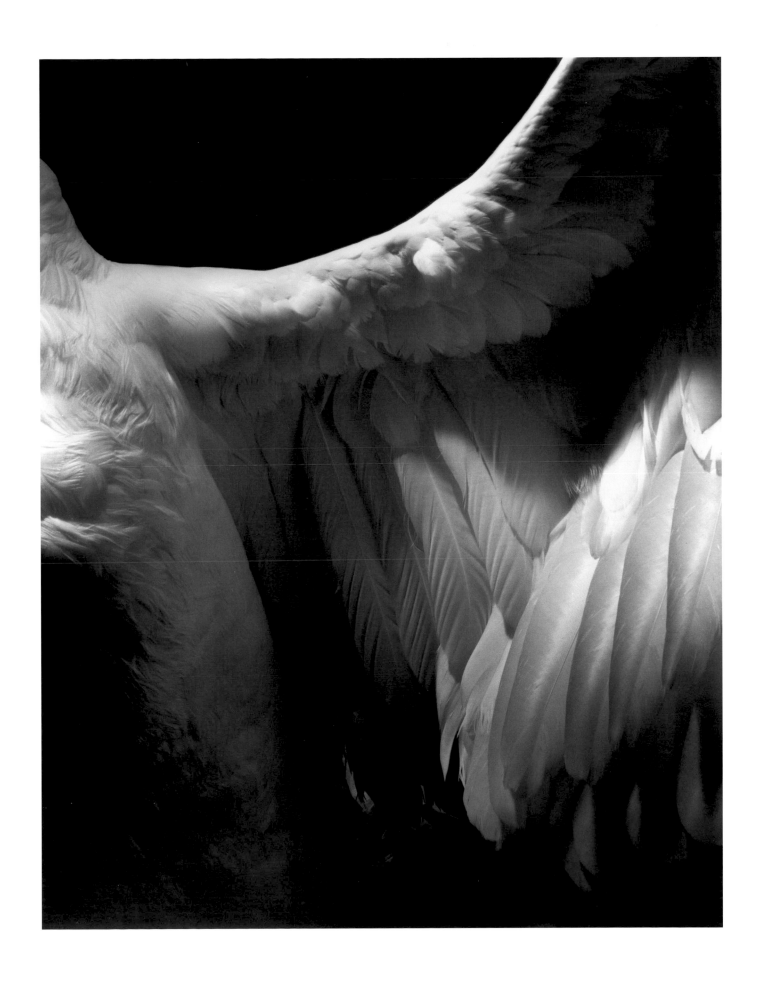

Aile de cygne, 1988

Der Strauss, 1996

Der Pavian, 1996

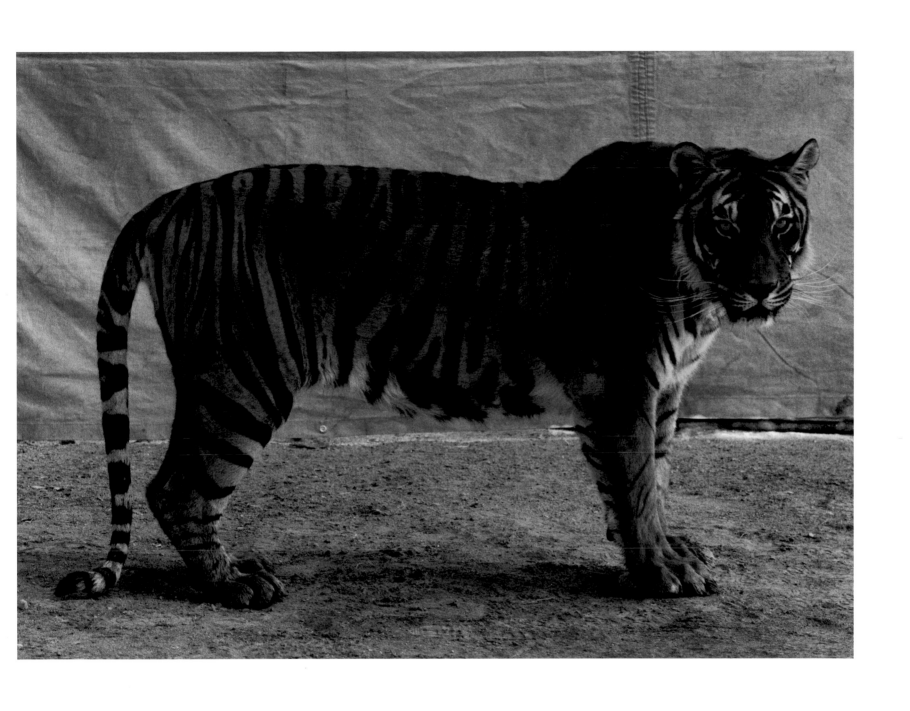

Der Tiger, 1996

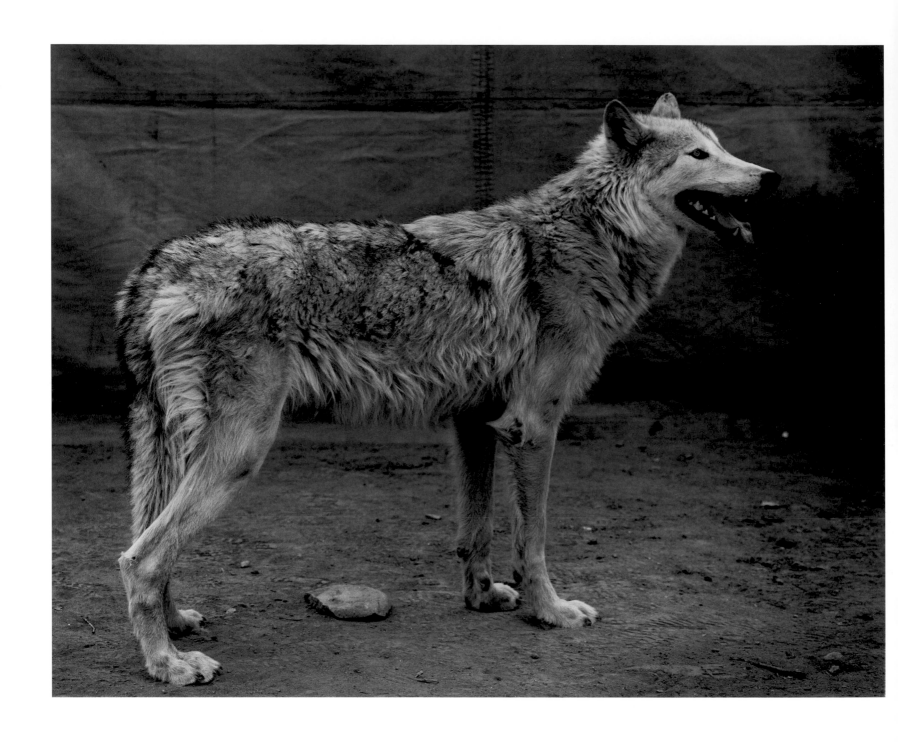

Der Wolf, 1996

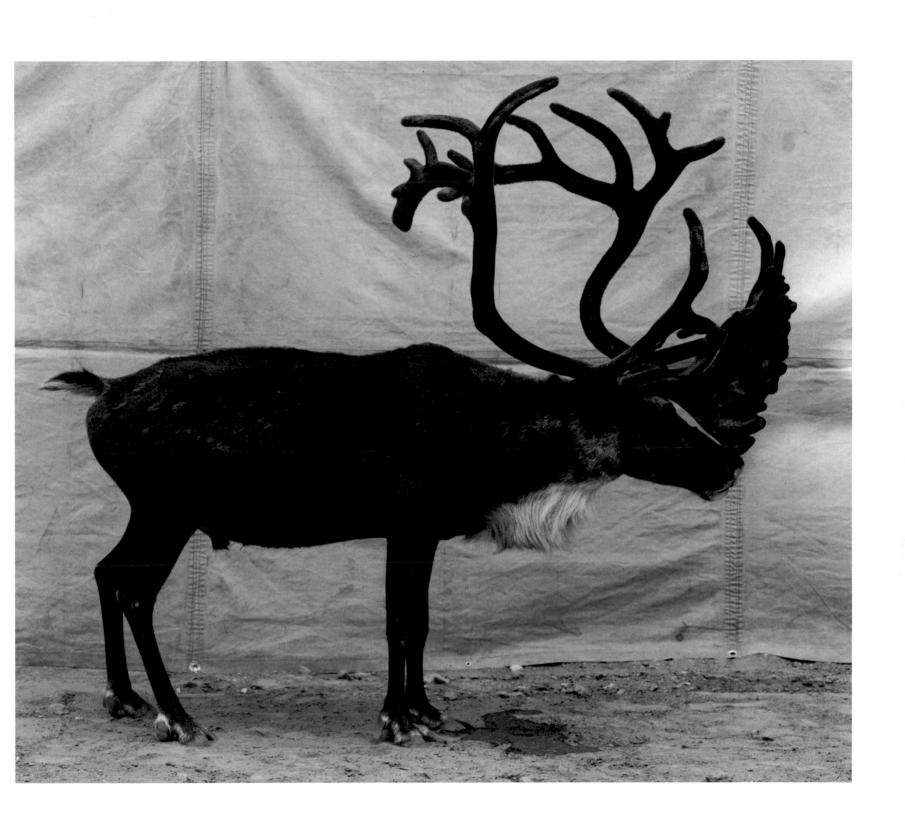

Das Rentier, 1996

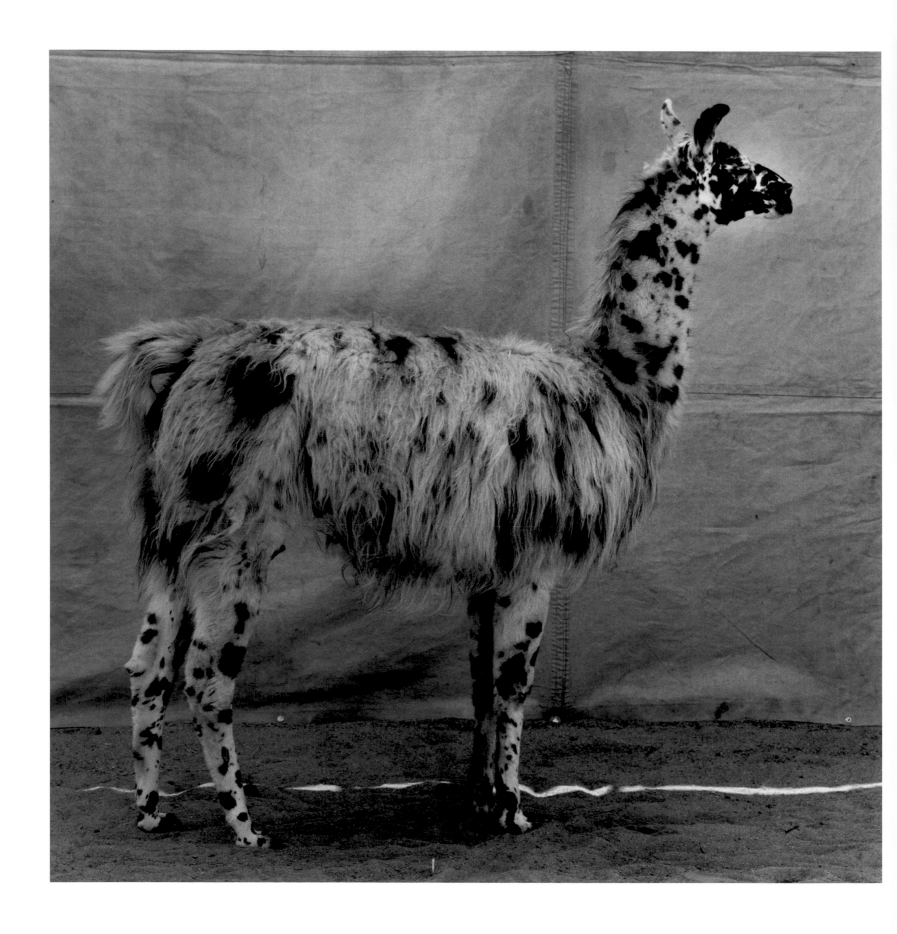

Das Lama, 1996

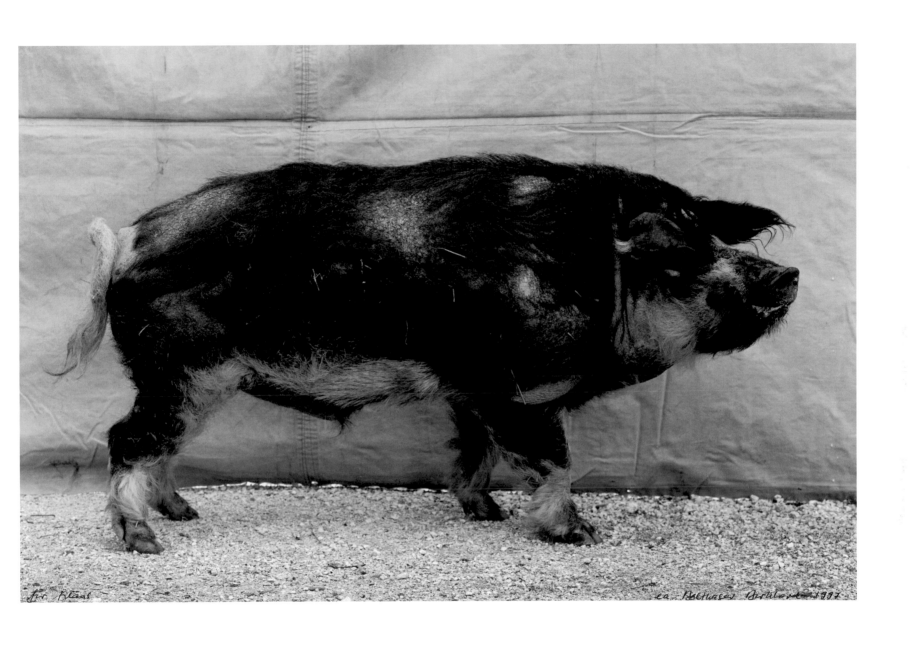

Das Wollschwein, 1997

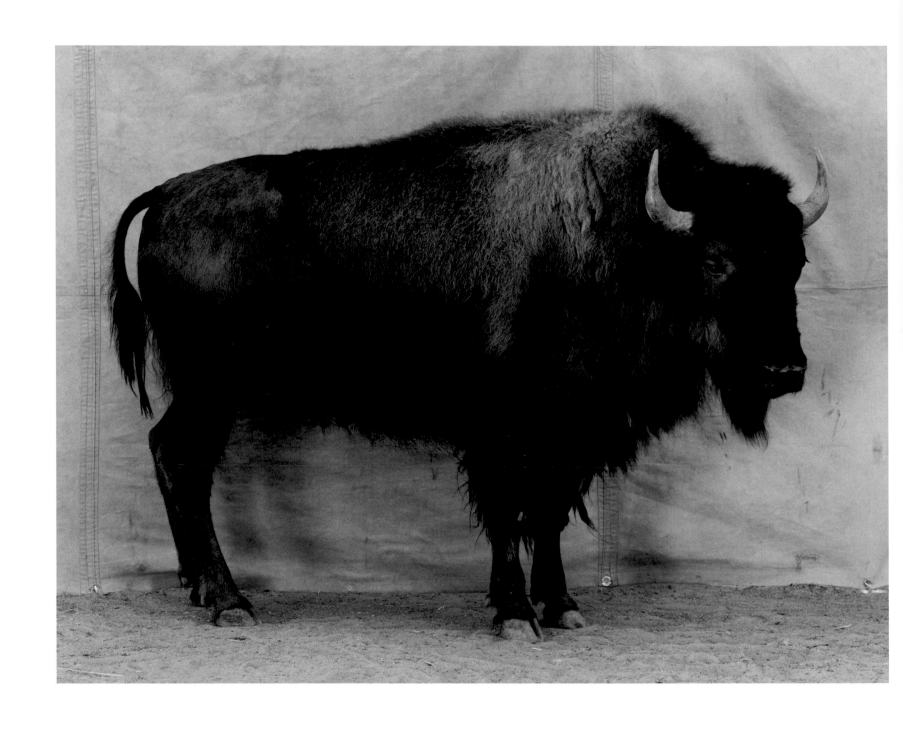

Der Bison, 1996

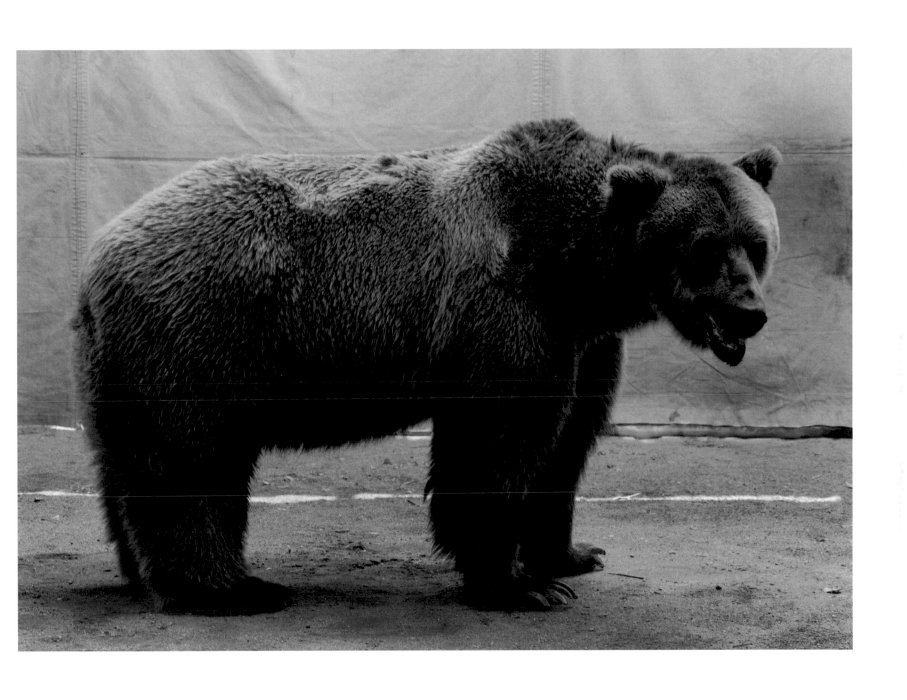

Der Grizzly, 1996

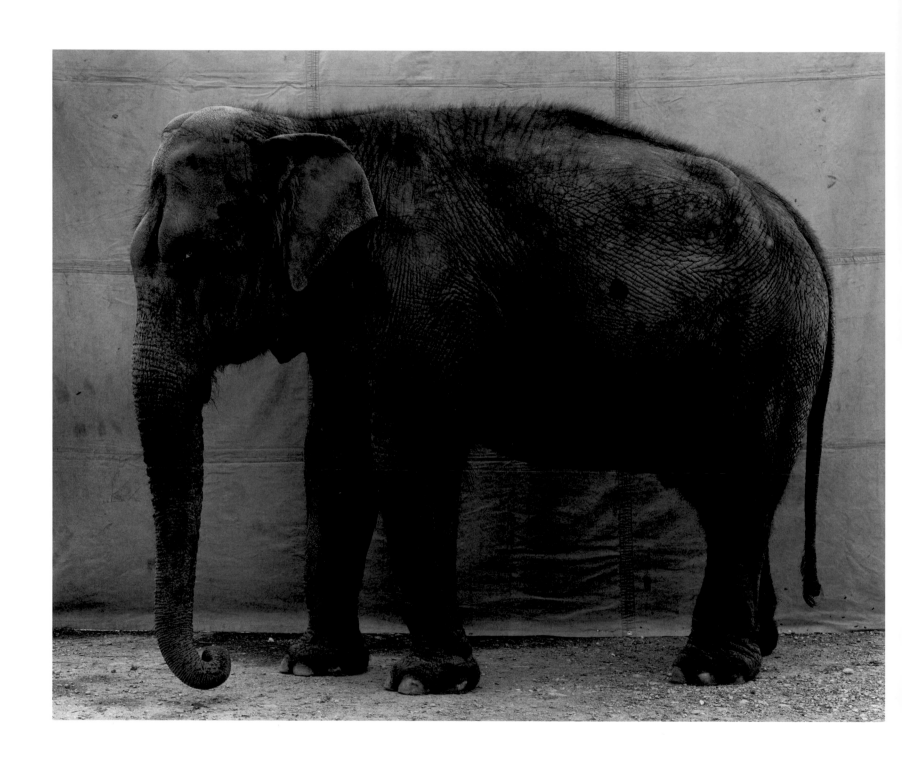

Der Elefant, 1995

Der Büffel, 1996

Der Poitou-Esel, 1995

Das Nashorn, 1995

Das Kamel, 1995

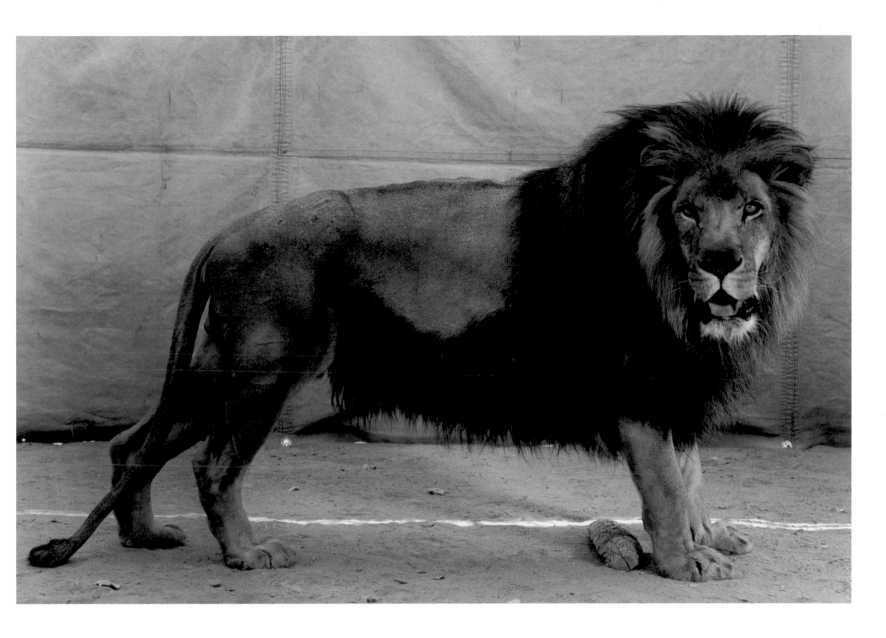

Der Löwe, 1996

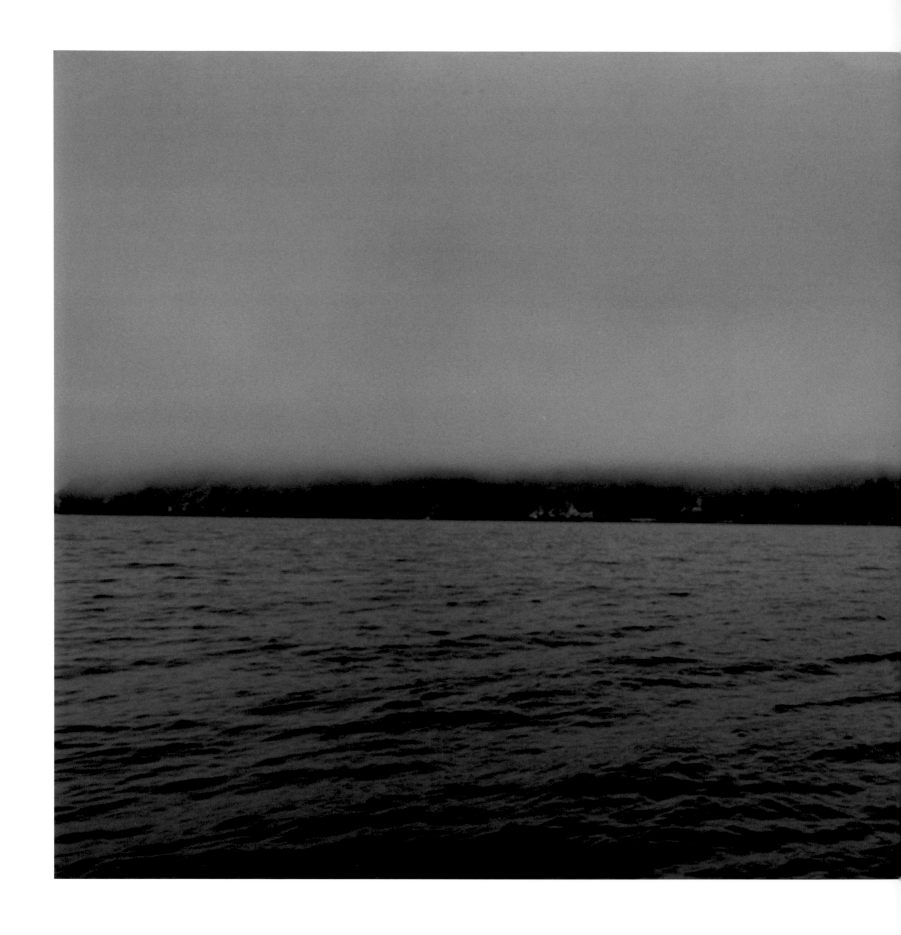

Scotland, 2000

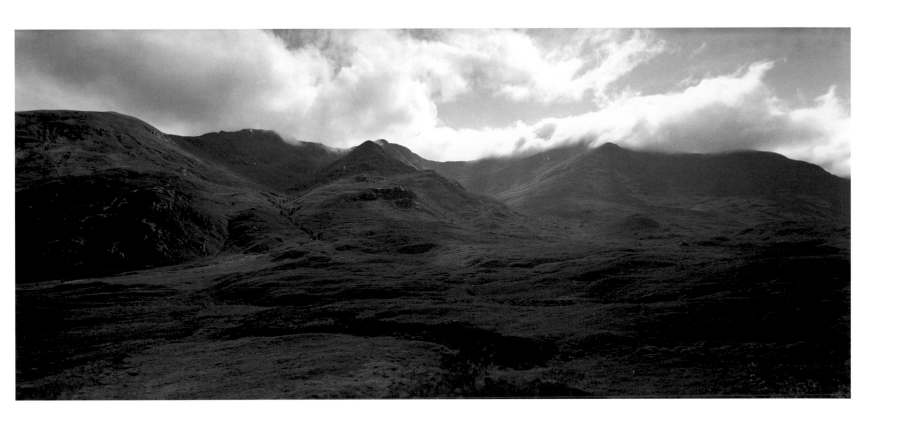

Scotland, 2000

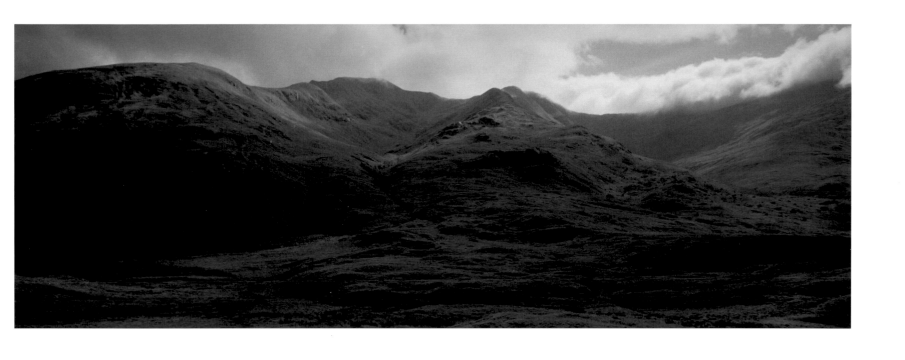

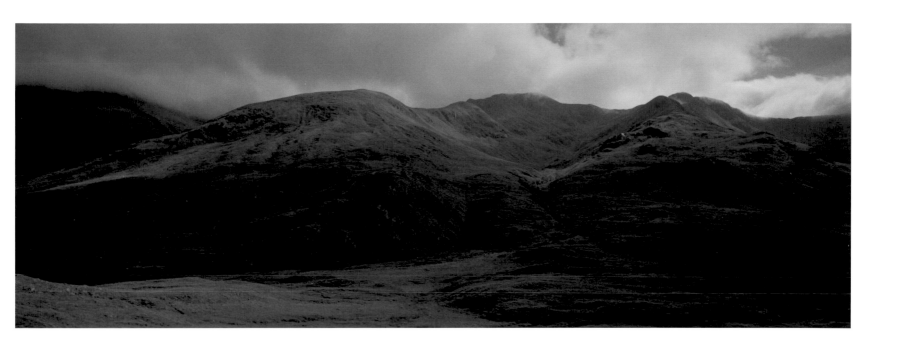

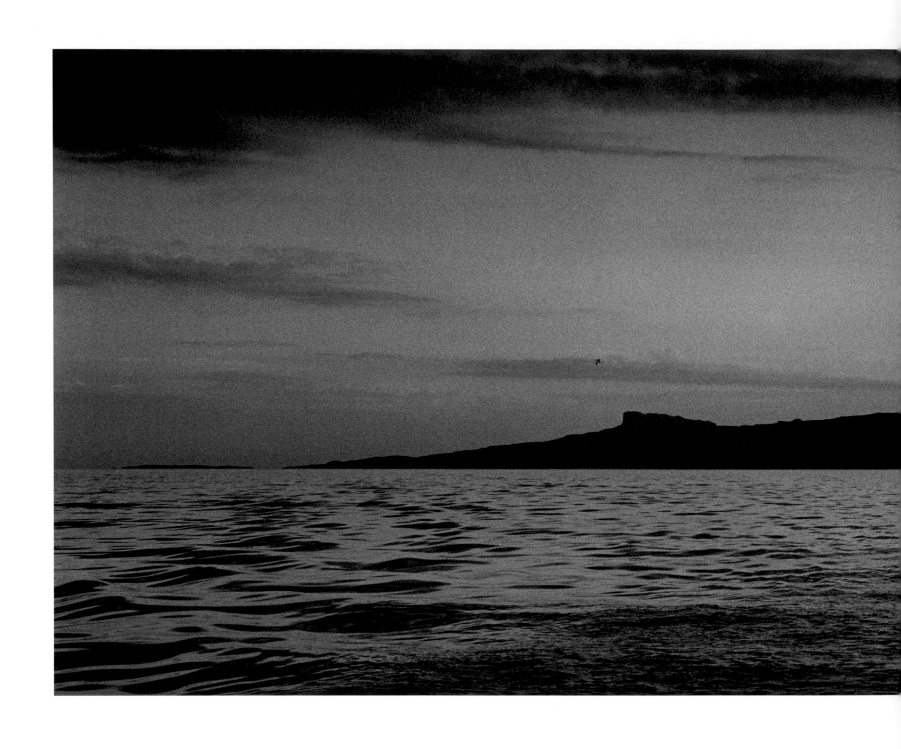

Scotland, 2000

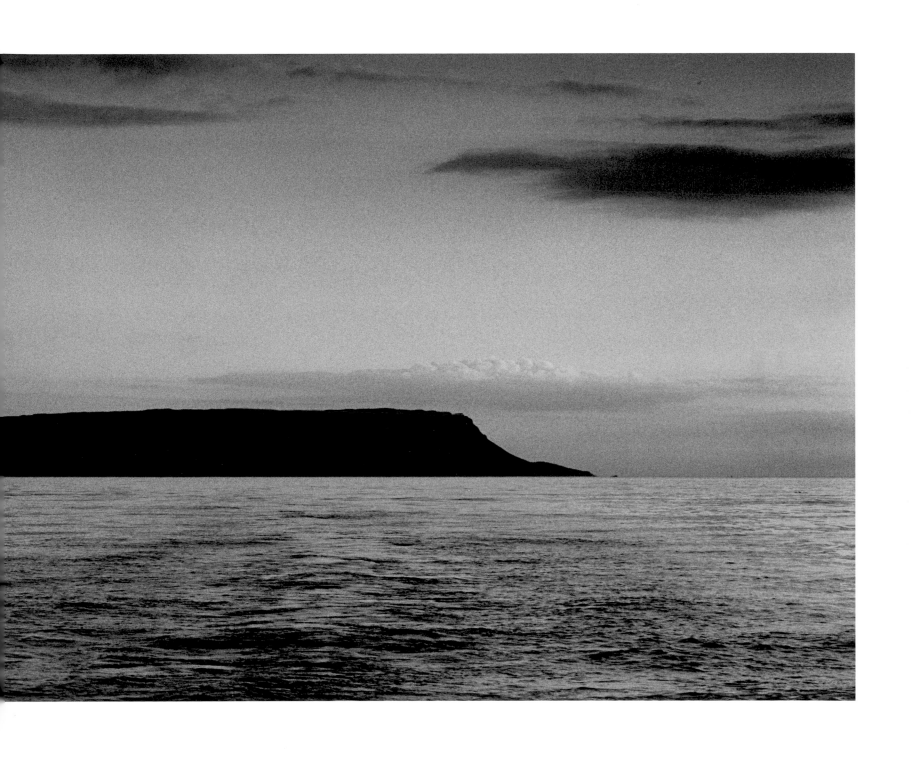

Wallflowers: In 2002 Tobia Bezzola organized an exhibition at the Kunsthaus on the theme of large-format photography with work from Balthasar Burkhard, Jean-Marc Bustamente, Maurizio Cattelan, Peter Fischli and David Weiss, Andreas Gursky, Teresa Hubbard and Alexander Birchler, Beat Streuli, Thomas Struth, Jeff Wall, and Jane and Louise Wilson among others. Burkhard was the only black and white photographer in the exhibition. Although this event does not claim to be exhaustive, it deserves credit for convincingly making the phenomenon of "large-format photography" a theme. In comparison to the giants and internationally-celebrated of large-format photography, what is most clear is above all Burkhard's pioneering role and absolute independence. Burkhard produced large-format photographs on photocanvases and in collage principle before it was even technically possible to produce very large high-quality prints. And he was the first at this survey exhibition to allocate photography the original role of mural painting, not as "adversary" but rather as the "younger sister of painting" to face "the real space of its architectural surroundings." Bezzola characterized the epochal developmental step in the history of photography as such, "Only at the close of the twentieth century can photography first face the central problem of integrating two-dimensional image architecture in the totality of real space."[31] Flipping through the catalogue one could come to the conclusion that Burkhard is, at this point in time, already a step further. In the eighties he had already integrated photography in space with his installations in the Kunsthalle Basel and the Musée Rath. Having explored the landscape from a helicopter in the nineties, the installative crossing of illusionistic image and real architecture was for him no longer the primary problem. Now he claims for himself what is for photography the most demanding presentation of theme within the genre of landscape painting: the "world view" panorama that Pieter Brueghel the Elder introduced to art history. Experiencing the view from above that Brueghel could have only imagined freed Burkhard also in conventional camera situations to a new visionary attitude vis-à-vis motifs. In contrast to some of his successors he (thanks to his austere reduction to black and white tones) never lapsed into blow-up kitsch postcard images.

World views – the cities: Harald Szeemann's Venice Biennale in 1999 postulated a shift of emphasis in art, "The twentieth century was an American one, the twenty-first will be Chinese."[32] For the first time was it shown with such clarity that contemporary artists in China often working in secret had developed new themes, techniques, and forms of expression. Burkhard was one who could follow the Chinese awakening with his monumental city photos. The mountain images taken from a helicopter were requisite for the city photos. What bored him (and thus never became a theme) is the direct view of the ground from above; what Nadar practiced with his flights in a hot air balloon over Paris and later the Swiss photographer Spelterini over Cairo. Burkhard on the contrary lets the eye wander exploring the space of endlessly stretching planes – as Brueghel did in his imagination. And another similarity is that Burkhard's camera and Brueghel's imagination both see differently than the human eye. Burkhard's city photos and Brueghel's view of the world clearly mirror everything within the field of vision, while the human eye is only capable of taking in a section of the sheer endlessness in focus. Naturally, Brueghel's and Burkhard's worlds are completely different, but not in the principle of the floating and roaming that might be commensurate with a seagull's field of vision. Brueghel's imagined view of the world and Burkhard's adaptation of a seagull's perception touch on each other. Burkhard excludes judgment, as Brueghel reproduced the world view that in his opinion the divine eye offered from above. Burkhard does not direct the gaze toward Third World slums or trash heaps, nor do destroyed landscapes or bleak industrial facilities come to the foreground.

Burkhard does not accuse, nor does he take sides in justifiably reprehensible circumstances. Arguably therefore Okwui Enwezor did not invite him to his Documenta 11 dedicated to global change. The city photographs however are not simply impressionistic pictures of atmosphere. Birds maintain their orientation using topographic features. Exactly in this way are the large, structure-producing lines visible in Burkhard's city and desert images. In the city photos the brutally straight streets of housing seem to continue endlessly into the haze. Black and white, these pictures are bereft of any joy. They seem foreign in spite of being recognizable; nocturnal and lugubrious in spite of the brightness. Feelings of doom spread. No artist has ever taken photographs like this from a helicopter before Burkhard. He dealt with mega-cities Mexico City, Los Angeles, and Tokyo systematically. In the photographs of these three cities the view from the helicopter through smog, haze, fog, and smoke becomes a vision of disorientation like in the earlier images of the Alps. In the photographs of Paris, London, Chicago, Tokyo, Helsinki, and Naples Burkhard selects tighter details that permit orientation; the architecture appearing here as a structure-creating element. In Mexico City and Los Angeles the architecture can only be discerned as nothing more than a scurfy pattern.

World views – the desert of Namibia: Burkhard says he is interested in morphology; in cities the relationship between structure-creating lines and amorphous seas of housing. Burkhard is a commuter always moving between extremes: from Berne to Chicago, from the atelier to the mountains, from friends to animals, and from the urban wasteland to the empty expanse of the "real" desert. He is flown by helicopter to the desert of Namibia. The crests and ridges are razor sharp, perfect beautiful lines; the flanks of the dunes modeled by the wind exhibit no traces of appropriation by man or animal. The formative powers of nature confront here no disruptive factors. Nature appears in its primordial state, something that later stimulated Burkhard to search for analogous conditions in other parts of the world. The world view perspective, but in the desert Burkhard is not interested in the sky. At low altitude the gaze falls in an extreme slope onto the dunes so that only a narrow band of sky remains visible over the horizon. Burkhard took photographs when the sun was low. The ridges of the dunes split the remaining sunlight into an exposed and deeply shadowed side. The gently sloping flanks of the dunes, the waves, inclines, and hollows of the desert landscape are reminiscent of Burkhard's large nudes. Had he objectified the body and thus accentuated its architecture, the "organic" formation of sand constructions created by the wind in intimacy-producing light would in this way undergo an anthropomorphization. The desert as realm of Shades eludes human malleability like the clouds in the expanse of sky that Burkhard photographed later in the mountains. Deserts and clouds move according to their own laws. When he returned, the ridges were no longer the same, everything had shifted. The desert, like Burkhard's large nude, merely laid down again. The theme of the desert pictures is in effect this elementary force of self-determination.

Magical places of nature: Scotland, primeval forests, gigantic trees in the Klöntal, Col de la Croix as well as the Bernina Glacier are places of magical primitiveness and permanent mutation. Burkhard's central concern in his current examination of nature is to make its laws of permanent change visible in static form: "Instead of fixating on the special something in the photo, the viewer is referred to the universal that lies behind phenomena. A moment is not captured, rather a condition is created and presented. (...) The photographs draw a line, actually mark a point in time from which other perspectives can arise; only because the artist looks for positions for his photographs that are not occupied, that are empty, do they remain free of connotations, whether of banal tourist or art-historically transfigured manner."[33] The city and desert photographs are taken from some nowhere place in the sky that the camera shares with a seagull. Just as it is

little possible to draw conclusions about the position of the artist, whether photographing the Bernina Glacier crevasse, dolphins off Scotland's coast, tropical giants in the still waters of the Rio Negro, or opposite the formidable branches of a sycamore in the Klöntal. Burkhard opens windows without our knowing where they are to be found. The observer is thus always much more in the picture than in front of it, because Burkhard categorically omits a foreground. One is in the picture like in a dream, a pulling effect exerted through oblique perspective and black holes.

When Burkhard opens spaces of eternal primitiveness in his most recent landscape photographs he shows places that, though permanently changing, are always as they were and as they always will be. In this way he is anything other than nostalgic or an environmental activist. He does not look for the origin, because it hardly ever appears. Instead he makes us conscious that it is there, but that we do not recognize it as such when we are in the same place as he is. Nature's inherent energy is concentrated in the deliberately selected and thus composed detail: in extreme wide format the leaping dolphins become expressions of freedom that contrast with the motionlessness of the tame animals free of any moral judgment. The treeless hilltops or the view of the coast almost completely concealed by fog always bring to mind their pendants: the apparition of cities, deserts, and the space of clouds equally determined by light and shadow. Burkhard is not a moralist – he shows the world as it is, because only when we accept it as it is, will it also really become visible. To visualize the laws of nature, he must shut out all distractions. The picture must not be narrative; "false" associations should be eliminated. Burkhard accomplishes this through the visualization of immanent structures, through which the picture gains autonomy. Tobia Bezzola pointed out this occurrence with clarity on the basis of Burkhard's Rio Negro, "The effect of the forest mirrored in the dark water of the Rio Negro suddenly relieves the picture from all that is narrative and psychological. The glassy symmetrical doubling arouses multiple labyrinthine organic lines, the curves, twists, and elongations of bleached branches and tree trunks, the fine shading and impalpable nuances of foliage to its own ornamental life. Admittedly modeling of the ornamental whole remains bound by perspectival photographic space. The question of portrayal, top and bottom, background and foreground is stilled by the general effect of the autonomous photographic image."[34] Burkhard follows this path to the autonomous photographic image time and again. Whether a photograph of an ancient sycamore in the Klöntal or a snowed-in farmstead on the Col de la Croix – like Hodler he always makes the step from arbitrary phenomenon to compellingly valid art form in his pictures.

Chicago 2004: How something is created communicates information about the result. It should be kept in mind that that is not always obvious, for especially in photography the image reflects reality plainly and in clear outline. The newest photos in this book, which curve back to Burkhard's beginnings, were taken between February 16-25, 2004 in Chicago. He came, he saw, he conquered – it did not work like that. Rather, he came, he saw, he waited…not one single photograph, day after day, almost an entire week without any photos. The shaman Joseph Beuys proclaimed that every man is an artist. In a way his utopian prophecy has been fulfilled since almost everyone in the western world is active as photographer or videographer. Never before have so many pictures been produced and consumed as in the present day. But is this uncontrolled flood of newly created images art? In deference to Walter Benjamin the answer to the question is in the negative: no art without aura. The photo industry makes reflections of reality possible – whenever and wherever. When the picture of the specified subject is only "mechanically" reflected, that is in the end the same as listening to a recording of a song composed and performed by someone else: a reproduction released at the press of a button. Art is however more than optical or acoustic reflection. Photographic art is the interpretation of that which it depicts in images. Photography, if meant as art, must also communicate what its creator was thinking, feeling, or

imagining. Complex steps are needed to imbue the image produced by the camera a priori with what Walter Benjamin called "the magical value of photography."[35]

Balthasar Burkhard in Chicago 2004: it was here in his city that he emancipated himself from being a successful Bernese reportage photographer to become a photo artist. He taught in Chicago for several years and returned again and again. In 2004 he went back with his assistant Rafael Buess in order to expand his view of Chicago through another chapter of photos. He knew what he wanted; needed however an enormous amount of time to make his vision and reality agree with each other. The period of waiting was anything other than passive. His relationship to the city is defined by familiarity and strangeness. He moves through the city like one dreaming that he has returned after decades to an earlier scene from life. Everything is still there, is nevertheless foreign. He lets the city make its impression. Distance is maintained. He resists the hectic bustle with his slowness. We drove around the city without an exact destination, seemingly without identifiable system. It would therefore be mistaken to speak of a strategic investigation. More of passive rambling. We drove around until it occurred to me that there were fixed points, that we kept on passing the same streets, that the artist was on to something.

Photography as art leads from the known to the unknown. The artist's image differs from the image that we all see in that it shows something that only he perceived. The photographer in his work might stop, freeze time. Time consists of an infinite row of moments connected together. But eternity is not reflected in everyone. That a photo implies something more, does not simply depict reality, but rather is concentrated in itself, happens very rarely. Every year millions of tourists in Chicago take the same pictures as Balthasar Burkhard: the fissure between skyscrapers from a worm's eye view or the vertiginous perspective from above into the gorges of the streets below. Burkhard already photographed Chicago as part of his city series in 1999. For the new pictures he photographed at dawn and in the first moments of darkness thus depriving the skyline of its clear decisiveness. As was the case in Japan a poetic text on the theme of light and shadow inspired Burkhard in 2004: notes by Hugo Loetscher from 1972 that Burkhard's assistant Buess brought to his attention. Loetscher describes therein the double life of skyscrapers illuminated by the sun during the day appearing completely different at night when the lights go on in their windows.[36] It is exactly this transition, from the illumination of the external form to the light from within dissolving the external shape, that is new in Burkhard's most recent investigation of the theme of shadow and light. He achieves images of unique density that are reminiscent of the night shots of skyscrapers by Steichen and Stieglitz. Andreas Gursky's nighttime detail of the Hong Kong and Shanghai Bank building from 1994 shows a close-up of what is taking place in the building; it turns the observer into a voyeur. Burkhard is completely alien to this way of seeing. He does not want to participate in secretly peering in, revealing, rather he wants distance and objectification. As in all of his landscape and city photographs people are not involved; Burkhard manages to photograph Chicago so that we do not see any people. In these Chicago pictures people play as insignificant a role as in Burkhard's desert, jungle, or on his glacier. The world which he photographs is his world. It exists only because he saw it that way.

1 Diane Arbus, "Five Photographs by Diane Arbus," *Artforum*, May 1971, quoted in *Diane Arbus*. Revelations, exhibition catalogue, Museum of Modern Art, San Francisco, 2003, p. 278.

2 Alan G. Artner, "5 artists who made last 5 years memorable," *Chicago Tribune*, Arts & Fun, 11 June 1978.

3 Donald M. Schwartz, "Beyond the frame. Swiss photographer transfers prints to huge hanging canvas," in *Sun-Times*, 12 June 1977.

4 Gretchen Garner, "Balthasar Burkhard, Photocanvases," *New Art Examiner*, Summer 1977, p. 18.

5 Bathasar Burkhard quoted by Schwartz (see note 3).

6 Robert Frank quoted by Philip Brookman, "Windows on Another Time: Issues of Autobiography," in Sarah Greenough and Philip Brookman, *Robert Frank: Moving Out*, Scalo Verlag, Zurich, 1995, p. 142.

7 As quoted by Greenough, "Fragments that Make a Whole: Meaning in Photographic Sequences," in Greenough/Brookman (see note 6), p. 96.

8 Schwartz (see note 3) names Polanski; Frańcois Grundbacher, "Vor und hinter der Kamera. Balthasar Burkhard – ein Fotograf der existentiellen Leere," in *Prisma. Das Schweizer Monatsmagazin*, September/October 1979, p. 55, also names Lee Marvin.

9 Martin Schaub, "Bilderschrift," in Das Magazin, *Tages-Anzeiger* and *Berner Zeitung*, No. 39, 30 September 1988, p. 17.

10 Susan J. Douglas, "Where the Girls Are: Growing up Female with the Mass Media," Crown Books, 1994, p. 13.

11 Grundbacher (see note 8), p. 52.

12 Henri Cartier-Bresson, "L'imaginaire d'après nature," in *Henri Cartier-Bresson, Die Fotografien*, with a text by Yves Bonnefoy, Munich, 1999, p. 333.

13 Susan Sontag, *On Photography*, Farrar, Straus and Giroux, New York, 1977.

14 Urs Stahel, "Fotografie in der Schweiz," in Urs Stahel/Martin Heller, *Wichtige Bilder*, p. 197.

15 Ulrich Loock, "Fotografische Bilder – monadische Torsi," in *Balthasar Burkhard*, exhibition catalogue, Kunsthaus Zug, 1994, p. 56.

16 Matthias Haldemann, "Poésie – zum Werk von Balthasar Burkhard," in *Balthasar Burkhard*, exhibition catalogue, Kunsthaus Zug, 1994, p. 56.

17 Martin Schaub, "Der Körper I," in *Balthasar Burkhard. Lob des Schattens*, exhibition catalogue, Musée Rath, Geneva, 1997, p. 64.

18 Werner Hofmann, "Courbets Wirklichkeiten," in *Courbet und Deutschland*, exhibition catalogue, Hamburger Kunsthalle, 1978, p. 610.

19 Ibid.

20 Hervé Laurent, "Präzisierende Anmerkungen zu den Wellen," in *Burkhard* (see note 17), p. 56.

21 Paul Strand, "Photography" in *Seven Arts*, Vol. II, No. 10 (August 1917), p. 542, quoted by Wolfgang Kemp, *Theorie der Fotografie II*, 1912–1945, Munich, 1979, p. 59.

22 "Wallflowers" is the title of a 1992 exhibition organized by the Kunsthaus Zürich on large-format photography. *Wallflowers*, exhibition catalogue, Kunsthaus Zürich, 2002.

23 Madeleine Schuppli, "Voyage," in *Balthasar Burkhard*, exhibition catalogue, Kunstmuseum Thun, 2001.

24 Tanizaki Jun'Ichiro, *In Praise of Shadows*, Leete's Island Books, New Haven, 1977.

25 Ibid.

26 Jacqueline Burckhardt, "Geisha," in *Burkhard* (see note 17), p. 30.

27 Tanizaki (see note 24).

28 Annelie Pohlen, "Wirklichkeit anderer Ordnung," in *Thomas Ruff*, exhibition catalogue, Bonner Kunstverein, 1991, p. 11.

29 Claire Stoullig, "Beweisstück," in *Burkhard* (see note 17), p. 66.

30 Ibid.

31 Tobia Bezzola, "Wallflowers," in *Wallflowers* (see note 22), p. 7.

32 Harald Szeemann, quoted by Konrad Tobler, "Biennale Venedig. Ein Ja zur Gegenwartskunst," in the *Berner Zeitung*, 5 June 1999, p. 43.

33 Roland Scotti, "Bildpoetik," in *Balthasar Burkhard*, exhibition catalogue, Kirchner Museum, Davos, 2003.

34 Tobia Bezzola, "Balthasar Burkhard," in *Wallflowers* (see note 22), p. 15.

35 Walter Benjamin, *Kleine Geschichte der Fotografie*, quoted by Wolfgang Kemp, *Theorie der Fotografie II 1912–1945*, p. 202.

36 Hugo Loetscher, "Chicago," in *du*, May 1972, p. 376.

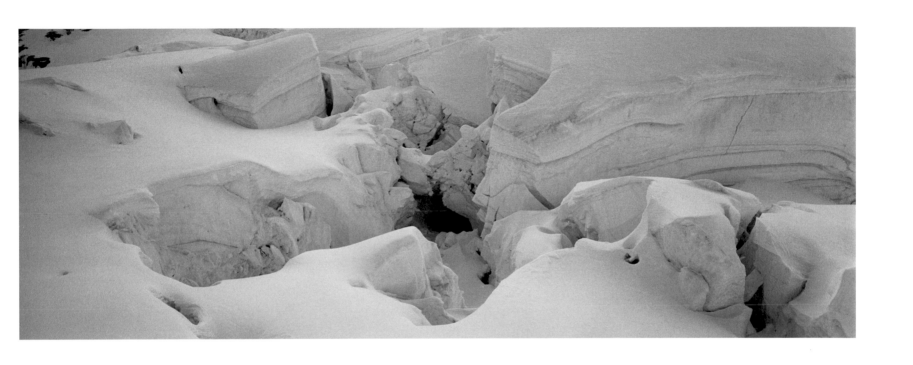

Bernina, 2003

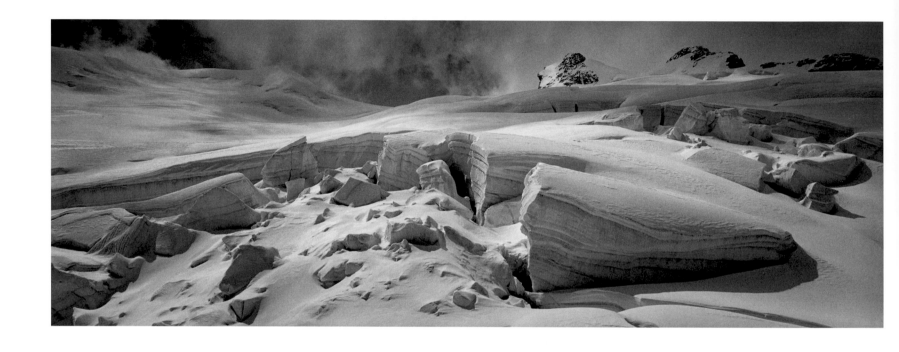

Bernina, 2003

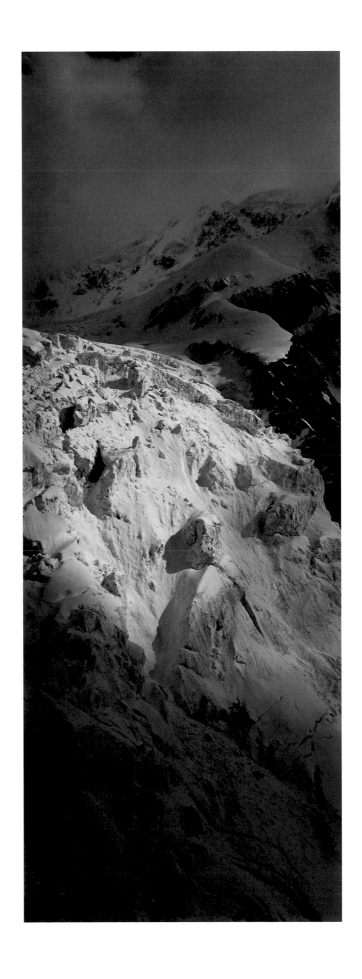

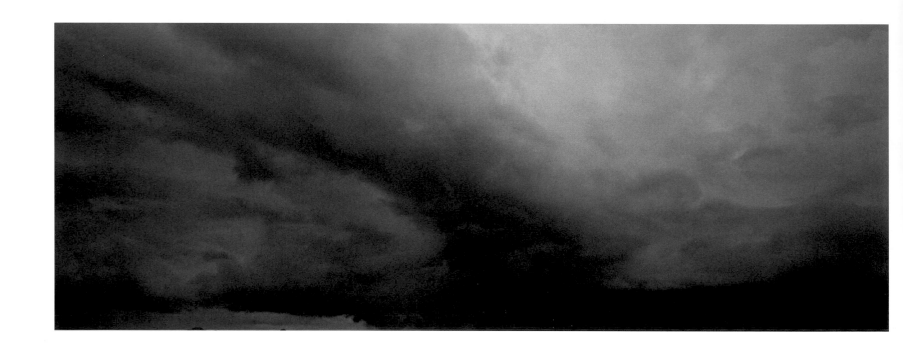

Rio Negro, 2002

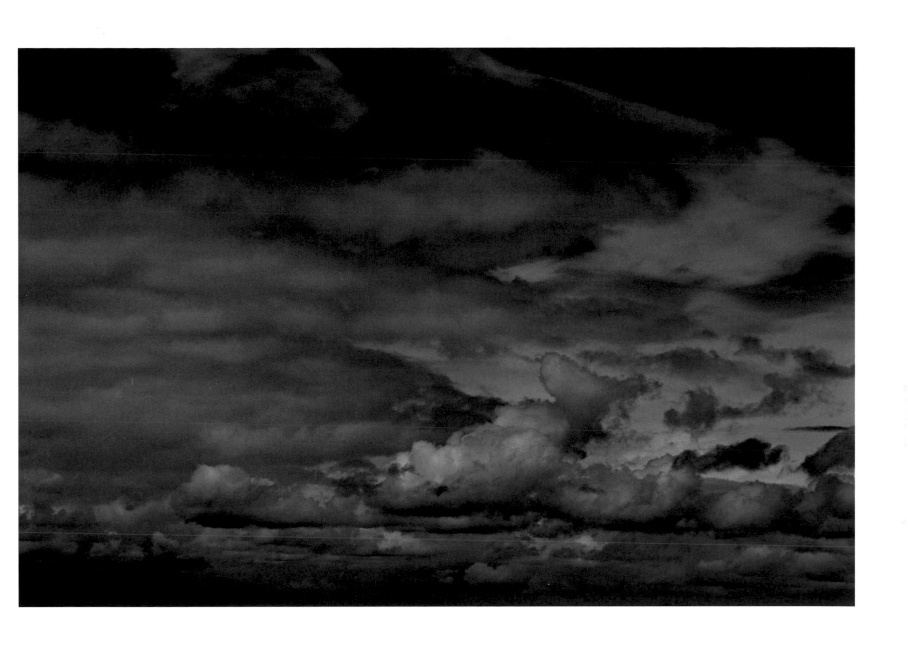

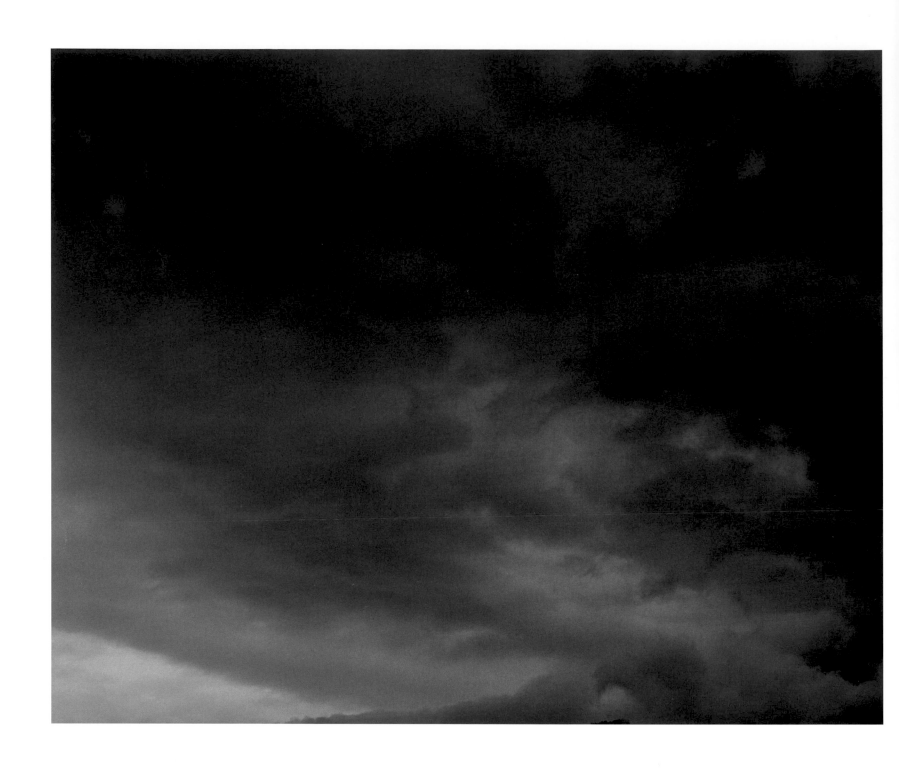

2003

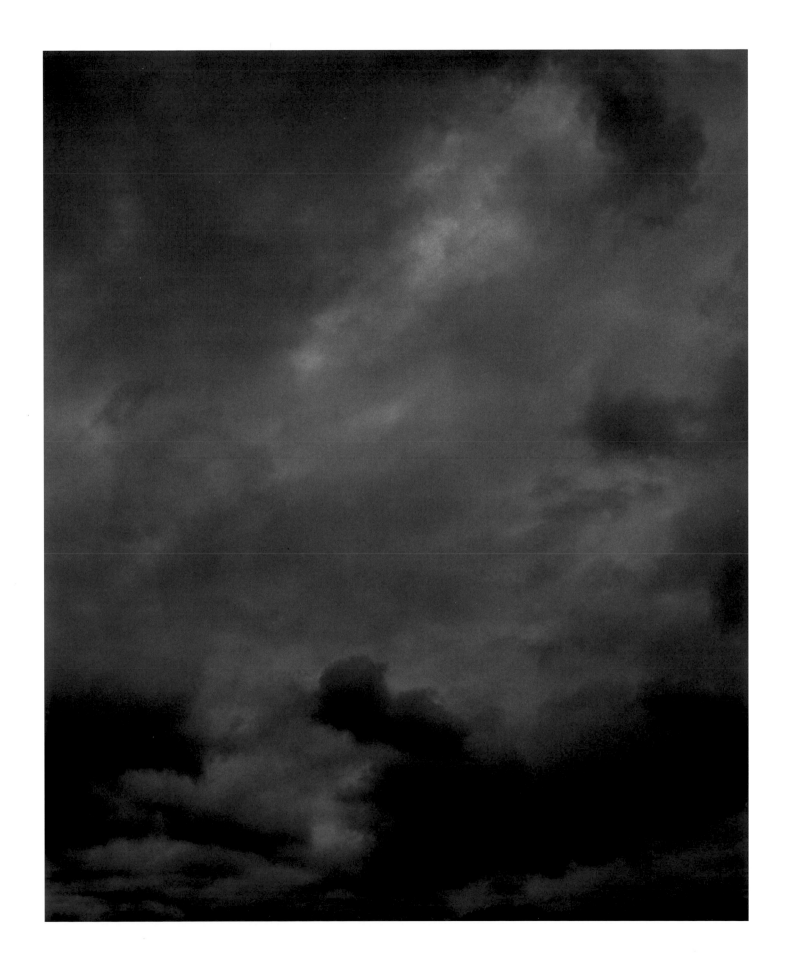

Klöntal, 2002

Klöntal, 2001

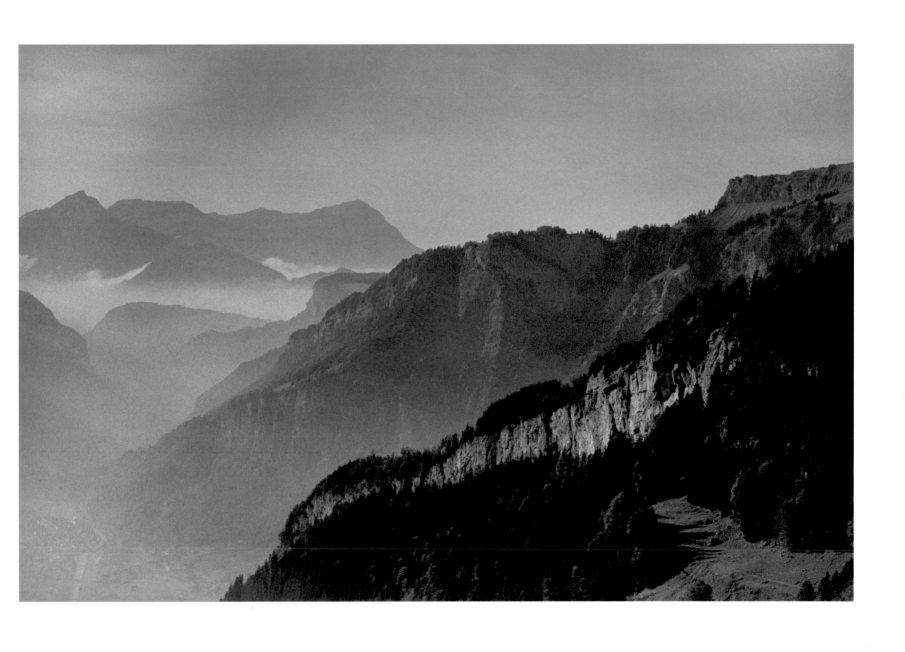

Rio Negro, 2002

Rio Negro, 2002

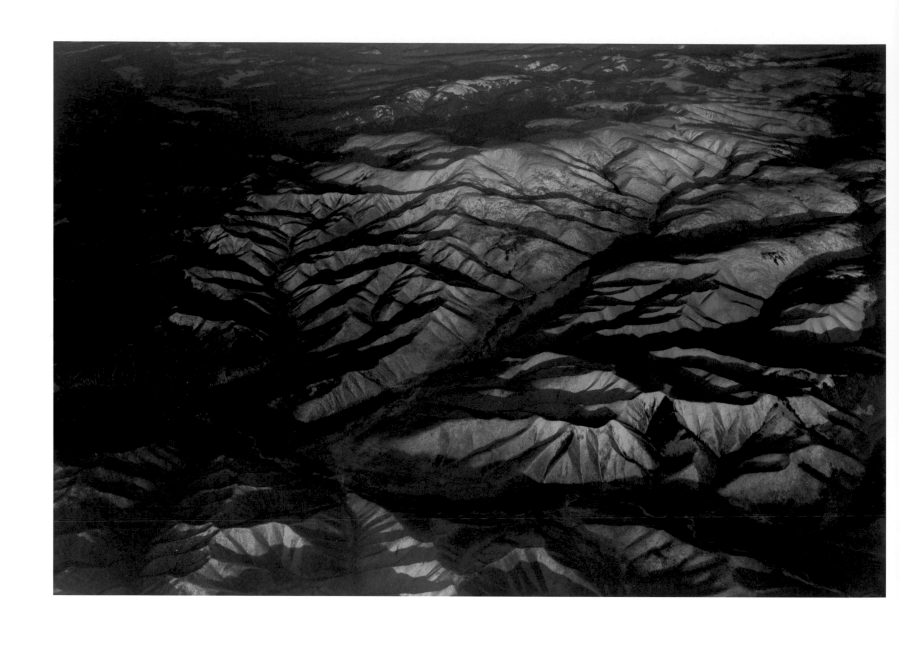

c. 2000

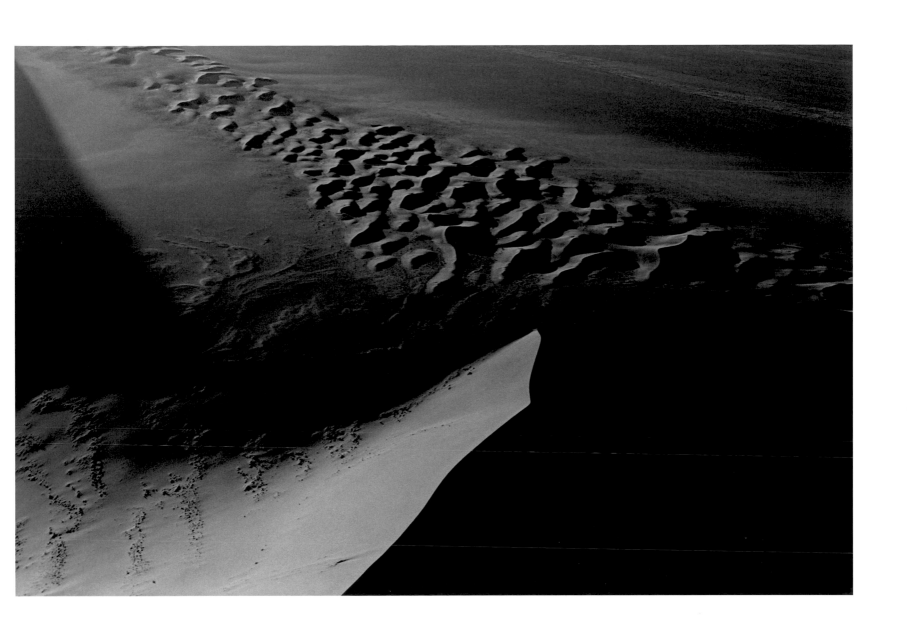

Namib, 2000

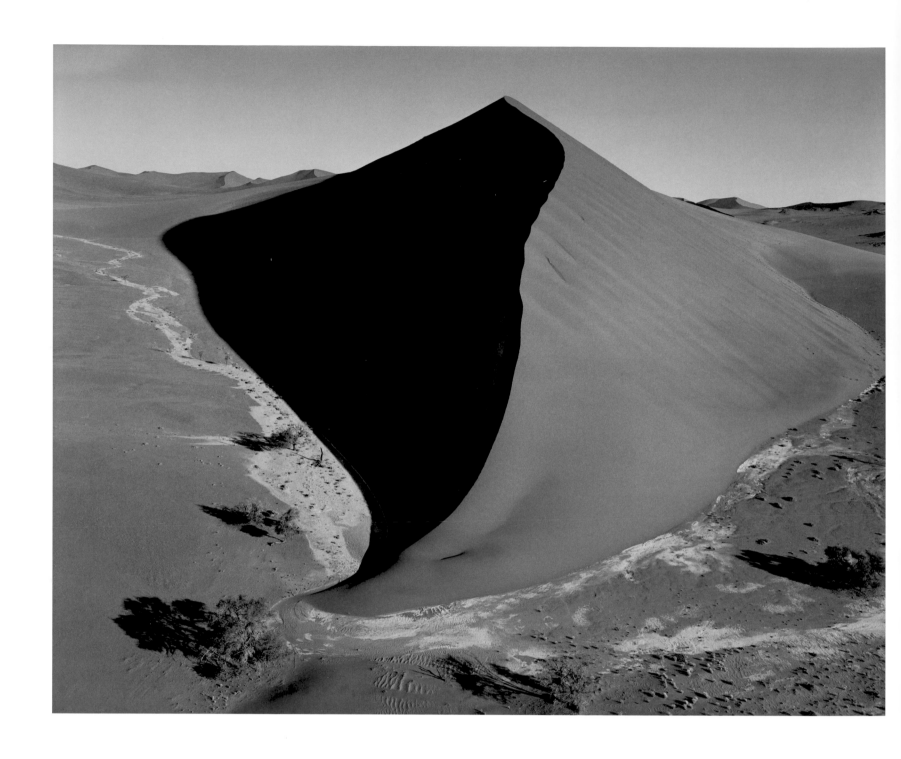

Namib, 2000

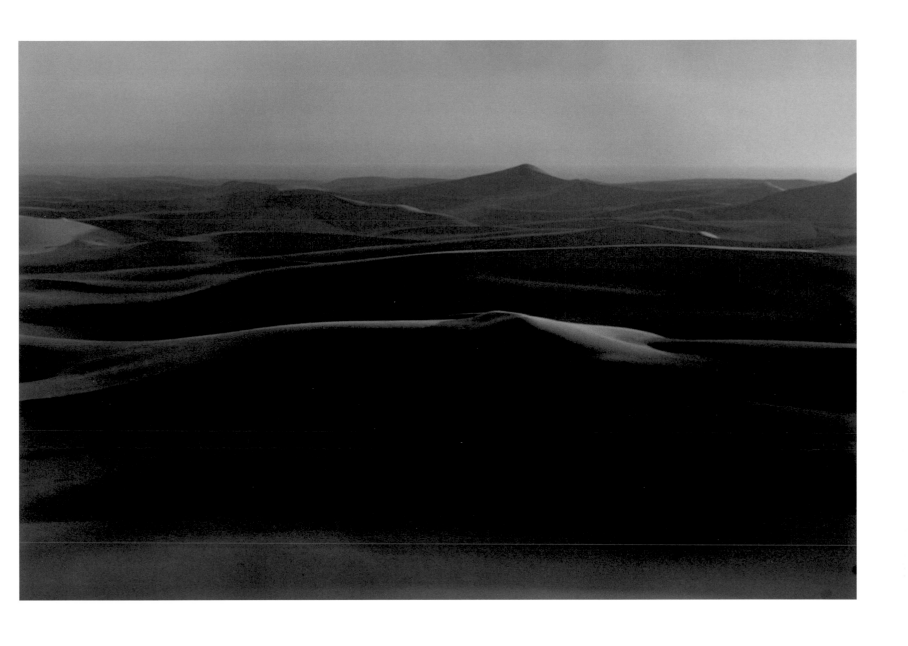

Chicago, 1999

Tokyo, 2000

Mexico City, 1999

Mexico City, 1999

Chica and Tzara, beginning of the 1990s

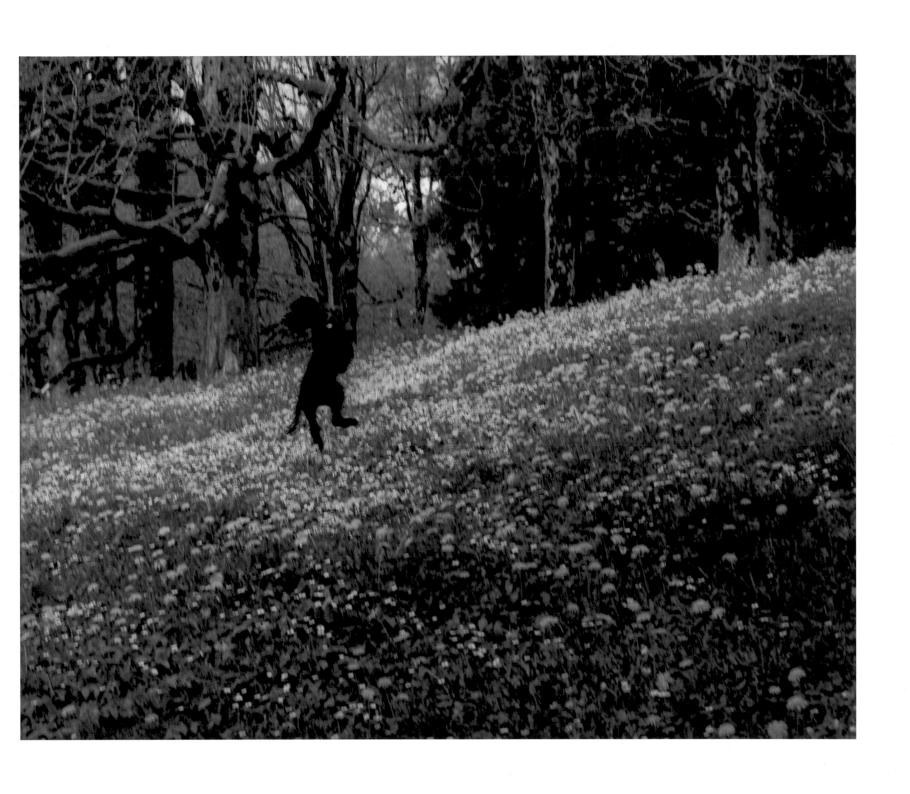

Lury, 2003

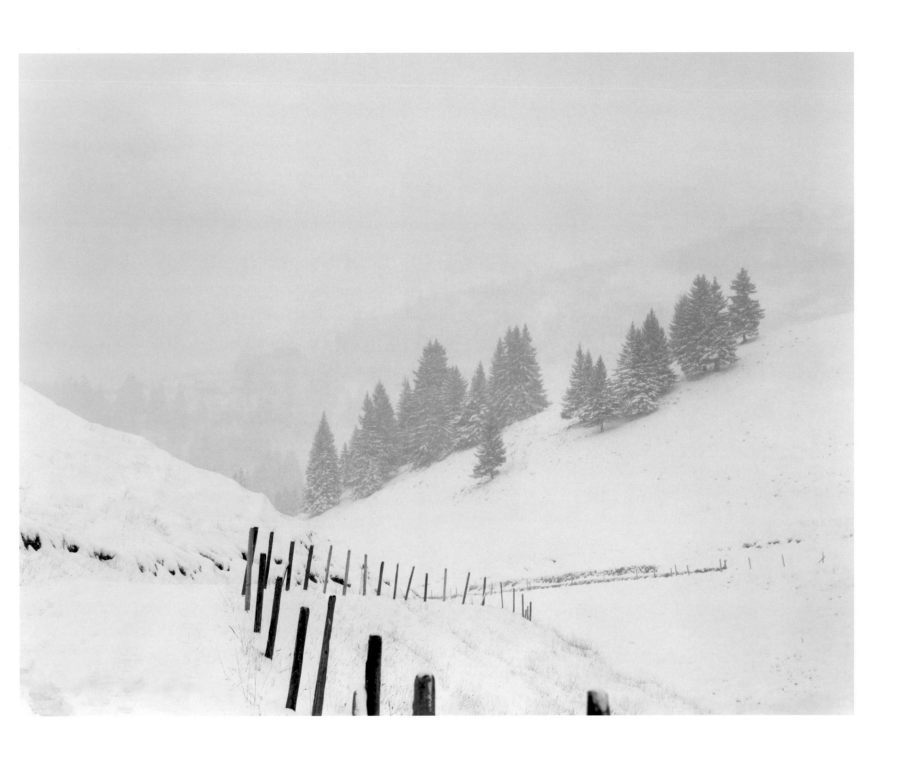

Col de la Croix, 2003

234

Remarkable that it is not our custom to speak of light as a building element in architecture. Of course one speaks of the sunlight that for just a short time penetrates the gorges of the streets and that one must bring into our rooms. That is why the "Chicago window" was invented – a large-pane window flanked by two moveable sashes.

It is not this light that is meant, nor is it the neon light in the Loop that already starts working at ten o'clock in the morning, with its figures, lines, words, and slogans as advertising running along the fronts of cinemas, restaurants, and department stores.

No, the light that is meant is the one turned on in the evening when it gets dark. And one does not have to think of the floodlights positioned to illuminate the Wrigley building, helping its white facade become even whiter so that it stands out from the rest of its skyscraper colleagues.

What is meant is the light turned on in the offices and apartments in skyscrapers. Illuminated stories, others that remain dark; a black and white mosaic that rarely remains the same throughout the course of an evening. This light traces the architecture, leaves empty spaces, shapes the building in a new way. This light bears an architectural function; one that is mobile and stays mobile. This light is a building element. The city rises once again. Cities like Chicago have a nightlife. Not because of its clubs or its amusements, rather because of its presentation in light. In this way big cities live twice, once in the day and once at night. And the skyline is different at night, even when it echoes that of the day. There is nothing more fascinating than watching a city like Chicago cross over from day- to nightlife. And like fixed stars the skyscrapers, with their galaxies of facades, form constellations that constantly shift and change.

Hugo Loetscher
du, *Mai 1972*

Chicago, 2004

Biography

1944
Born in Berne.

1961–1964
Studies under Berne photographer Kurt Blum.
1964 His first independent work, *Die Alp* (1963), is awarded the Eidgenössische Stipendium für angewandte Kunst (Federal Grant for Applied Arts).
1964 Travels to England.

1965–1968
Beginning 1965 has his own studio and works as a freelance photographer.
Becomes chronicler of the Kunsthalle Bern where he maintains close contact with artists and curators.
With Harald Szeemann, he travels to and documents other centers of art including the Venice Biennial among others.
1967 Travels to Italy, France, and Spain.
1968 Begins collaboration with Berne architects Atelier 5 whose work he photographs over several years.
Designs shop window for the department store Loeb in Berne.

1969
Together with Harald Szeemann develops the poster for the legendary exhibition "When Attitudes Become Form" at the Kunsthalle Bern. Further exhibition posters result, for Panamareko, Markus Raetz, and the Kunsthalle Bern among others.
Co-productions with Markus Raetz.
Films: together with filmmaker Georg Radanowicz *Dreizehn Berner Museen*.
The film 21 *Schweizer Künstler in 21 Minuten* is produced on the occasion of the exhibition "22 Schweizer Künstler" ("22 CH '69") at the Stedelijk Museum Amsterdam. The film consists of 21 one-minute self-portraits of artists invited to show at the exhibition. Idea: Balthasar Burkhard, Herbert Distel. Realization: Peter von Gunten.

1970
Begins work on publications about and with artists, together with Johannes Gachnang among others.
Exhibitions: Galerie Markt 17, Enschede (with Markus Raetz). "Creative Photography," Galerie Impact, Lausanne. First group exhibition in a museum: "Visualisierte Denkprozesse," Kunstmuseum Luzern.

1971
Group exhibitions: 7ème Biennale des Jeunes de Paris. Galleria Diagramma, Milan. Kunstverein Kassel. Karl-Ernst-Osthaus Museum, Hagen. Galleria Ip 220, Turin.

1972
Together with Jean-Christoph Ammann makes his first trip to the United States.
Films and photographs artists and happenings at the Documenta 5 in Kassel. This documentation is exhibited a year later by Harald Szeemann in Berne, Milan, and Bari.
Receives the Eidgenössische Stipendium für angewandte Kunst (Federal Grant for Applied Arts).

1974
Group exhibition: "Photographie in der Schweiz von 1840 bis heute," Kunsthaus Zürich.

1975–1978
Lives in Chicago where he teaches at the University of Illinois as Visiting Lecturer of Photography 1976/77.
Documents work by Tom Kovachevich and Claes Oldenburg.
1977 First solo exhibition: "Photocanvases '77."
1978 Plays the role of the crook in Urs Egger's film *Eiskalte Vögel*.

1979
Remains primarily in New York through 1981.
Solo exhibition: "A Portfolio," Swiss Center Gallery, New York.

1980
Solo exhibition: "Portraits," Centre d'art contemporain, Geneva.
Group exhibition: Hyde Park Art Center, Chicago.

1982
Returns to Switzerland; lives for a year in La Chaux-de-Fonds.
Solo exhibition: "Der Arm," Galerie Toni Gerber, Berne.
Group exhibition: "Mise en scène," Kunsthalle Bern.

1983
Moves to Berne.
First trip to Japan.
Eidgenössisches Kunststipendium (Federal Art Grant).
Large solo exhibition: "Fotowerke," Kunsthalle Bern.

1984
Solo exhibitions: "Balthasar Burkhard – Niele Toroni," Musée Rath, Geneva. Le Coin du Miroir, Dijon.
Participates in the Internationale Bauausstellung Berlin ("La Ricostruzione della Città," Triennale di Milano, 1985)

1985
Production and installation of a photogram for the Volksbad St. Gallen, presented by the Verein Kunsthalle, St. Gallen.

1986
Intervention, Kunst am Bau together with Niele Toroni for Atelier 5, Staatliches Lehrseminar Thun.
Exhibition in the Chapelle de la Salpêtrière, Paris, in line with *Mois de la photographie* where Burkhard designs an architecturally site-specific photo installation entitled "Surfaces sensibles."

1987
Three-month residency in Japan, followed by participation in the exhibition "Swiss Artists in Residence in Japan," Meguro Museum of Art, Tokyo.
Solo exhibitions: "Espace FRAC, Nouvelles Scènes," Dijon. Galerie E. & O. Friedrich, Berne.
Group exhibitions: "Blow-up Zeitgeschichte," Württembergischer Kunstverein, Stuttgart; Haus am Waldsee, Berlin; Kunstmuseum Luzern; Louisiana Museum of Modern Art, Humblebaek. "Drapeaux d'artistes," Musée d'art et d'histoire, Geneva.

1988
First large solo exhibition in the Kunsthalle Bern. Burkhard designs the exhibition according to the architectural circumstances of the newly renovated exhibition spaces. The exhibition is taken over by Kunsthalle St. Gallen and the Musée municipal de La-Roche-sur-Yon (1989).
Permanent installation in the Schweizer Rück, Zurich.
Group exhibition: "Zeitlos," Hamburger Bahnhof, Berlin.

1989
Moves to Boisset-et-Gaujac, France.
Awarded the Prix de la Banque hypothéquaire du canton du Genève. On this occasion the Musée Rath in Geneva dedicates an exhibition to him.
Group exhibition: "Miroir 89," Musée de Carouge und Centre d'art contemporain, Geneva.

1990
Through 1992 guest professor at the Ecole des Beaux-Arts Nîmes.
Solo exhibition: Hôtel Rivet, Nîmes.
Group exhibitions: "Fotografie in der Schweiz. Wichtige Bilder," Museum für Gestaltung, Zurich. "Schweizer Kunst, 1900–1990," Kunsthaus Zug.

1991
Solo exhibition: Galerie Rodolphe Janssen, Brussels.
Permanent installations at the Cantonal Hospital Aarau and the Kantonalbank Bern.
At the 5th Venice Architecture Biennial, Switzerland is represented by Herzog & de Meuron; photographs by Balthasar Burkhard, Hannah Villiger, Margherita Krischanitz, and Thomas Ruff are shown.
Group exhibitions: "Autrement dit, les artistes utilisent la photographie," Musée d'art et d'histoire de Fribourg. "Le Consortium collectionne," Château d'Oiron.

1992
Permanent installation in the Kantonsschule Winterthur and in the Spar- und Leihkasse Bern.
Group exhibitions: Swiss Pavilion, World Exposition, Seville. "Pour un Musée d'art moderne et contemporain," Musée Rath, Geneva. "Tribute to...," Kunsthalle St. Gallen.
"L'Architecture de Herzog & de Meuron," Fribourg; Museum Wiesbaden (1983).

1993
Solo exhibition: Galerie Rodolphe Janssen, Brussels
(with Franz West). Galerie Peter Kilchmann, Zurich.
Installation "Cinq Drapeaux" on the university
campus in Dijon within the scope of *les 7 jours de
l'art à l'université*. Installation, UBS, Geneva.
Group exhibition: GAS, CAPC Musée d'art
contemporain, Bordeaux.

1994
Large solo exhibition at the Kunsthaus Zug. Works
co-produced by Burkhard with Niele Toroni and
Franz West are presented.
Facade design, Deutsche Bank, Zurich.
Group exhibitions: "Zeitgenossen," Kunstmuseum
Bern. "La Collezione di Fotografia svizzere della
Banca del Gottardo," Galerie Gottardo, Lugano;
Galerie Mataci, Tenero; Centro d'arte
contemporaneo, Bellinzona.

1995
Returns to Switzerland.
A long-term collaboration with USM, Münsingen
begins. Develops architectural photographs for
advertising series about USM Haller furniture system.
Solo exhibitions: Magasin au foin, Grand-Hornu. Le
Consortium, Dijon (with Sophie Ristelhuber).
Group exhibitions: "Photographies," Galerie
Rodolphe Janssen, Brussels. "Bilder von Hören,
Bilder zum Hören," Stadthaus Olten.

1996
Permanent installation, Wasserwerke Zug.
Solo exhibitions: "Heliographien," Kabinett, Berne.
Museum Baviera, Zurich (with Tom Kovachevich).
Group exhibitions: "Comme un Oiseau," Fondation
Cartier pour l'art contemporain, Paris. "Im
Kunstlicht," Kunsthaus Zürich. Gemäldegalerie der
Akademie der bildenden Künste, Vienna. "Condamnés
à la liberté," Espace de l'art concret, Mouans-Sartoux.

1997
Permanent installation with Niele Toroni and
Roland Gfeller-Corthésy, Crédit Suisse, Zurich.
Solo exhibitions: "Balthasar Burkhard. Eloge de
l'ombre," Musée Rath, Geneva. Galerie Liliane et
Michel Durand-Dessert, Paris. "On your mark!",
Galerie Blancpain Stepczynski, Geneva.
Group exhibitions: "Animaux et animaux," Museum
zu Allerheiligen, Schaffhausen. "Wege zur Kunst.
Wege zur SaMMlung," Sammlung Migros-Museum
in der Kunsthalle Bern.

1998
Begins work on large cityscapes (Madrid, London,
Naples, Paris – 1998; Helsinki, Chicago, Los Angeles
– 1999; Tokyo – 1999/2000). The video *Ciudad* is
filmed in Mexico City, produced for the International
Architecture Symposium Pontresina, 1999.
Solo exhibitions: Galerie Rigassi, Berne. "Ville,"
Galerie Liliane et Michel Durand-Dessert, Paris. "A
l'arrêt," Schweizerische Mobilar, Berne. Patrick de
Brook Gallery, Knokke. Espace d'art contemporain,
Porrentruy. "Photoarbeiten," Kunsträume Zermatt.
Group exhibitions: "Dijon/le Consortium, coll, tout
contre l'art contemporain," Centre national d'art et
de culture Georges Pompidou, Paris.

1999
Solo exhibitions: Palais des Beaux-Arts de
Charleroi, Belgium. Musée des Beaux-Arts de
Grenoble.
Within the framework of the 1st Photography
Triennial in Hamburg: exhibition at USM Hamburg
and Galerie Sfeir-Semler, Hamburg. Galerie
Blancpain Stepczynski, Geneva. "International
architecture photographed by Balthasar Burkhard,"
USM Showroom, Chicago. "Städte," Galerie Fabian
& Claude Walter (with Annelies Štrba), Basel.
Group exhibitions: "New Natural History," National
Museum of Photography, Film & Television,
Bradford. "Missing Link," Kunstmuseum Bern.
"Fotografien aus der Privatsammlung Paul Schärer,"
by Teo Jakob, Berne. "Invitation," Musée d'art
moderne et contemporain, Geneva.

2000
Travels to desert in Namibia. In addition to
photographs, he produces the video *Namib 2000*
with music by Mich Gerber and camerawork by Pio
Coradi.
Permanent installation: *Saint Georges et le dragon*,
Mons. HypoVereinsbank, Luxemburg.
Solo exhibition: Galerie Blancpain Stepczynski,
Geneva.
Group exhibitions: "La Arquitectura sin Sombra,"
Centre de Cultura Contemporánia de Barcelona;
Monasterio de la Cartuja de Santa Mariá de las
Cuevas, Seville. Catherine Putman, Editions, Paris.
"XL Photography, Art Collection Neue Börse,"
Deutsche Börse, Frankfurt am Main. "Desert &
Transit," Kunsthalle Kiel. "Le Désert," Fondation
Cartier pour l'art contemporain, Paris. "Domiciles,"
Centre d'art de Tanlay. "L'Invitation à la ville,"
Centre, Brussels. "Animaux d'art et d'histoire,"
Musée d'art et d'histoire, Geneva. "Collection 2,"
FRAC, Alsace. "Dédales, polyphonie du labyrinthe,"
Maison de la culture d'Amiens. "Luftbilder
Landbilder," Kunsthaus, Langenthal.

2001
Solo exhibitions: Helmhaus Zürich. "Balthasar
Burkhard – Voyage," Kunstmuseum Thun. Galerie
Liliane et Michel Durand-Dessert, Paris. Galerie
Sfeir-Semler, Hamburg. Galerie Rodolphe Janssen,
Brussels.
Group exhibitions: "Franz West. Obsorge," Kunsthaus
Zug. "Black and White is Beautiful," Studio la Città,
Verona. "Le siècle du corps, photographies
1900–2000," Musée de l'Elysée, Lausanne. "Trade.
Waren, Wege und Werte im Handel heute,"
Fotomuseum Winterthur. "Frontside," Littman
Kulturprojekte, Basle. "Innen Aussen 1," Kunsthaus
Zug. "El desert," Centre Cultural de la Fundació "La
Caixa," Barcelona. "Noorderlicht," Groningen.
"Ciudad," Centro Culturale Svizzero, Milan.

2002
Travels to Rio Negro, Brazil.
Performance *Rainmaker* and presentation of *Ciudad*.
Academia Engelberg, Kloster Engelberg.
Solo exhibitions: Kunstraum Medici, Solothurn.
"Rio Negro," Galerie Tschudi, Glarus; Galleria
Salvatore Ala, Milan.
Group exhibitions: "L'herbier et le nuage," Musée
des arts contemporains, Hornu.
"Wallflowers," Kunsthaus Zürich. "Die Stadt.
Stadtbilder in Zeiten der Transformationsprozesse,"
Städtische Galerie, Delmenhorst. Galerie Tanit,
Munich.

2003
Solo exhibitions: "Rio Negro," House of Art,
CZ–Ceské Budejovice; Galerie Sfeir-Semler,
Hamburg. "Balthasar Burkhard. Standpunkt 1,"
Kirchner Museum, Davos. Galerie Tschudi, Zuoz
(with Not Vital). The Fruitmarket Gallery,
Edinburgh.
Group exhibitions: "L'immagine ritrovata. Pittura e
fotografia dagli anni Ottanta a oggi," Museo
cantonale d'arte, Lugano. "Mémoires du visible,"
Musée du Louvre, Paris. "Bäume, Wälder, Wurzeln,"
Die Mobilar Bern. "Comment rester zen," Centre
Culturel Suisse, Paris. "Montagna. Arte scienza
mito. Da Dürer a Warhol," Mart, Rovereto. "En
Résonance," Lycée Saint Charles de Marseille.

2004
Solo exhibitions: "Balthasar Burkhard.
Héliogravures 1991–2003 et travaux
photographiques," MAMCO, Geneva.
Travels to Chicago.

Bibliography

Monographs

Balthasar Burkhard. Photographer. Zurich: Scalo Verlag, 2005.

Balthasar Burkhard. héliogravures, published on the occasion of the exhibition in the Galerie de l'ancien collège à Châtellerault, 2003.

Standpunkt 1. Balthasar Burkhard, catalogue of the exhibition in the Kirchner Museum Davos, 2003. Zurich: Scheidegger & Spiess, 2003.

Balthasar Burkhard, Helmhaus Zürich exhibition catalogue, published by the Helmhaus Zürich, 2001.

Voyage, exhibition catalogue Kunstmuseum Thun, published by the Kunstmuseum Thun, 2001.

Balthasar Burkhard. Namib, Wildstrubel. Köniz: Atelier du Livre, 2001.

L'écrivain public, published on the occasion of the exhibition in the Palais des Beaux-Arts de Charleroi, Palais des Beaux-Arts, 1999.

Balthasar Burkhard, exhibition catalogue Musée de Grenoble. 1999.

Balthasar Burkhard. Eloge de l'Ombre/Lob des Schattens, exhibition catalogue Musée Rath, Geneva. Baden: Lars Müller, 1997.

"Klick!", sagte die Kamera / "Clic!", dit l'appareil de photos / "Click!", said the camera. Baden: Lars Müller, 1997.

Mason, Rainer Michael. *Balthasar Burkhard, A l'arrêt*, published by the Galerie Blancpain Stepczynski, Geneva, 1997.

Balthasar Burkhard, exhibition catalogue Kunsthaus Zug, published by the Kunsthaus Zug, 1994.

Helix Aspersa. *Balthasar Burkhard.* Gent: Imschoot, 1991.

Balthasar Burkhard, catalogue to exhibition at the Kunsthalle Bern (1988); Kunsthalle St. Gallen, Musée de la Roche-sur-Yon (1989), published by the Kunsthalle Bern, 1988.

Balthasar Burkhard/Niele Toroni, catalogue to exhibition at the Musée Rath, published by the Musée d'art et d'histoire, Geneva, 1984.

Zaugg, Rémy, *Ausstellung, Balthasar Burkhard*, published on the occasion of the exhibition "Fotowerke" at the Kunsthalle Basel, 1983.

Contributions in books and group exhibition catalogues

Mémoires du visible. Cuivres et estampes de la chalcographie du Louvre, catalogue to exhibition in Musée du Louvre. Paris: Editions de la Réunion des musées nationaux, 2003.

Post Ex Sub Dis Urban Fragmentations and Constructions. Ed. The Ghent Urban Studies Team. Rotterdam: 010 Publishers, 2002.

Vues d'architectures. Photographies des XIXe et XXe siècles, catalogue to the exhibition at the Musée de Grenoble, 2002.

L'immagine ritrovata. Pittura e fotografia dagli anni Ottanta a oggi, catalogue to the exhibition at the Museo Cantonale d'Arte Lugano, 2002/03. Ostfildern-Ruit: Hatje Cantz, 2002.

Die Stadt. Stadtbilder in Zeiten der Transformationsprozesse, catalogue to the exhibition at the Städtische Galerie Delmenhorst. Bremen: Hauschild, 2002.

Wallflowers, catalogue to the exhibition at the Kunsthaus Zürich, published by the Kunsthaus Zürich, 2002.

Trade. Waren, Wege und Werte im Welthandel heute, catalogue to the exhibition at the Fotomuseum Winterthur (2001); Nederlands Foto Instituut, Rotterdam (2002). Eds. Thomas Seelig, Urs Stahel, Martin Jäggi. Zurich: Scalo Verlag, 2001.

El desert, catalogue to the exhibition in the Fundació "La Caixa," Barcelona, published by the Fundació "La Caixa," Barcelona, 2001.

Hypovereinsbank Luxembourg. Architektur und Kunst, published by the Hypovereinsbank Munich, 2000.

Collection 1989/1999, frac provence-alpes-côte d'azur. Arles: Actes Sud, 2000.

La Collection de la Fondation Cartier pour l'art contemporain. Arles: Actes Sud, 2000.

XL Photography. Art Collection Neue Börse. Ostfildern-Ruit: Hatje Cantz, 2000.

Desert & Transit, catalogue to the exhibition at the Kunsthalle Kiel (2000); Museum der bildenden Künste Leipzig (2001), published by the Schleswig-Holsteinische Kunstverein/Museum der bildenden Künste Leipzig, 2000.

La arquitectura sin sombra, catalogue to the exhibition at the Centro Andaluz de Arte Contemporáneo, Seville, published by the Junta de Andalucía, 2000.

Le désert, catalogue to the exhibition at the Fondation Cartier pour l'art contemporain, Paris. Arles: Actes Sud, 2000. (English edition: The Desert, Thames & Hudson, 2000).

La Biennale di Venezia. 48. esposizione internazionale d'arte. Venice: Marsilio, 1999.

Missing link. Menschen-Bilder in der Fotografie, catalogue to the exhibition at the Kunstmuseum Bern. Thalwil bei Zürich: Stemmle, 1999.

New Natural History, catalogue to the exhibition at the National Museum of Photography, Film & Television, Bradford (1999); Hasselblad Center, Göteborg (2000), published by the National Museum of Photography, Bradford, 1999.

Boller, Gabrielle, encyclopedia entry about Balthasar Burkhard, in: *Biografisches Lexikon der Schweizer Kunst.* Ed. Schweizerische Institut für Kunstwissenschaft Zürich und Lausanne. Zurich: Verlag Neue Zürcher Zeitung, 1998, p. 181 f.

Brochure accompanying the project "Kunst und Architektur" at the Ost Basel Station, H. 1-6. Baden: Lars Müller, 1998–2000.

Animaux et animaux. Zeitgnössische Kunst und Zoologie, catalogue to the exhibition at the Museum zu Allerheiligen, 1997/98, published by the Kunstverein Schaffhausen, 1997.

Foto Relations: 12 Künstler aus der Schweiz und ihre Arbeit mit Fotografie in den 90er Jahren, catalogue to the exhibition in the Kunsthaus der Stadt Brünn/Brno, 1998, published by M. Smolenicka, Berne, 1997.

Fragile – Handle with Care, catalogue to the exhibition at the Gemäldegalerie der Akademie der bildenden Künste, Vienna. Männerdorf: Edition NOMAD, 1996.

Comme un oiseau, catalogue to the exhibition at the Fondation Cartier pour l'art contemporain, Paris. Paris: Gallimard/Electa, 1996.

La collezione di fotografia svizzera della Banca del Gottardo, catalogue to the exhibition at the Galleria Gottardo, Lugano; Galleria Matasci, Tenero; Centro d'arte contemporaneo, Bellinzona, published by the Fondazione Galleria Gottardo, Lugano, 1995.

Körper-Fragment-Wirklichkeit. Beispiele aus der Schweizer Kunst des 20. Jahrhunderts, catalogue to the exhibition at the Kunstmuseum Solothurn, published by the Kunstmuseum Solothurn, 1994.

Collection des Œuvres photographiques, published by the Musée de La Roche-sur-Yon, 1991.

BCG 91: Collection de l'art contemporain, published by the Banque hypothécaire du canton de Genève, 1991.

Autrement dit: les artistes utilise la photographie / Mit anderen Worten: Künstler verwenden die Fotografie / Detto altrimenti: gli artisti adoperano la fotografia, catalogue to the exhibition at the Ancienne caserne de la Planche, Fribourg. Berne: Benteli, 1991.

Stahel, Urs/Heller, Martin, *Fotografie in der Schweiz. Wichtige Bilder*, published on the occasion of the exhibition "Wichtige Bilder" at the Museum für Gestaltung Zürich, published by Verlag der Alltag/Museum für Gestaltung Zürich, 1990.

Le Consortium collectionne, catalogue to the exhibition at the Château d'Oiron, 1991.

Schweizer Kunst 1900–1990 aus Schweizer Museen und öffentlichen Sammlungen, catalogue to the exhibition at the Kunsthaus Zug, 1991, published by the Kunsthaus Zug, 1990.

Balthasar Burkhard, Philippe Deléglise, Michel Huelin, …, catalogue to the exhibition at the Musée de Carouge, Geneva, published by the Centre d'art contemporain, 1989.

Artistes suisses au Japon = Swiss artists in residence in Japan, catalogue to the exhibition at the Meguro Museum of Art, Tokyo, 1987/88, published by the Meguro Museum of Art, Tokyo, 1987.

Drapeaux d'artistes, catalogue to the exhibition at the Musée d'art et d'histoire, Geneva, published by the Musée d'art et d'histoire, 1987.

Mit erweitertem Auge. Berner Künstler und die Fotografie, published in conjunction with the exhibition at the Kunstmuseum Bern of the same name. Ed. Bernische Stiftung für Fotografie, Film und Video (FFV). Berne: Benteli, 1986.

Centre d'art contemporain. Genève 1974–1984, published by the Centre d'art contemporain, Geneva, 1984.

La suisse à la septième biennale de Paris, 1971, published by the Eidgenössische Departement des Innern and Fondation Pro Helvetia, 1971.

Magazine and Newspaper Articles

Krienke, Mary, "Balthasar Burkhard und Not Vital," in: *ARTnews*, No. 2, February 2004, p. 136.

Martin, Franziska, "Stiftung Kunstsammlung Teo Jakob," in: *Teo Jakob, Report 5*, November 2003, p. 36.

Olonetzky, Nadine, "Baumriesen, Gletscher, Wolken," in: *NZZ am Sonntag*, 27 July 2003.

Müller, Silke, "Grandiose Welten. Balthasar Burkhards Foto-Expeditionen," in: *Art*, No. 4, April 2003, pp. 51-65.

Brevi, Manuela, "Burkhard: novita dal Rio Negro," in: *Arte*, No. 351, November 2002, p. 192.

Remy, Patrick, "A la rencontre des photographes," in: *Œil*, No. 538, July/August 2002, pp. 10-12.

Däniken, Hans-Peter von, "Im Einklang mit der ganzen Welt," in: *Tages-Anzeiger*, 9 February 2001.

Tobler, Konrad, "Das Auge verliert sich in der Weite," in: *Berner Zeitung*, 3 February 2001.

Perini, Adriano, "Balthasar Burkhard," in: *Photo Magazine*, No. 98, July 2000, p. 19.

Coronelli, Chiara, "A Grenoble: per Burkhard e Moral," in: *Arte*, No. 317, January 2000, p. 114. In: *Rücksicht. 40 Jahre Kunst in der Schweiz*. Eds. Beat Wismer and Stephan Kunz. Published by Aargauer Kunsthaus Aarau, 2000.

Daghini, Giairo, "Le devenir des villes," in: *Faces, Journal d'architectures*, No. 46, 1999, pp. 2-9.

"dAPERTutto," in: *Kunstforum International*, No. 147, September – November 1999, pp. 174-265.

Herstaat, Claudia, "1. Triennale der Photographie," in: *Kunstforum International*, No. 147, September – November 1999, p. 366 f.

Fiedler, Andreas/Tobler, Konrad, "Megastädte unter dem Foto-Mikroskop," in: *Berner Zeitung*, 5 June 1999.

Zardini, Mirko, "La ville es ses adjectifs," in: *Faces, Journal d'architectures*, No. 46, 1999, pp. 10-13.

Pfister, Thomas, "Balthasar Burkhard: Der Elefant, 1997," in: *Jahresbericht 1998*, Kunstmuseum Bern, 1998, p. 61 f.

Giger, Bernhard, "Das diffizile Gleichgewicht des Lichts," in: *Berner Zeitung*, 13 June 1997, p. 23.

Schaub, Martin, "Auf den Begriff gebracht," in: *Tages-Anzeiger*, 11 June 1997.

Bastais, Héléna, "Balthasar Burkhard: Un bestiaire d'avant-scène," in: *Etudes*, April 1997, p. 541 f.

Kleinschmidt, Klaus, "Das Arche-Noah-Projekt des Balthasar Burkhard," in: *Süddeutsche Zeitung Magazin*, No. 25, 1997, pp. 32-41.

Criton, Sonia, "Une conscience de l'agrandissement," in: *Pratique, Revue de Réflexions sur l'art*, No. 1, Spring, 1996, pp. 46-63.

Wauters, Anne, "Entre ciel et terre," in: *Art & Culture*, No. 2, October 1995, p. 54 f.

Schaub, Martin, "Fotografische Urworte. Balthasar Burkhard im Kunstmuseum Zug," in: *Tages-Anzeiger*, 1 December 1994.

Mack, Gerhard, "Zug: Balthasar Burkhard im Kunsthaus," in: *Kunst-Bulletin*, December 1994.

Tobler, Konrad, "Bergbilder jenseits konkreter Landschaft," in: *Berner Zeitung*, 19 October 1993, p. 23.

Szeemann, Harald, "Unerwartete Schweizer/innen: suizos sorprendentes," in: *Kunst-Bulletin*, June 1992, pp. 22-27.

Vankeerberghen, Véronique, "Balthasar Burkhard. L'anatomie des corps signes," in: *Artefactum*, February/March 1992, p. 31.

Abeele, Lieven van den, "Balthasar Burkhard," in: *Forum International*, No. 10, November 1991, pp. 52-57.

Wauters, Anne, "Le corps fragmenté," in: *Art & Culture*, October 1991, p. 33.

Chauvy, Laurence, "Sobre et audacieux: le travail d'un artiste en quête de vérité," in: *Journal de Genève*, 5 December 1989.

Wechsler, Max, "Balthasar Burkhard. Kunsthalle," in: *Artforum*, February 1989, pp. 134-144.

Stahel, Urs, "Fotografie in der Schweiz," in: *Der Alltag*, No. 1, 1989, pp. 134-188.

Wechsler, Max, "Fotografien in raumbezogener Installation," in: *Vaterland*, 24 October 1988.

Schaub, Martin, "Bilderschrift," in: *Das Magazin*, No. 39, September/October 1988, pp. 16-19.

Zaugg, Fred, "Die Ahnung des Ganzen aus der Betrachtung der Teile," in: *Der Bund*, 30 September 1988.

Douroux, Xavier, "Un travail de titan," in: *Plus*, No. 3/4, May 1988, pp. 72-80.

Nozière, Christine, "Des artistes suisses en résidence au Japon," in: *Rivista d'arte e di cultura*, No. 16, 1988, p. 9.

Nottin, Philippe, "Sensitive Surfaces: 15 Artists at the Salpêtrière," in: *Cimaise*, No. 184/185, November/December 1986, pp. 63-76.

Magnaguagno, Guido/Stahel, Urs, "Neue Schweizer Fotografen," in: du. *Die Zeitschrift für Kunst und Kultur*, August 1985, pp. 24-95.

Stahel, Urs, "Zwölf Fotografen und ihre Arbeit," in: du. *Die Zeitschrift für Kunst und Kultur*, August 1985, pp. 26-67.

Descombes, Mireille, "Burkhard et Toroni au Musée Rath: un dialogue qui se joue des perspectives," in: *Tribune de Genève*, 13 March 1984.

Schaub, Martin, "Eine nachhaltige Lektion aus der Schule des Sehens," in: *Tages-Anzeiger*, 24 May 1983.

Graffenried, Regina von, "Seine Fotografien entstehen im Kopf," in: *Berner Zeitung*, 10 February 1982.

Grundbacher, François, "Vor und hinter der Kamera," in: *Prisma. Das Schweizer Monatsmagazin*, No. 9/10, September/October 1979, pp. 49-56.

Artner, Alan G., "5 Artists who made last 5 years memorable," in: *Chicago Tribune*, 11 June 1978.

Schwartz, Donald M., "Beyond the frame," in: *Chicago Sun-Times*, 12 June 1977.

"Balthasar Burkhard," in: *Camera. Internationale Monatsschrift für Photographie und Film*, May 1971, pp. 4-12.

Zdenek, Felix, "Burkhard/Raetz: Die Wirklichkeit als umgekehrter Spiegel," in: *Kunstnachrichten* (Luzern), Heft 8, April 1971, pp. 2-4.

Porter, A., "Ultrabanalität," in: *Camera*, August 1970.

Book Illustrations, Photo Essays, and Interviews

Balthasar Burkhard on Meret Oppenheim, in: du. *Die Zeitschrift für Kunst und Kultur*, February 2001, p. 61.

Herzog, Samuel, "Was wir machen, ist Seelenarbeit. Annelies Štrba und Balthasar Burkhard im Gespräch," in: *Kunst-Bulletin*, No. 6, June 1999, pp. 24-28.

Burkhard, Balthasar, "Portfolio 1979," in: *images 4–1998*. Published by Centre de la Photographie, Geneva, 1999, pp. 44-53.

Fabian, Daniela, "Interview mit Fotograf Balthasar Burkhard," in: *USM International*, No. 2, 1997, p. 8.

Balthasar Burkhard in conversation with Sonia Criton, in: *Pratiques, Revue de Réflexions sur l'art*, No. 1, Spring 1996, pp. 64-68.

Architecture of Herzog & de Meuron, with photographs by Balthasar Burkhard. New York: P. Blum, 1994.

Franz Gertsch. Holzschnitte, catalogue of the exhibition at the Kunstmuseum Bern, 1994, with photographs by Balthasar Burkhard. Baden: Lars Müller, 1994.

Burkhard, Balthasar, "Fotoessay," in: du. *Die Zeitschrift für Kunst und Kultur*, No. 5, May 1992, pp. 35-43.

Das Seminar. Eds. Atelier 5, Balthasar Burkhard, Niele Toroni, Giario Daghini. Zurich: Ammann, 1988.

Atelier 5, 26 ausgewählte Bauten, fotografiert von Balthasar Burkhard. Zurich: Ammann, 1986.

Queloz, Catherine, "Marquer le lieu. Entretien avec Balthasar Burkhard et Niele Toroni," in: *Faces. Journal d'architectures*, No. 4, 1986, pp. 19-24.

Balthasar Burkhard, "Photos," in: *Rémy Zaugg, Für das Kunstwerk, Kunstmuseum Bern, Atelier 5*. Zurich: Ammann, 1983, pp. 102-134.

Senn, Paul, *Paul Senn: Bilder aus der Schweiz*, photographs selected by Balthasar Burkhard. Lausanne: Genoud, 1982.

Pierre Klossowski: Simulcra, catalogue of the exhibition at the Kunsthalle Bern, 1981, with photographs by Balthasar Burkhard, published by the Kunsthalle Bern, 1979.

Rémy Zaugg. Réflexion 1977, with photographs by Balthasar Burkhard, published by the Kunsthalle Bern, 1979.

Niele Toroni, catalogue to the exhibition at the Kunsthalle Bern with photographs by Balthasar Burkhard, published by the Kunsthalle Bern, 1978.

Berner Kunstausstellung, 1853, 1885, … 1904, catalogue to the exhibition in the Kunsthalle Bern with photographs by Balthasar Burkhard, published by the Kunsthalle Bern, 1975.

Maus Museum. Eine Auswahl von Objekten gesammelt von Claes Oldenburg, with photographs by Balthasar Burkhard, published by Documenta 5, Kassel, 1972.

Architektur Luis Barragán; Fuente de los Amantes, Los clubes Mexico DF, 1964
Inszenierung und Photographie im Raum: Balthasar Burkhard, 1997

Für Ihre Räume: USM U. Schärer Söhne AG, CH-3110 Münsingen
Telefon 031 720 72 72, Telefax 031 720 72 38, www.usm.com

USM
Möbelbausysteme

Architektur Pierre Koenig; Case Study House #22, Hollywood Hills, 1959
Inszenierung und Photographie im Raum: Balthasar Burkhard, 1997

Für Ihre Räume: USM U. Schärer Söhne AG, CH-3110 Münsingen
Telefon 031 720 72 72, Telefax 031 720 72 38, www.usm.com

USM
Möbelbausysteme

The original German edition of this book was published on the occasion
of the exhibition at the Kunstmuseum Bern, 11 June – 24 October 2004.

Balthasar Burkhard: OMNIA
Edited by Matthias Frehner
In collaboration with the Kunstmuseum Bern

Editor: Teresa Go
Book design: Claas Möller / Steidl, Göttingen
Scans: Steidl, Göttingen
Production: Art-D & Trico, Prague

© 2005 for the photographs: Balthasar Burkhard
© 2005 for the text: Matthias Frehner
© 2005 for this edition: Scalo Verlag AG

Scalo head office:
Scalo Verlag AG
Schifflände 32, CH-8001 Zurich, PO Box 73 CH-8024 Zurich, Switzerland
tel: +41 44 261 0910, fax: +41 44 261 9262
publishers@scalo.com, www.scalo.com

Distributed in North America by Prestel, New York; in Europe, Africa, and Asia by Thames and Hudson, London;
in Germany, Austria, and Switzerland by Scalo.

ISBN 3-03939-001-5
First edition 2005